THE PRAGMATIC IDEAL

THE PRAGMATIC IDEAL

MARY FIELD PARTON AND THE PURSUIT OF A PROGRESSIVE SOCIETY

MARK DOUGLAS MCGARVIE

NORTHERN ILLINOIS UNIVERSITY PRESS
AN IMPRINT OF CORNELL UNIVERSITY PRESS
Ithaca and London

First published 2022 by Cornell University Press

Library of Congress Cataloging-in-Publication Data

Names: McGarvie, Mark D. (Mark Douglas), 1956– author.
Title: The pragmatic ideal: Mary Field Parton and the
 pursuit of a progressive society / Mark Douglas
 McGarvie.
Description: Ithaca, New York: Northern Illinois
 University Press, an imprint of Cornell University Press,
 2022. | Includes bibliographical references and index.
Identifiers: LCCN 2021023364 (print) | LCCN
 2021023365 (ebook) | ISBN 9781501762659 (hardcover) |
 ISBN 9781501762666 (paperback) | ISBN
 9781501762680 (pdf) | ISBN 9781501762673 (epub)
Subjects: LCSH: Parton, Mary Field—Political and social
 views. | Darrow, Clarence, 1857–1938—Political and
 social views. | Progressivism (United States politics)—
 History. | Women social reformers—United States—
 Biography. | Women political activists—United States—
 Biography. | United States—Intellectual life—
 1865–1918. | United States—Intellectual life—
 20th century. | United States—Social conditions—
 1865–1918. | United States—Social conditions—
 1918–1932. | United States—Politics and government—
 1901–1953.
Classification: LCC E743 .M34 2022 (print) | LCC E743
 (ebook) | DDC 303.48/4092 [B]—dc23
LC record available at https://lccn.loc.gov/2021023364
LC ebook record available at https://lccn.loc.gov
 /2021023365

It is a responsibility to tear down errors of the past and to put in their places new ideas. It is a greater responsibility to hold fast to the truths of the past undisturbed in the complex experimental present.

 —Luella Clay Carson, from "A New Opportunity in the Building of a State," 1906

Contents

ACKNOWLEDGMENTS

I started the primary research and background reading for this book in 2016. I was working in the Parton family papers in the archival library at the University of Oregon when the Chicago Cubs won their first World Series since 1908 and Donald Trump was elected president. Seldom had such joy been so closely followed by so much trepidation. But on a very personal level, I felt as if the world was aligning with my scholarly interests, bringing millions of baseball fans to consider, albeit briefly, life in the United States in the early 1900s, and millions more to wonder about the nature of democracy and the fate of our nation's liberal ideas. Furthermore, Donald Trump's brand of populism revived interest not only in his political hero, Andrew Jackson, but also in other populist predecessors, such as William Jennings Bryan, who danced on the political stage for more than thirty years at the turn of the prior century. Trump's presidency seemed both to confirm the dire predictions of scholars who had wondered whether liberalism's apparent decline was terminal and to compel new consideration of alternative political theories and systems of government. The project I had conceived early in 2016 seemed especially poignant. I think it still is.

I have always contended that writing objective history is not only possible but required. We study history not to form judgments but to gain understanding. Once we come to judgment, we stop trying to understand. All of us who write history do so not only with a goal of rendering the past meaningful today and tomorrow but also with the aim of being true to those who formed the history about which we write.

While these precepts have governed everything I have written and every class I have taught, they have never been more real to me than in writing this book—a microhistory dealing largely with one woman—someone's mother and grandmother, a woman of passionate convictions, and a person so full of life that it seemed at times literally to ooze from her. She and her heirs deserve my respect and objectivity, but no more so than any other historical actors. My subject is different only because, unlike so many billions of people who have preceded us on this globe, Mary Field Parton has left us a voluminous paper

record, wonderfully preserved by her daughter Margaret and expertly cared for by the people at the archives of the University of Oregon. My primary thanks go to them and in particular Lauren Goss.

My previous books have dealt with the societal and political effects of the legal delineation of public and private sectors in the United States, most specifically in regard to philanthropy and the separation of church and state. However, even as I was writing my earlier books, Larry Friedman, my friend, coeditor, and former PhD adviser, encouraged me to study people as well as their ideas. I owe a debt of gratitude to other former teachers as well. Professors Robert Wiebe, Casey Blake, and Dave Thelen introduced me to the Progressive movement and the exciting years in US history between 1890 and 1940. I only hope this work is a somewhat worthy product of their instruction.

While researching for this project, I received wonderful assistance from some people not only at the University of Oregon Archives (Parton Papers) but also at the Newberry Library and the Chicago Historical Society and Museum. At the latter, a special thank you is due Katie Levi for her help obtaining many of the images used in this book. Subsequently, as I began writing, Alannah Shubrick, my research assistant at William and Mary, Marshall-Wythe School of Law, offered insights on both Mary and the ideas percolating around her from the perspective of a young woman who came of age in the twenty-first century. I valued the chance to share ideas, and a few inevitable frustrations, with fellow William and Mary faculty member Tom McSweeney during my tenure at that school. I also appreciated the opportunity to bounce some thoughts off the very fertile minds of Timothy Breen, Mark Valeri, Greg Mark, Rick Herrera, and Francis Flavin at varied stages of this work. Cary Hemphill typed the entire manuscript from pages written in longhand and made numerous suggestions and corrections that improved the book. In fall 2020, I became a Visiting Research Scholar at the American Bar Foundation. The Foundation, and in particular its executive director Ajay Mehrotra, provide a wonderfully supportive and collegial environment for research and writing. I am extremely appreciative of the opportunity.

Most significantly, acquisitions editor Amy Farranto worked with me very patiently to revise and position my text for publication. This book would not exist without her support, guidance, and dedication. The readers who offered suggestions in the peer-review process also are very much appreciated.

To all of you—thank you!

Blythe, my wife of thirty-eight years, deserves much more than thanks. She has read every page of this text multiple times and never wavered in her confidence or encouragement. To the extent that I have even a modicum of understanding of women, I owe it to her.

THE PRAGMATIC IDEAL

Introduction

> *The might of the majority does not make right, and you know it! Right is on the side of people like me. Of the enlightened few, of the great intellects of the visionaries, who see and understand the truth.*

—Henrik Ibsen, An Enemy of the People

A liberal democracy inevitably confronts a tension between concern for the public good and the protection of individual liberties.[1] Throughout most of the country's history, the people of the United States have valued their individual freedom as constitutive of the public good, at once ignoring the tension and resolving it as well. Yet at certain times in the nation's history, aggressive campaigns have been waged to limit individual rights, especially in regard to property, in order to pursue a greater degree of social equality.

Young Mary Field lived in such a period. The story of her life serves very well as a means of accessing the ideas, concerns, conflicts, and political movements of a tumultuous time in the United States. Her concern for the welfare of the underprivileged led her to adopt radical political positions; but even she found it difficult, if not impossible, to sacrifice her own individual rights to secure her communitarian goals.

This captivating woman embodied many of her culture's tensions and inconsistencies. Those tensions arose, in part, from rapid cultural change, but also from new currents of thought that defied long-standing beliefs among the people of the United States. Pragmatism dominated the country's collective psyche in the early 1900s, much as republicanism did in the Revolutionary War era and as the Cold War ideology did in the years after World War II. Pragmatism expressed an intellectual disaffection for ideologies or philosophies.

Rejecting a deductive framework rooted in the acceptance of a given truth based upon natural law or religion, pragmatism's followers preferred building usable truths from personal experiences. Devotees of pragmatism were encouraged to form their beliefs through daily interactions with others and to then express the truth of these new beliefs in social action.

Paradoxes frequently arise in a person's thought and behavior from the absence of a controlling worldview. Using inductive reasoning to draw conclusions from experience almost inevitably leads to inconsistent conclusions. Pragmatism, in its acceptance of tentative and multiple truths, tolerates these inconsistencies.

Mary Field Parton lived her life in fulfillment of pragmatic principles. If pragmatism is best understood as an antiphilosophy, its clearest expositors are the lives of people who built their own truths from personal experiences with others and used them to promote social reform. These people put ideas into action and, in doing so, defined and developed those ideas. Mary perceived ideological debates as inadequate responses to society's problems. She espoused pragmatism through her devotion to progressive causes, her commitment to helping those in need, and her willingness to embrace public policies that addressed social problems. Her writings were not philosophical so much as personal—more practical politics based on emotion than analytical treatises rooted in ideas. These writings, in conjunction with Mary's actions, serve as a perfect example of a life defined by pragmatic thought.

This book elucidates the intellectual and political culture of the early 1900s, looking at Mary Field Parton's life as fulfilling the pragmatic ideal. Accordingly, it concentrates on Mary's adoption of the prevailing thoughts of her age and the actions these thoughts influenced. Many aspects of one's life normally found in a biography are not present here. At times, the text moves away from Mary for several pages to develop the intellectual, social, or political context in which she lived, only to return to her story to help explain this context. The book employs a format I have used in teaching, presenting a compelling story of an individual person or event as the means of accessing an era or a cultural or intellectual movement. With this microhistorical approach, the life of Mary Field Parton can provide a means of understanding the political and intellectual culture of the early 1900s.

Certain eras in US history represent transitions to a future that challenges the cultural values, beliefs, and orientations of even the recent past. Many believe that the second and third decades of the twenty-first century constitute such an era, as computer technology and new forms of international interdependence threaten to restructure the nature of work, conceptions of privacy and

individual rights, and even the sustainability of liberal democracies that, until recently, appeared to represent the pinnacle of human political expression. In such a context, we may well be advised to consider periods in our own national history during which rapid technological and cultural change provoked tremendous social unrest and threatened the most basic principles underlying political and social life in the United States.

Mary Field Parton lived in such a time period and saw her life as dedicated to social change. Philanthropy, undertaken specifically, to improve the lives and opportunities of people of all races, genders, and ethnicities, served as the primary means of Mary's reformist crusade. Mary Field Parton pursued this goal as a settlement house worker, an advocate for sexual freedom and equality, and a supporter of organized labor in the early twentieth century. Her experiences and attitudes epitomize the tensions in changing societal understandings of democracy, capitalism, and sexual relations, then and now.

Mary Field Parton came of age during an era romanticized on both sides of the Atlantic as the belle epoque and referred to in the United States as the Gilded Age or the Gay Nineties. These terms conjure images of prosperity, happiness, and fulfillment, and popular culture offered some confirmation. Art nouveau and the Arts and Crafts Movement competed as provocative architectural and cultural expressions in an aesthetic revival that also found expression in fashion and art. Sexual freedom seemed almost tangibly attainable as the Moulin Rouge opened in Paris and amusement parks offered tunnels of love to more restrained audiences in the United States. Literary greats Oscar Wilde, George Bernard Shaw, and Mark Twain amused and challenged patrons of theaters and bookstores alike. Yet it was also the Victorian era, and the artistic, intellectual, and sexual rebellions of the time seem ever so much more worthy of celebration because of the rather stultifying and oppressive veneer of social conformity that blanketed society.

Largely forgotten in this image of the United States in 1900 is the social tension that dominated the era, as industrialization, immigration, technological change, the rise of the social sciences and professionalization, and the origins of a national culture built upon all of these phenomena challenged the preconceived values of the country's people. Mary embraced the changes in society and, in fact, propelled many of them. A born rebel, with a sensual passion for life, a keen sense of duty, and a commitment to Christian love and brotherhood, she viewed her society as an artist would a canvas. She boldly set out not only to pursue her own desires and interests regardless of social restraints but also to reform society so as to eliminate the archaic value judgements and endemic inequalities that might restrain others less rebellious, less committed, and less secure than she. In the process, she helped to shape a new expression

of liberalism that emphasized group rights more than individual rights and so-
cial interests even more than rights. In her philanthropic activities and her writ-
ings, she brought the esoteric idealism of the social reformers of her time to
large segments of the population—the very people who were the objects of
reform. Rooted in both a sympathetic humanitarianism and a class conscious-
ness, the new liberalism rejected classical liberalism's negative construction of
rights in preference for an activist government promoting moral values, politi-
cally defined as social justice.

Previous historical accounts have pictured Mary Field Parton almost exclu-
sively as the mistress of famed attorney Clarence Darrow. Darrow was not
only her lover, but also her mentor; he exercised a tremendous influence over
her thinking and her career. Yet to perceive Mary as only an adjunct to the
more famous man is not only unfair to her but also historically inaccurate.
Mary became a noted and successful writer, a recognized leader in the Ameri-
can labor movement, and a role model for women in the early to mid-twentieth
century who aspired to express themselves in business careers and in politics.
One of the so-called "new women" who came of age in the first two decades
of the 1900s, Mary challenged conventional thinking regarding female virtue
and sexuality, women's social roles, and the ability of women to pursue their
own interests and desires while also being good wives and mothers. A keen
intellect and crusading reformer, Mary deserves recognition for her important
role in pioneering social and political change.

At the time of the nation's founding, science was used to discover and prove
absolute truths. Newtonian physics recognizes rules of nature that function
100 percent of the time; the natural laws governing humanity were consid-
ered no less absolute than those governing matter. Conversely, in the late nine-
teenth century, science was applied to develop relative truths. The social
sciences measured human behaviors and relied on statistical "normalities" to
deem thoughts, actions, and inclinations within or outside accepted expecta-
tions. Psychology, political science, and sociology prescribed truths based on
slight statistical variances that then served as normative standards of behav-
ior in a rigid Victorian United States.

People of all inclinations and of varied abilities struggled to harmonize the
ideas of previous generations with the world in which they found themselves.
A new understanding of liberalism formed one expression of the attempt to do
so. Two great movements, one intellectual and the other political, redefined
liberalism in the United States during the lifetime of Mary Field Parton: prag-
matism and progressivism. The social and economic changes that led to both

of these movements offer a context for understanding both Mary's worldview and developments in liberal thought during the late 1800s and early 1900s.

For most of the country's history before the Civil War, craftspeople made the products in demand by consumers. Leather, iron, wood, cloth, and glass products were made from start to finish by one person. A craft worker took great pride and satisfaction in his or her work and the pay it earned. Sometimes craft workers ultimately owned their businesses; regardless, they retained a strong personal involvement with their products and the customers who bought them. The early years of the industrial revolution, experienced most profoundly in the steam-driven textile mills of New England, began to change this personal dynamic into an impersonal one. Mill workers, usually young women still in their teens, labored on machines to produce large quantities of cloth material to be shipped and sold across the country and even around the globe. The skills of the individuals on the machines mattered little, their creativity even less. In this new industrial environment, workers became interchangeable and accordingly were valued less for the individual talents each brought to the workplace. The mindless repetition of work at a machine replaced the creative energy and training exercised by craft workers just a generation earlier. Generally, all of the workers received approximately the same wages, and none shared in the profits generated by their labor. A sharp delineation between owners and laborers arose, with unprecedented degrees of wealth separating them and with most laborers having little hope of one day becoming owners.

Americans in the antebellum era had adapted the liberal republican principle of equality expressed in contract law to assert the inherent right of free labor: the right of each person to sell his or her labor on the open market. More than just an economic principle from which to deride slavery, free labor embodied ideals that were becoming a part of the national self-image: equal opportunity, a fair day's work for a fair day's wage, social mobility, and honest labor as the basis for virtue.[2] The Republican Party relied upon the free labor ideal after the Civil War to build a postwar society premised on individualism, the free market, a defense of property rights, and a celebration of the home as each man's castle, offering autonomy, sovereignty, and domestic felicity to its owner. The growth of factories, immigration, and the concentration of corporate power, however, created perceived threats against which the free labor ideal might not survive.

Both an acceptance of the free labor ideal and a festering fear of the forces that threatened that ideal gained widespread social acceptance by the close of the century. Political parties at that time expressed religious, ethnic, and regional

identities more than ideological positions. Liberals formed the country's middle class and dominated the nation's institutions after the Civil War; they informed opinion in church pulpits and newspapers, educated the young, and owned most of the businesses. Forming a new elite, these liberals, much like their predecessors of the founding era, reached out across political and cultural boundaries to discover and debate "the general laws that govern social relations." They sought to elevate American culture and to create a transatlantic community. Writing articles for a cosmopolitan audience, they weighed in on the issues of the day: the limits of democracy; the deterrence and punishment of crime; the civil rights of women and Blacks; and the roles of education, private charity, and moral reform in uplifting society. Philanthropic activity became almost a requirement for social acceptability among mostly urban liberals who demonstrated their social commitments to the arts and sciences while combating social ills. In doing so, these liberals fostered an image of themselves as social leaders capable of making rules for others. They offered a counterpoint and corrective to the enfranchisement of poorly educated immigrants and Blacks and justified the embrace of rule by the "better classes."[3]

Social position created duties for the rich and the well educated and encouraged new conceptions of the role government might play in improving society. New York landscape architect and longtime Republican Andrew J. Downing, much like Frederick Law Olmstead, saw public parks as providing an environment that might elevate "working men to the same level of enjoyment with the man of leisure and accomplishment." Bemoaning the growth of class distinctions, Downing sought to preserve a society in which "every laborer is a possible gentleman," needing only "the refining influence of intellectual and moral culture" to develop his innate abilities.[4]

By the end of the nineteenth century, nearly all of the nation's manufacturing had been industrialized. Industrialization changed not only the economic and social dynamics for American workers but challenged many political assumptions as well. Most important, it raised significant questions about the meanings and importance of individual rights and equality in the nation's understanding of democracy. In this changing society, workers offered their own vision of the country's future, quite different from that proffered by liberal elites. Labor organizing constituted an attempt to voice political as well as economic concerns, though the law saw it almost exclusively as an economic movement. The workers' early attempts at organizing encountered violent persecution from owners, which the courts and general public largely endorsed. In response, workers turned to ever more radical theories of societal organization. The communist doctrines of Karl Marx and the anarchism of Mikhail Bakunin gained

support among laborers and disaffected liberals from the 1880s into the twentieth century.

Mary Field Parton supported the cause of workers in the labor movement. Her experiences working with "wage slaves" and strikers' families pushed her further from a traditional liberal perspective endorsing the use of government power to protect individual rights toward a new liberal conception of using expansive government power to advance group interests. She grew increasingly disillusioned with individual rights and capitalism and increasingly distrustful of law and democracy. Yet her most significant deviation from classical liberalism may be her preference for using emotion and inductive reasoning rather than objective rational judgments deduced from fundamental truths as bases for social policy.

In advocating greater public concern for the plights of workers, the new liberals premised an increase in governmental intervention in the private sector on the basis of morality. Yet many of them, Mary included, simultaneously abhorred moralistic legislation aimed at curbing "sin": alcohol consumption, the teaching of evolutionary science, and women's declining virtue. Liberalism, in the late 1800s and early 1900s, attempted to supplant a morality derived from biblical allegories with one built on an increased awareness of human suffering and the means of alleviating it. Liberalism's proponents simultaneously sought to use law and government to impose their moral judgments upon society while simultaneously working to protect themselves from the imposition of other people's moralities. The contradictions within this new liberalism caused some liberals to reject philosophy entirely and others to lose faith in the legal and political institutions that served as expressions of an earlier worldview. The widespread corruption of the age only exacerbated this loss of faith on the part of some.[5] But for others, corruption compelled even greater devotion to morality and reform, necessitating an expansion of government power. The shift from limited government to large government, and from reason to emotion as justification for it, caused tremendous tensions within liberalism. This shift also raised a new question: Can one truly love those whom one does not respect?

Mary Field Parton's life and work indicate the extent to which early twentieth-century society in the United States considered radical alternatives in response to societal change. Yet her life and work also indicate that even radical thinkers could not easily divorce themselves from the classical liberalism that had defined the nation from its founding. Parton struggled to harmonize her emotional reactions to social injustice, which compelled her to adopt a paternalistic

political expression, with her intellectual understandings and attachments to the legal protection of individual rights and democratic self-government. Her attempts to resolve this tension contributed to the development of contemporary liberalism and the inconsistencies evident in it that haunt liberals in this country to the present day.

The new liberalism endorsed by Parton expressed a version of political thought that, up until that time, had been more associated with the conservatism of such groups as the Federalists in the early republic. Almost Burkean in prioritizing a communal whole formed in accordance with Christian ethics, the new liberalism recognized civil duties and obligations as correlative to individual rights.[6] Respecting the political independence of all, this view nonetheless tolerated a prescriptive form of government that relied on an intellectual elite for shaping policy.

Parton participated in a small community of intellectual and economic elites who worked to redesign society to render it more equitable, compassionate, and tolerant. To do so they relied largely on emotional appeals, hoping to redefine justice in the United States as rooted in a communitarian social concern for others instead of a formalistic legality respecting individual autonomy. In reliance on emotion, however, these elites succumbed to intellectual inconsistencies, and in stressing communitarian concerns they lost, to a great extent, the rights orientation that lay at the heart of democratic self-government. Expressing concern for the rights and freedoms of every American, these reformers nonetheless came to support an elitist form of paternalism that would threaten the political and social autonomy of most of their fellow citizens.

The new liberalism espoused by Parton echoes the Federalist Party initiatives of the early republic but has perhaps its strongest roots in the religiously inspired reform movements of the 1830s and 1840s. The Benevolent Empire of the Jacksonian era in the United States expressed a revitalized Christian commitment to communitarian obligations, challenging the strict rights orientation of law defining and protecting rights.[7] This reassertion of Christian duties in a political context coincided with an intellectual movement that would ultimately challenge the premises of classical liberalism and the form of the nation's democracy. Utilitarians like John Stuart Mill and Jeremy Bentham justified the protection of rights on the basis of their social utility. Though still arguing for rights and conceiving of them as negative restraints upon government, these utilitarians nonetheless took giant strides toward the pragmatic positions that would define modern liberalism beginning later in the century.

This book elucidates the tensions in the continued reliance on rights as the discourse of law despite adopting policy initiatives that empowered govern-

ment, once considered the greatest threat to individual rights, to redefine and protect the collective whole. The resultant intellectual inconsistencies express themselves in the creation of a privileged class that defends its rights even as it reorganizes society with little regard for the rights of others. Privilege produces the ironic condescension, even disdain, that many liberals have harbored for the supposed beneficiaries of their largesse, whom they have frequently perceived as not sharing their cosmopolitan sensibilities and commitment to reform. Supposedly advocates for popular democracy and the social empowerment of all people, liberal elites have often adopted a position that they best know the needs of the poor, the uncultured, the uneducated, and the disadvantaged, justifying the subordination of them through modern expressions of paternalism.

Yet paternalism fitted Mary Field Parton most unnaturally. She bristled against conformity and not only rejected the imposition of prevailing social values but also took joy in openly castigating those who would use them to censor private behaviors. Perhaps most significantly, people of Mary's status were expected to adhere to a public image of propriety and to jealously safeguard that image even when personal inclinations dictated a contrary private course.[8] Sexual mores in the Victorian era, in the words of one social historian, "laid increased emphasis on impulse control and strict personal accountability."[9] In no realm did Mary's rebelliousness express itself so greatly as in her rejection of Victorian sexual mores.

Her behaviors evinced unmitigated scorn for any who deemed it appropriate to censor another's thoughts, attitudes, or conception of morality. She aggressively defended the individual rights listed in the Constitution as means of preventing moralistic laws from limiting people's behaviors. Yet her prescriptions for social justice contained both a heavy reliance upon moral judgments and a disregard for the rights, especially those rooted in property, of others in the society. She herself frequently failed to live in a manner consistent with the values she hoped to impose on others. Parton could not escape her own predilections for condescension and luxury. Devoted to the cause of labor organizing, she nonetheless referred to her own paid servants as "morons"; committed to social egalitarianism, she enjoyed an elite social life adorned as much by status as money. She lived as a rebellious iconoclast, reveling in the revolutionary ideas and lifestyle choices shared among her coterie of friends while identifying with the great thinkers of the past. To her credit, she recognized her inconsistencies, cautioning her fellow reformers that society is safe from revolution when the radicals are drinking wine and beer under the arbors.

Sometimes very bright people have a hard time dealing with the society in which they live. The pettiness, incompetence, and stupidity of the people with

whom they work and interact frustrate them daily. Similarly, they can be impatient with prevailing tastes, values, and priorities. Mary certainly exhibited this tendency toward frustration and impatience. Yet she was also hopeful for a better society composed of better people. She and her political allies, imagining themselves to be Platonic philosopher-kings, claimed to have the answers to society's ills, needing only the opportunity to implement them. These liberals, relying on their own judgments while largely dismissing the voices of those they chose to aid, advanced a new style of paternalism that refuted every premise of self-determination at the core of democratic theory. In order to exercise their own paternalistic visions, they frequently devalued rights in preference for interests.

In 1965, Christopher Lasch argued that liberal intellectuals generally subscribe to the idea that "men of learning [should] occupy . . . the strategic loci of social control." This perspective arose coterminously with the Progressive movement and reflected the fact that intellectuals, by 1900, had become "estranged from the dominant values of American culture."[10] Subsequent historians, more concerned with the viability of liberal policies than with liberals as people, have missed the fact that liberals may well have sown the seeds of their own decline when they began to see themselves as different. Their connection to the poor and needy stems from emotion and moral duty, expressed as love for humankind, rather than from respect for equal persons possessed of reason and rationality. Mary Field Parton illustrates this feeling of superiority—of believing herself set apart from the masses and capable of making decisions for them—that has come to permeate the culture of liberal intellectuals. The inconsistencies between their ideas and their lifestyles only furthered their separation from those they hoped both to help and to dominate.

As this book goes to press, the Western-style liberalism born in the Enlightenment confronts perhaps its greatest crisis in the past three hundred years. As recently as 1992, Francis Fukuyama assuredly claimed that the fall of the Soviet Union had initiated an era of universal acceptance of liberalism.[11] Less than three decades later, young people in Europe and the United States express little confidence in democracy, and scholars and social commentators alike predict the imminent demise of liberalism, perceiving both a greater receptivity to socialism and the rise of reactionary populist movements as evidence of a deep and profound cultural malaise.[12] These concerns of today mirror those raised in the late 1800s and early 1900s as challenges to liberal democracy. The responses offered by Parton and her legion of reformers therefore offer a relevant reference point in understanding the nature of today's angst and the means of addressing it.

CHAPTER 1

A Victorian Childhood in Defense of Tradition, 1878–1896

When reading about the Victorian age, many people may well think of the novels of Mark Twain and Charles Dickens. Twain and Dickens developed compelling, yet largely contradictory, depictions of childhood in that era.[1] In the second half of the nineteenth century, urban England and the rural United States offered disparate physical, psychological, and political environments for the molding of a young mind. However, an overbearing pressure to conform to moral norms and expected roles characterized childhood in each location. Such a cultural context could only exacerbate the rebellious tendencies of a precocious young girl who held very little respect for authoritarian impositions.

Mary Field grew up in the Midwest, but her family had its roots on the East Coast. Both of Mary's parents, George Bard Field and Annie Jenkins Stevens, came from old New England families that could trace their American lineages back to the 1600s. But Mary's heritage also evinced a tendency toward rebellion, as both families had histories as religious dissenters, with Quaker heritage on Mary's mother's side and Huguenot refugee ancestors on her father's side.[2]

George Field grew up quickly, serving as a drummer boy in the Union Army during the Civil War. A few years later, in February 1874, while visiting his brother at Brown University, he recorded seeing young Annie Stevens ice skating in Providence, Rhode Island: "a tiny girl in a tight red jacket and swirling

skirt, with flying curls and pink cheeks, skim[med] over the ice like an ecstatic baby cardinal." He claims to have fallen in love instantly.[3] The couple married later that year and began a family shortly thereafter. Their first child, Alice, was born in 1876; Mary followed on January 1, 1878. A third child died in infancy. Sara was born in 1882 and Elliott in 1885, the year the Fields moved to Cincinnati, Ohio. A last daughter, Marion, was born in 1887.

Mary and Sara became "inseparable companions," really the only friends either had for much of their childhood. Her family and friends regarded Mary as a very pretty girl with brunette hair and large dark eyes, but she paled in comparison to her younger sister, whom everyone found extraordinarily beautiful. Sara possessed "large melting brown eyes, soft dark curls" and a temperament that was "always so sweet and charming." Mary, by all accounts, possessed a very different temperament. Her older sister, Alice, noted: "Mary was always spoiling my fun. I liked to have things orderly and she liked to stir things up and have everything in confusion." Alice enjoyed setting up tables for play tea parties, arranging her tea set and dolls just the way she wanted. Her younger sister waited until Alice's table was perfect and then crawled underneath it and pushed it up, toppling everything to the floor. Mary always stuck out her tongue at the portrait of her paternal grandmother, a stern-looking woman who seemed to stare disapprovingly at the mischievous girl. She gave the strong impression to her parents and siblings that she actually took a fiendish delight in being naughty. She enjoyed swearing, if only, she said, to taunt God and the Holy Ghost, and she deliberately stepped on the loose radiator shields at the Quaker meeting house, reveling in the overreactions of the staid people responding to the clanging noise she made.[4] Clearly, Mary chafed at the restrictions of life in a very proper and religious family and fought gamely to express herself; suffering both from the limitations imposed on her and the punishments she received in contesting them, she describes her girlhood as full of "whippings, prayers, religion, [and] dyspepsia."[5]

Mary's childhood, in several ways, reminds one more of Dickens than of Twain. Annie Field, a devout Quaker, closed herself in her bedroom each morning for meditation. She taught her daughters to trust in God's will and respond to the inner light "He" had created in each person. Mary struggled to do so. When the family attended First Day meetings each Sunday, she passed the time by counting flies, bonnets, even the number of squares in the plaid scarves some women wore or the number of buttons on a dress—anything to remain silent, appear attentive, and avoid punishment. George Field, a stern Baptist, practiced a fundamentalist religious perspective and understood his life, family, and home as a "Victorian fortress" defending Christian values and beliefs from perdition.[6] George Field tried to be an attentive father, but his dic-

tatorial nature hindered him. In setting aside Monday nights for family activities, he required all the children to participate, even if homework presented a compelling alternative. Mary recalled that her father joined in "almost dutifully," and the children replied "with similar enthusiasm."[7] George Field's religious views formed the basis of his life and his parenting. He "saw moral decay everywhere, even in the celebration of Christmas."[8] He did not permit the name of Charles Darwin or his "theory" of evolution to be spoken of in the Fields' home.

The Field family moved to Detroit when George assumed a position as a traveling salesman selling tea, sugar, and molasses. The Fields formed one of the growing numbers of middle-class families, accounting for nearly one-fifth of Americans by the late 1800s, whose income derived from white-collar employment.[9] Detroit still had a sizeable French community, which pleased the descendant of Huguenot refugees. The Fields moved into a large house on Charlotte Avenue, a broad street lined in large maple trees. Horses and buggies clip-clopped past the house, but the young girls could only wonder where these might be headed, for other than to attend church or school, the girls were prohibited from venturing beyond the white picket fence that surrounded their home. The home and yard were always beautifully maintained: the lawn manicured, the wisteria growing on the wide front porch perfectly trimmed, the lilacs edging the property always the same size. Inside the home, rich mahogany woodwork provided evidence that the home belonged to a successful Victorian gentleman. The front parlor, the family's showpiece, was off limits to the children—"a sacred place with a shut-up smell where the children were never allowed to play." The family rented the twelve-room home for $35 a month. George and Annie Field permitted the best-behaved child each month to take the rent next door to the landlord, providing a valued opportunity to leave the yard and inevitably be given a cookie by the nice neighbor lady.[10]

The Victorian household seemed a very confining place to Mary, who found every aspect of life prescribed for her. Fashion, generally so important to girls, played no part in Mary's young life. Mary's mother, once married, eschewed the red jacket that caught George's eye and dressed almost exclusively in solid gray. The girls wore white "dignity aprons" over their school dresses and gingham aprons over their clothing at home. A dressmaker visited twice a year, spring and fall, to make warm- and cold-weather clothing for the girls. Annie Field performed the necessary mending on the Singer sewing machine, an incredible new device that the girls found fascinating. Mary one day brought a magazine home from school given to her by a friend. It contained pictures of beautiful dancers and actresses, each dressed in the latest fashions. Her mother found it and burned it, calling it "a very bad magazine." On another occasion, Mary found

her walk home from school, even though shrouded by "an arcade of cathedral-like trees," to be "so very hot" that she took off her shoes and walked barefoot. Her mother was aghast. Such an act constituted rebellion in her home.[11]

Mary and Sara played with dolls, but preferred outside games—hide-and-seek, tag, pom-pom-pullaway, London Bridge, blindman's bluff, and croquet. Girls from the neighborhood visited the sisters, but the Field girls never left their own yard. Years later, Mary remembered one "glorious day." Her parents were away, "probably on some missionary junket." She and Sara took their mother's entire set of beautiful china out to the yard to play house. Remarkably, they did not break any of it and were never found out.

The Field family retained a maid during Mary's entire childhood, but her parents insisted that the children make their own beds and keep their rooms clean. Mary helped can peaches, strawberries, and apples and absorbed some basic cooking skills. Despite the near constant presence of the maid, who was paid three dollars a week, Mary remained largely unaware of disparities in wealth. She saw "very wealthy" people at church, but never any poor people. Everyone, to her, seemed to have a similar lifestyle.[12]

No Quaker meeting house existed in Detroit in the 1880s, so the family attended the patriarch's preferred Baptist church. George Field kept very few books in his home, none of them children's books. The books Mary read came from school. She enjoyed the books written by Kate Greenaway, as much for their lush illustrations as their stories.[13] Generally, her reading was curtailed by her father, who banned not only most magazines but also such books as *Alice in Wonderland*. He similarly prohibited card playing, termed a "wicked" amusement, in his home. Mary's father did read Baptist publications and subscribed to have the *Detroit Free Press* delivered every day but Sunday. He believed that nobody should work on Sunday, and forcing the delivery boy to do so was encouraging sin. He prevented his daughters from any contact with boys and men. No boys were ever permitted to come over to play. The girls could not even visit the horses in the stable near their home because men worked there. Men and the places they frequented became, in Mary's words, "temptingly mysterious." Her parents communicated nothing about sex to their growing girls, other than teaching them that "there was something nasty" about it. Even in the conservative Victorian United States, George Field's strict moralism was out of step with the times. Remembering her childhood, in 1912, Mary wrote some notes regarding her father: "Omnipotent father—Religious, hard-working, severe, honest, all the granite virtues of a New Englander. But he goes into the business life of today where those virtues are a positive detriment and all his failure he visits on his family. Bullies his wife, tyrannizes over his children. Fear rules the home."[14]

By the time the family settled in Detroit, George Field's evangelical Calvinism had come to dominate the culture of his household and to shape the young minds of his children. Nineteenth-century Baptists fully accepted the old Calvinist doctrine that humanity was inherently evil and needed strong social inducements to avoid sin. An active church, strict criminal laws enforced by a strong government, and constant personal, family, and community scrutiny of one's behavior were all required if anyone was to overcome the weaknesses that plagued human souls. The Baptist church at that time still forbade card playing and dancing as "sinful frivolities that set men and women on the path to hell." Children of church members learned early in life that their human nature was "vile and sinful" and that the eternal torments of hell's fires awaited all sinners. Childhood teachings encouraged submission both to God and to temporal authorities, a dependence upon others, and an awareness of the futility of human autonomy. The church's lessons encouraged humility and selflessness—even self-abasement in some cases. One nineteenth-century mother, albeit some years earlier, taught her young daughter to pray: "I am a lost undone creature by nature and I have added and made myself more vile by practice."[15] Mary's strong will and rebellious individualism did not readily accept such teachings. Of more lasting consequence were her parents' examples of missionary action and the church's admonitions to demonstrate love for God in social action. These lessons stayed with Mary. Missionary work, with its promise of seeing the world, seemed to be the only career open to the Field girls. As was typical of many young girls of the time, Mary and Sara thought more of marriage, and the careers of potential husbands, than of their own career possibilities. Mary hoped to marry a butcher, for then she could eat steak every night.[16]

"Spare the rod and spoil the child" served as an all too literal maxim for parents throughout the Victorian age. Corporal punishment of children diminished greatly in the late 1700s and early 1800s but returned with vigor after the success of the Second Awakening, persisting with great social approval until the 1950s.[17] Readers of both Dickens and Twain are familiar with what seems to modern minds a preoccupation with whippings, thrashings, and spankings. Yet, even in this cultural context, Mary's parents stood out as unusually devoted to beating their children. George and Annie Field confined especially young children to their rooms, sometimes for as long as a week, without contact from friends or siblings. The children punished in this way ate what they took to calling "prison rations," alone in their rooms. More commonly, especially as the children became older, they suffered whippings. Mary, in particular, received a lot of whippings. Punishment was always delayed until the evening, after supper and George's time with the *Baptist Weekly*.

Mary would sometimes have to wait for hours for her punishment. Finally, her father signaled to her that it was time and would march her upstairs to her bedroom and bare her bottom before removing his belt and whipping her. Even as an old woman, Mary agonized through tears over memories of having to pull down her underclothes in front of her father. Baring her bottom bothered her even more than the pain of the whipping itself. Though Mary struggled with much of Victorian-era propriety, she was modest. Even her nightclothes she kept firmly buttoned at the neck and wrists. She showed little, if any, flesh on most occasions. The frequency and severity of the punishments Mary received indicate the degree to which she possessed a rebellious spirit. Mary hated and was deeply affected by her childhood discipline. She wrote about it, shared it with her own children, and discussed it with her siblings decades later. Nevertheless, despite all that she endured, she could not be forced to conform.[18]

George Field believed that the discipline of his children, and Mary in particular, constituted much more than a correction of poor behavior. He acted to defend values and lifestyles that he perceived to be under attack from multiple forces active in the United States. He felt that his religion, his confidence in free enterprise capitalism, his respect for the law and property rights, and his status as a social leader and the head of his household were all threatened. He viewed Mary's rebellion in that context. Perhaps most threatening of all to the head of the household were the religious changes in the late nineteenth-century.

The religious beliefs of Mary's parents compelled them to pursue both an evangelical outreach to convert nonbelievers to Christianity and a moral obligation to aid the less fortunate. These inclinations were consistent with the mainstream Christian understandings that formed after the Second Awakening and prevailed throughout the second half of the nineteenth century. By the late 1800s, several variants in Christian beliefs and the rise of irreligion challenged the hegemony of the Fields' form of Christianity.

Liberal theology, as developed at seminaries and divinity schools, especially those at the University of Chicago, understood the Bible to be a collection of works written by men to express their own beliefs about God and his relationship to human life. From this perspective, the books of the Bible, while instructive, must be read in their own historical and cultural contexts. While liberal Christians may have shared certain beliefs with traditional Christians, the liberal Christian was inclined to interpret Scripture as a text of historical values and beliefs and to subordinate traditional doctrine to present needs and concerns. Liberal theology emphasized a person's moral duties and their relationship to one's rational mind. Accordingly, liberals, while largely dismissive of creeds and dogmas, could be uncompromisingly judgmental about

presumptions regarding social duties. Perhaps the major significance of liberal theology was that it allowed people with what might be termed "minimal creedal beliefs" to be reassured that they remained solidly within the Christian faith. Many Americans may have doubted the Genesis story of creation, the active providence of a living God, or the physical resurrection of Jesus, but they could still identify themselves as members of a Christian church.

Liberal theology generally recognized the "Higher Criticism," which read the Bible not as literal truth but as a form of myth. Sporadic acceptance of the Higher Criticism by liberal Christians divided churches throughout the nation in the late 1800s. Alfred North Whitehead wrote of liberal theology that it "confined itself to the suggestion of minor, vapid reasons why people should go to church in the traditional ways." Yet, despite criticism, liberal theology served as the basis for the civil religion and, for many Americans, the belief that the nation's future and its way of life were not only compatible with, but dependent upon, Protestant Christianity.[19]

Simultaneously, agnosticism, atheism, and freethinking grew to extents unknown since the founding era. Charles Darwin published *The Origin of Species* in 1859 and *The Descent of Man* in 1871. However, it was not until the late 1890s and early 1900s that scientists found strong fossil evidence to support the idea of human evolution. Embracing science as ushering humanity into a new progressive age, scores of Americans celebrated a cultural escape from superstitions. Naturalist writers of the late 1800s, such as Jack London and Theodore Dreiser, expressed the idea that "individuals thrived best when their natural instincts were unclaimed by allusions of the supernatural or by the notion that moral behavior was rewarded." These writers were not alone in seizing the opportunity presented by scientists such as Darwin to draw Americans' attention to the limitations religion placed on people and to question the appropriateness of such limitations based entirely on a doctrine that was, to these scientists, rooted in myth and mysticism. Prominent scientist John William Draper, who founded the NYU Medical School, in publishing his *History of the Conflict between Science and Religion* in the late 1870s, pitted human reason, curiosity, and exploration against superstition and mind control. Similarly, Andrew Dickson White, the first president of Cornell University, advocated emancipating learning from the "pedantry" of religious teachings. In a series of articles entitled "The Battlefield of Science," he defended the use of public funds to promote a purely secular education, and in his 1896 book *A History of the Warfare of Science and Theology in Christendom*, he clarified his ideas that science and faith were in a perpetual war with one another in Western society.[20] Science and the professionalization of the humanities both encouraged a new generation of Americans to believe only that which could be factually proven or

persuasively argued. This new academic style, at least as much as the substantive curriculum, challenged both the acceptance of the Bible as the word of God and the verity of the moral teachings that this word contained. Faith as a basis of knowing came under great attack. In this intellectual environment, more people found it possible to express purely atheistic views. Robert Ingersoll, a noted agnostic who championed freethinking, rejected not only the mysticism of the Bible as unbelievable but also its moral teachings as contradictions of human nature. He called the Bible a "lie" and announced that he hated Christianity. If the book were proven to be true, he hated its God.[21]

George and Annie Field perceived liberal religion and irreligion to threaten their society and espoused, ever more fervently, a traditional evangelical doctrine and its moral compulsions. However, the Christian moralism that defined so much of the Fields' lives actually encouraged less devout Christians to turn away from religion, only adding to George's perception of a society in decline. The lobbying by Christians for moralistic restraints on fashionable behaviors raised resentments and led many liberal-minded Americans to adopt an anti-Christian attitude. Historians who consider the late nineteenth century to be a secular age can point to the fact that by the mid-1890s, nearly one in ten Americans considered himself or herself an atheist and many more expressed a very tepid endorsement of religion.[22] Once great supporters of religious toleration, atheists and agnostics in the 1870s and 1880s began to argue that "Christianity and freedom are absolutely and totally irreconcilable." Groups of secularists held festivals on Sunday mornings in place of traditional church services. The president of the American Secular Union, Samuel Putnam, traveled across the United States "preaching the gospel of humanity" on Sunday mornings.[23]

Businessmen confronted Christian moralism with no less resentment than academics did during the late 1800s. The increasingly secular mood of the country allowed businessmen to attack the various Christian groups fighting to close businesses on Sundays, create income or wealth taxes, limit hours of work each week, and impose moralistic standards on how business was to be conducted and what it produced. In the second half of the nineteenth century, many Americans, as often titularly Christian as atheistic, sought to pursue their professional lives in a completely secular realm—"without the constraint of religious obligations." William Graham Sumner contributed to the development of an alternative morality, "social Darwinism," that celebrated the "survival of the fittest" in a society that increasingly recognized winners and losers.[24]

A reinvigorated Social Gospel movement, arising among liberal intellectuals in the late 1800s, had much in common with the Fields' understandings of Christian duty, but the movement's derogation of doctrine, which complemented its invocation to religious duty, threatened George Field as much as

atheism. This new Social Gospel movement arose in a body of popular literature premising greater social concern for Americans in need upon Christian morality. The movement paid no attention to religion as a means of salvation, viewing it only as a moral code compelling benevolence. The movement strongly influenced political thinking among the liberal elite.

The Social Gospelers challenged the secular ideal of rights just as they dismissed the Christian ideal of salvation. Henry George, one of several intellectuals and Christian leaders who challenged the classical liberal ideal of justice rooted in legal equality by arguing for social justice, asserted the need for greater political attention to the social good over individual rights and personal autonomy. Other writers in the movement such as Randolph Bourne, Henry Demarest Lloyd, and Edward Bellamy also focused less on the protection of individual rights than on the recognition of communitarian duties. In conjunction with leaders of the Social Gospel movement, perceiving Christian ethics to demand social change to realize humanity's responsibilities to God, these men attacked capitalism and human freedom as counterproductive to the social good.

Henry George and his fellow radicals argued that they respected the founders' defense of personal rights and autonomy but tempered it with a recognition of social duty. These writers sought a remembered pastoral community of farmers, craftsmen, and independent proprietors forming a social network defined by local loyalties and cultural restraints. In this way, the radical liberalism of these authors emanated from conservative longings for a lost world. They desired to construct a society rooted in values expressed in moral accountability, cooperation, and popular democracy. Economic freedom, these writers believed, had destroyed such a society; and state power, exercised in conjunction with moral restraint, would be needed to limit the predatory effects of unrestrained capitalism.[25] In their desire for moral reform the radical authors found political allies among the supporters of the Social Gospel. Both groups recognized a conflict between Christian moral values and the values of the Gilded Age. They hoped to develop, in Lloyd's words, a "collective conscience," to pursue the right course, premised upon conceptions of the social good and the duties of each person to every other person. Both groups accepted that people now had to be redirected toward a better moral understanding. George appealed both to people's romantic longings for maximizing personal autonomy and their fervent desire to end human suffering. As a college student, Mary would come to read and to endorse the Social Gospel writers, and as a young independent woman she became friends with many of them.

George Field could at least identify a common faith with the Social Gospelers, but anarchists, often surfacing in labor disputes, represented pure terror to

him. Anarchism appeared as a popular alternative to the complexities of recon-
ciling political philosophy with societal needs. Anarchism probably never con-
stituted, in the words of one scholar, the "dominant radical ideology" of the
late 1800s and early 1900s, but it did gain significant support and notoriety. Not
very well defined, popular usage of the term included many diverse social ac-
tivists. Anarchists expressed a broad desire to replace the coercive institutions
of the modern nation state with groups of people freely collaborating for
mutual benefit. Anarchists viewed capitalism not as an expression of a rights-
oriented ideology or even as an economic system, but as a form of oppressive
institutional power. Society's use of violence, in law and police power, to sup-
port capitalism required and legitimized the anarchists' use of violence to tear
down a corrupt regime.[26]

Anarchism flourished among groups of recent immigrants to the largest
US cities and became, fairly or unfairly, identified with the dissatisfied Italians
and Russians among them. For more than thirty years, beginning in the 1880s,
anarchists terrorized Americans by bombing police stations, courthouses,
churches, and places perceived as representative of capitalist values. The move-
ment also attracted intellectuals. The idealism of Peter Kropotkin, Mikhail
Bakunin, and Leo Tolstoy—and in particular Tolstoy's assertions that the state
depended on force and violence to impose a preferred doctrine of justice,
though not one necessarily amenable to the greatest social progress—gained
adherents from among the ranks of well-educated reformists. However, the
anarchists' goals seemed to depend upon a world populated by elite thinkers
and expressed irreconcilable aspirations of securing individual liberty and eco-
nomic equality. Perhaps the anarchists' greatest contribution to liberal think-
ing lay in their conception of society as rooted in "voluntary participation."

George Field was far from alone in believing cultural decline was eroding
Americans' values and threatening democracy. Rapid technological and eco-
nomic change, an increase in immigration from Asia and southern and east-
ern Europe, and an increase in violence in the nation's cities created confusion
and worry in many Americans. Noted historian Frederick Jackson Turner pre-
sented a lecture at the Historical Congress at the World's Columbian Exposi-
tion of 1893 (see figure 1.1) in which he noted the passing of the frontier and
the deleterious effects on the country's character attributable to that fact.[27] The
frontier expressed an ideal of freedom and limitless possibilities that formed
Americans' values and self-image. The passing of the frontier damaged both.
Anxieties fueled reactionary calls to protect society from evil. The rise of the
Ku Klux Klan, the imposition of immigration quotas on darker-skinned people
and those from Catholic countries, and the growth of the temperance move-
ment all reflect attempts by social conservatives to protect life as they knew

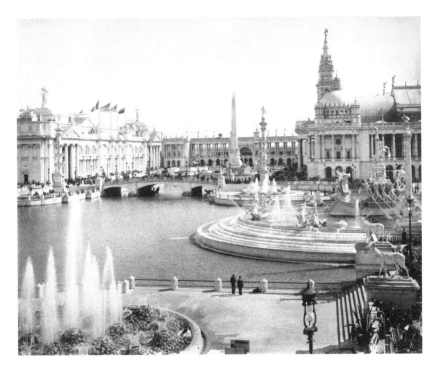

FIGURE 1.1. Columbian Exposition, Chicago 1893. The exposition park was known as the "White City" for its gleaming white buildings set amid park grounds and canals. Celebrating four hundred years of social progress since the landing of Columbus, the park presented a sophisticated appraisal of the United States' cultural past and future, which had broad appeal to a wide range of people who flocked to the grounds from all over the world. Courtesy of the Chicago History Museum, ICHi-025057.

it.[28] At the same time, George Field read about bombings by anarchists, socialist calls for nationalizing land and factories, the more than doubling of the national divorce rate in less than one generation, and atheistic encouragements of free love.[29] Fearful, angry, and protective of his home and his values, he acted harshly toward his children, if only to protect them from the incipient dangers around them.

As she matured, Mary, along with her siblings and her mother, increasingly suffered under the tyrannical paternalism of George Field. Not only were the girls, even as teenagers, prohibited from leaving the yard, their father's discipline and moralism exacted a heavy toll in the home. Mary recounted: "Mother was a silent figure; she wept a great deal—we could see that from her eyes, but she wouldn't speak of it."[30] These years brought Mary closer to her mother. Mary retained her rebellious nature as she grew older and took pride in the rebellious aspects of her Quaker heritage, which came from her mother's

family. She told classmates that her ancestors had been friends to Indians and early and constant opponents of slavery who were persecuted by the religiously intolerant Puritans. She also grew closer to her aunt Elizabeth, Annie's sister, who had been "read out of her Rhode Island meeting because of her worldliness." Elizabeth married a nonbeliever, dressed scandalously, and acted in theater plays.[31]

Older children in middle-class families in the 1890s generally did not work outside of the home. In fact, a work-free adolescence that extended childhood innocence became a distinguishing characteristic of the middle class. As a result, children in such homes spent more time with their parents and matured more slowly than either their parents or children from working class backgrounds.[32]

Her parents taught Mary nothing at all about sex. Until age fourteen, she believed that kissing resulted in pregnancy. Grace Grennel, the minister's daughter of all people, had to disabuse her of that notion. But Grace taught her nothing more. Mary first learned how sex was performed and how children were created during her senior year in high school. She was appalled and could barely even look at boys or men afterward: "I used to lie awake nights, filled with curiosity and disgust. It was not for months that the moral nausea left me when I heard that people were going to be married."[33]

Even the most mild of Mary's rebellions continued to provoke her father's rage. Alice had become an accomplished pianist by the time she entered high school. Mary too had been given lessons but had little interest in the instrument. However, every Sunday she had to practice as the family sat together after church. One Sunday, angry at the need to practice and disconsolate over the pervasive dreariness of the otherwise quiet house, she played "Little Brown Jug How I Love Thee" on the piano. George, a teetotaler, objected both to Mary's disrespectful behavior and the song's wicked endorsement of alcohol consumption. As Mary learned that a high school girl in her father's home was not too old for yet another whipping, her mother went to her room and cried.[34]

Mary's world exploded late in the summer of 1895 when she was seventeen years old. Her small family had constituted her entire world, and although she chafed at the smallness of it, she felt secure within it. Nineteen-year-old Alice, always the good girl and the apple of her father's eye, missed curfew one night and came home to find all the doors and windows locked. She had been at a party with others from her recently graduated high school class, some of whom were leaving soon for college, and lost track of time. Finding her home locked, she stood outside and cried, occasionally yelling to be let in. She woke the household and Mary heard her father insult his daughter in vicious terms and refuse to let her in the house. She and her siblings were too afraid to move. Alice went to the home of a friend that night and the next morning

enrolled in college in Cincinnati. Her father refused to see her or let her into the family's home for five more years. Mary realized that she too had to leave; she could never find happiness in the environment in which she lived.

Recalling her feelings from 1895, Mary remembered becoming aware that women could be strong, even competent. Before her sister struck out on her own in defiance of her father, Mary had never imagined a woman behaving that way: "I can't remember any strong women at that time—they were all sweet. [Girls were] treated like dolls or pets." Society valued their sweetness, their passivity, not their intelligence or their talents. Grown women were regarded in much the same way.[35]

Before 1895, the only career Mary ever envisioned was becoming a foreign missionary. She and Sara spoke of the exciting possibilities that form of work offered to visit new places like China or Africa. She had her parents' support for such a dream because she would be doing "God's work" and fulfilling a traditional woman's duty of living a moral life and caring for others. At that time, philanthropy constituted one of the few acceptable careers for women, and women formed the greatest part of Americans working in private sector charities.[36] Teenaged Mary, however, began to consider broader possibilities for her future.

After Alice's departure, Mary secretly started to think of her own escape— of going to college and pursuing new, previously inconceivable options. In the meantime, life at home became even more restrictive. Mary knew that she was naive. Not only did other high school students seem to know much more about sex, they knew much more about the world. They had been to dances, to the theater, out shopping in big stores in Detroit. Mary lived her life "behind a white picket fence," which she described as both "literal and figurative."[37] After her father's experience with Alice attending a party, he prevented Mary from attending any dances or parties while in high school. The only freedom granted to her was the opportunity to teach Sunday school to poor children in Detroit. Her parents were thrilled to see their teachings, intended to foster a commitment to others, finally take hold. Mary loved the chance to see more of the world even if it was, as she described it, a "slum" in Detroit. The experience also exposed her to the poverty in which many Americans, whom she referred to as "the plain people," lived.[38]

By the summer of 1896, Mary stood as a fledgling adult, eighteen years of age and quite cognizant of the political turmoil that raged across the United States. Few elections in the nation's history have offered Americans so clear a choice of their future as that of 1896 between Republican William McKinley and Democrat William Jennings Bryan.[39] The very rapid and drastic societal changes in the late nineteenth century coincided with a new cultural embrace

of efficiency, professionalism, and expertise that reshaped not only the economy, but also relationships among people.[40] The new economy created jobs, previously unexperienced wealth, and tremendous improvements in the lifestyles of millions of Americans. This economy also aided in the country's growth as an international power. Still, people worried about the concentration of wealth in large corporate businesses and failed to understand the economic models and financial principles on which these corporations operated. Not only the economic shift to industrial production and financial markets created alienation, so too did the scale and scope of the new business organizations. In the seven years before the turn of the century, mergers converted 4,277 companies into 257. Jobs were lost or relocated; competition was reduced; economic power was consolidated.[41] By the time of the 1896 election, many Americans had become disillusioned with free enterprise, perceiving monopolies to be the ultimate expression of economic freedom. These Americans' antagonism to the economic system diminished the degree of separation between the radical anarchists and socialists and the major political parties.

Reform initiatives in the two major parties contested with each other over which could best restrain the power of the corporations. The Progressive movement developed largely in the Republican Party, while the Democratic Party in the 1890s came to embrace a form of populism. Each expressed an impulse to romanticize an earlier America and attempt to recapture it. Yet the Progressives generally tended to look forward and the Populists to look backward. Progressives tended to use legal language emphasizing rights, and Populists spoke in moralistic terms stressing social equality.

Different perspectives on progress, values, and the country's future divided Americans in 1896; the same differences also further divided Mary from George Field. The Republican Party seemed to be the party of the nation's future, respecting a strong, assertive, and active populace. The party of Lincoln had freed the slaves; been much more supportive of women's suffrage than the Democrats; and endorsed business expansion, manifest destiny, and early imperialism. Her father was a Democrat, which Mary described as "a great shame to us. . . . All the other children's fathers were Republicans and I thought it was something very shameful and very foreign being a Democrat—very low, something connected with saloons."[42] Mary's youthful insight held a germ of truth. The Democratic Party had long been known as the party of urban political machines—such as Tammany Hall in New York—of recent immigrants forming ethnic minorities, and of southerners still fighting the Civil War. However, the Democratic Party also represented the moralism commonly endorsed in evangelical households.

The Progressive movement formed among a new coterie of professional career people constituting an expanding middle class. These people valued functionality, rationality, regularity, and expertise and sought to have those values govern both their private lives and their government. These professionals accordingly advocated substituting a new set of values for what they perceived to be outmoded beliefs. In doing so, Progressives hoped to preserve both capitalism and an individualistic democracy while recognizing the need for reform.[43]

Yet, in some ways, Progressivism evoked the Social Gospel movement. Progressives generally derived their morality from Judeo-Christian teachings. Progressives sought to find meaning in their own lives by working for the advantages of others, and though many were lapsed or liberal Christians, they remained quite at ease with imposing moral judgment on others in the same fashion as an old village preacher might have two hundred years earlier.[44] Progressivism worked from the bottom up rather than from the top down. Though Progressives generally recognized a need to expand government, they focused primary attention on changes in personal behavior. Much like the Brothers Grimm more than a half century earlier in Germany, Progressives aspired to make everyone middle class. This goal brought Social Gospelers, pragmatists, and settlement house workers together within the Progressive movement. Even Theodore Roosevelt, despite his leadership in empowering government to correct social ills, ultimately addressed the need to remake individuals.[45] His advocacy of the strenuous life, through which he overcame childhood asthma and physical weaknesses, established a new image of energetic masculinity.[46]

Traditionally conceived expressions of philanthropy, in the form of private charities, served as the initial outlet for Progressive energies, but by the 1890s, Progressives envisioned government playing a larger role in reforming society. Progressivism asserted the need to preserve essential rights and freedoms by subordinating them to social efficiency. Economic dependence, corruption, and great inequities in wealth and power threatened democracy as much through their inefficiencies as their unfairness. Price-fixing, monopolies, and tax dodging served nobody's interests but those of the "robber barons." The solution lay in empowering a group of experts, composing a government bureaucracy, to establish rules for businesses. In 1883, Progressives passed the Pendleton Act creating the Civil Service Commission, with the objective of eliminating patronage and making the bureaucracy a meritocracy. In 1887 they passed the Interstate Commerce Act, hoping to bring both rationality and fairness to the nation's business practices, and in 1890, they passed the Sherman Antitrust Act to combat monopolies.[47] Obviously, these programs expanded

the power of the federal government. Early Progressives ironically sought to preserve individualism through an endorsement of greater governmental power. They saw their centralizing tendencies promoting social harmony as benevolence, not paternalism, though the distinction was oftentimes forced. Perhaps most important, Progressives began to conceive of freedom as a positive right—able to be enhanced, possibly even created, by government action. Classical liberalism, of course, perceived rights negatively—asserting the need to restrict government's scope and power to prevent intrusions upon people's freedoms.[48] In this conception alone, Progressivism serves as a major signpost in the development of liberalism in the United States.[49]

By the 1890s, many Americans—alert to anarchistic bombings, the political success of socialist candidates in some municipalities, and the increasing violence used in union organizing—feared a class-based revolution.[50] Progressivism offered an alternative. It drew on cooperation between people committed to a political ideal rooted in rationality and benevolence. Progressives hoped to improve education standards and opportunities, ensure the health of the nation's food, eliminate corruption, and protect people's rights to work and own property. Technological progress and the expansion of human knowledge reinforced Progressives' hope that "reason and goodness" could ultimately prevail.[51]

Robert La Follette would become one of the most famous agents for change in the country's political history, yet his ideals differed little from those of Abraham Lincoln. As La Follette took his seat in Congress in December 1885, he "never questioned that the Republican Party uniquely fitted the nation's needs or that the opportunity to rise from rags to riches made the United States the finest civilization the world had ever known." He shared earlier Americans' faith in the ideal of the self-made man, but believed it depended on "an open competitive society in which an individual's abilities alone would determine his success." For LaFollette, conditions, not principles, had changed. By the 1890s, open competition seemed to be declining, subverted by large corporations, monopolies, trusts, and pools. La Follette conceived of the Progressive movement as a response to the need to protect the majority's power to govern in a democracy when power and wealth were increasingly concentrated in a smaller and smaller minority. Accordingly, the Progressives first attempted to institute direct democracy by taking political power from party leaders and economic elites through the use of primary elections to nominate candidates.[52]

The Progressives next attempted to limit the dangers posed by the huge corporations. They hoped to preserve, or even enhance, capitalism and competition through governmental intervention. This intervention would take the form of antitrust laws, addressing corporate size and fears of monopolies. Additionally, Progressivism endorsed regulation focusing on corporate behav-

iors. But business regulation did not extend to intrusions upon individual liberties; few Progressives advocated any huge taxes on individuals or corporations either to punish them or to redistribute wealth.[53]

The Progressive movement benefited from the growth of a national press, led by muckraking journalists like Lincoln Steffens, who convinced Americans that they all faced the same problems—corruption, loss of economic control over their lives, and gross inequities in political power—which demanded national solutions. Magazines such as *Collier's*, the *Saturday Evening Post*, and the *World's Work*, read by millions from coast to coast, reinforced the idea that the nation needed structural change. Books fomented support for the movement more than newspapers and magazines. Steffens's *Shame of the Cities* in 1904, Ida Tarbell's *History of the Standard Oil Company* in the same year, and Upton Sinclair's *The Jungle* in 1906 exposed corruption and safety problems that threatened life in the United States. The early Progressives supported initiatives with broad public interest, involving matters such as consumer health and personal security, to pass regulations governing the food industry and public safety. In these initiatives, the Progressives gained significant labor support. Yet most Progressives refrained from endorsing unionization. Progressives generally could not commit themselves to labor's communitarian policies, through which individual workers sacrificed individual freedom in order to pursue a greater good for the community of laborers. Still, Progressives and labor leaders found common ground in fighting power and corruption.[54] Despite the nation's slow recovery from the economic depression that started in 1893, McKinley eschewed any endorsement of more radical proposals.[55]

The Progressives could move to restrain corporate power more easily than they could address broad cultural fears and discontents of the American people. The Democratic Party in 1896 did not believe that Progressive reform went far enough to re-create the moral communities of the country's imagined past. A populist wave united various alienated, confused, and ostracized groups of people into a new political force under William Jennings Bryan.[56] One essential characteristic of all populist movements is the identification of an evil. In Bryan's case, he identified several. Perhaps first among them were the robber barons, men like Andrew Mellon, Andrew Carnegie, John D. Rockefeller, Jay Gould, E. H. Harriman, Henry Ford, John Jacob Astor, and J. P. Morgan. Criticism of these men stemmed from, in the words of historian Steve Fraser, "a sensibility—partly religious, partly egalitarian, and democratic"—that expressed itself in populist movements from the campaign of Andrew Jackson to that of Bryan. Populism centered on a form of criticism, "laced with moral censure, warning that 'tories of industry' were a threat to democracy and that parasitic, aristocratic pretension and tyranny have always trailed in the wake

of concentrated wealth, whether accumulated dynastically or more impersonally from the faceless corporation."[57]

Close behind the robber barons on the Populists list of evils were the voices of secularism and atheism, which had grown tremendously in the 1890s; the elite money lenders and their defender in the White House, President Cleveland, who held to a tight money gold standard; and the various advocates for modernity who valued a reliance on law to protect the property rights of owners against labor, railroads against farmers, and national interests over community values. Rural and uneducated people perceived these evils as causing a loss of control in their lives. They found their wages, hours, and working conditions determined by economic forces these people did not understand, and they sought to regain control of their lives by destroying modernity. Bryan outlined a Populist platform that would elevate "a natural local society" after destroying the "unnatural national powers" perceived to have fostered corruption in government and business. The populists faced the problem of how to empower and organize locally oriented people to work together on national problems.[58] To address this concern, Bryan too endorsed an unprecedented increase in the powers of the government. He argued that the government had always exercised its power but had done so to help the railroads, the owners of industrial plants, and the bankers. He wanted to use government power to help the farmers and laborers, endorsing legislation that would bring prosperity to the masses. The Democratic Party, under Bryan, changed its position dramatically from that of Cleveland. In adopting Bryan's populist message, the Party assumed both the legitimacy of positive action by the government to ameliorate economic disparities and the perpetual existence of class conflict. The issue, for the Populists, was not whether government had the power to act or even whether it would act; the issue instead was on whose side the government would exercise its power when acting.[59] The Populists sought to fight the growth of a national culture and return to community governance by increasing the powers of the federal government. Populism frequently appeals more on an emotional level than a rational one. Aside from their clear differences, liberals in both the progressive and populist movements espoused the appropriateness of using a morality derived from Christianity as a basis for law and policy, advocated the need for strengthening government, and denigrated the importance of personal property rights relative to the social good.

For many Americans, policies took a back seat to style. McKinley appeared confident, cosmopolitan, and forward-looking, Bryan censorious and backward-looking. Of course, nearly all intellectuals rejected populism for its relative lack of sophistication, its excessive moralism, and its tendency to look for scapegoats and identify enemies. Of nearly equal concern to many, despite their es-

pousal of liberalism, was populism's flirtation with excessive democracy. H. L. Mencken facetiously voiced the intelligentsia's rejection of populism: "As democracy is perfected, the office of president represents, more and more closely, the inner soul of the people. We move toward a lofty ideal. On some great and glorious day the plain folks of the land will reach their heart's desire at last, and the White House will be adorned by a downright moron."[60]

Significantly, in 1896, each party endorsed a form of progressive liberalism and the election promised a political turn to the left. McKinley's victory generated a buoyant attitude across the nation and ushered in the "Gay Nineties," describing middle- and upper-class people enjoying their wealth and freedom as seldom before. Mary wanted to participate in that society. But her dreams in 1896 seemed to her as unrealistic as a trip to the moon.

Despite her rebellious nature, Mary lived as a good girl from a conservative religious family through her teen years. Her very sheltered life filled her with fear and ignorance of much of the world and produced a conservative, almost reactionary attitude regarding conceptions of good and bad, of possibilities and impossibilities. Her upbringing fostered a parochialism that sought security and comfort from what was familiar. Still, her childhood provides indications of the woman Mary would become. While her rebellious attitude provides the foremost clue of that person, Mary's Christian faith, in one form or another, persisted throughout most of her life, and the sense of moral duty it prompted energized her as an adult. As a girl, she had no real sense of the possibilities that she might pursue in the twentieth century, but the time was becoming ripe for a rebellious, passionately dedicated reformer who also happened to be a beautiful woman.

CHAPTER 2

Expanded Opportunities beyond the Home, 1896–1905

When Mary graduated from high school in 1897, she summoned up the nerve to ask her father to send her to college. After some consideration, he offered to send her to a nearby Baptist college. Mary would have none of that. She responded, "But Father, I want to go to the University of Michigan. Blanche is going there, and I want to be with her." George Field remained adamant: "Every boy or girl I have ever heard of has come out of that university an unbeliever. I will not permit you to become an unbeliever."[1] Apparently, his control over the people in the household extended, in his view, over their minds as well as their bodies.

Mary decided to approach her mother's closest friend, a wealthy woman in Boston named Mrs. Preston. In her letter, Mary explained that her father would not pay for her to attend the University of Michigan and sought Mrs. Preston's help. A reply came within days. Mrs. Preston would pay Mary's tuition for all four years and enclosed a first check of $25.00. Mary covertly packed her bags over the next few days and then quietly slipped out the back door in the early morning, heading for the train station. She was shaking as she left her family home, afraid that if she were discovered she would be restrained. She was still shaking as she boarded the train to Ann Arbor. Two days after she arrived at college, she received a letter from her father in which he banished her forever from the family home. Her younger brother, Elliott, told his "sweet sister" how upset

he was at his father's reaction: "But of course I was just as afraid of him as [you] were."[2]

Mary benefited greatly from the country's changing attitudes regarding education. Public education soared after 1880, especially for girls. In 1880 there were only eight hundred public schools in the United States; by 1900, more than six thousand existed. Old teaching methods succumbed to new, as memorization was replaced by an emphasis on thinking and reasoning. Science became a part of the standard curriculum from early grades through high school. By 1900, almost equal numbers of men and women attended college, about 2 percent of each gender ages 18–24. In that year, 85,338 women attended college, but only 5,237 ever completed their degrees.[3]

Mary saw her departure for college as an act of rebellion more than as a quest for self-actualization. She recognized that she was living "a life that I just wanted to get away from, and that the quickest way to get away was through college." Mary now recognized that earlier dreams of becoming a missionary emanated less from a desire to help others than from the need "to escape the small town I lived in—Detroit was small in spirit—and see those wonderful countries so far away." But, even in rebellion, she recited her Calvinist duties to having once "put my hand to the plough, not [to] turn back."[4]

Her college years infused Mary with a new sense of purpose, compelling her to reconsider her place in society and the roles she might play (see figure 2.1). She pursued a challenging course of study at the University of Michigan, choosing philosophy and history as majors, while also enjoying sociology, which exposed her to social unrest, alternative political and economic systems, and stories of social radicals.[5] The social sciences and economics offered new courses of study that appealed to a young generation anxious for social change. Economics, in particular, drew on the communitarianism in Americans' cultural identity, rooted in Calvinist doctrine, the influences of the Scottish Enlightenment, and classical republicanism, to challenge the individualistic character espoused by the social Darwinists and adherents to the myth of the "self-made man." Many academic economists proudly endorsed socialism.[6] One professor invited Eugene Debs, well-known labor leader and socialist, to class; he created in Mary and her classmates a tremendous sympathy for migrant workers. Another professor brought a homeless man into the classroom to talk to the students. Mary summarized her reactions: "Father taught us that tramps were bad men who were too lazy to work. But, from this man in our classroom, I learned for the first time about migratory labor and about the desperation of men who must rely on seasonal occupations. I began to understand that society and not their own wickedness creates these men." Yet

FIGURE 2.1. University of Michigan Library, 1900. The movement to coeducational universities had just begun in the late 1800s. Young Mary Field found the beautiful grounds, intellectual stimulation, and social opportunities a panacea, offering both an escape from an oppressive home and a window into a future of possibilities she had never imagined. Courtesy of the Library of Congress. Detroit Publishing Co., Publisher. *Library, University of Michigan, Ann Arbor, Mich.* United States Ann Arbor Michigan, None. [Between 1900 and 1910] Photograph. https://www .loc.gov/item/2016810258/.

history became her favorite course. Like many students since, she was struck by the difference between the study of history in high school and in college. She discovered that the history she learned in college emphasized analysis and explanation, it dealt with "the flow of human life . . . the connections and inter-connections [of] cause and effect." History and philosophy became lifelong pursuits, but in college she used them as a means of questioning her father's fundamentalist religious teachings. In the words of her daughter, Mary "called herself an agnostic [during these years], but the religious indoctrination of her early childhood had been too powerful to enable her to abandon God completely." Her religion became more sublimated than rejected and served as a means of approaching, and even accepting, initiatives for social justice.

Her philosophy courses exposed her to the writings of William James. During her time at the university, Mary read his works on psychology and appreciated his theory of moral reasoning as developed in his 1896 essay "The Will

to Believe." More important, she identified with the need for her generation to develop new truths as bases for reevaluating society. James's pragmatic approach, when combined with his religious beliefs, would be meaningful to her throughout her life.[7] By the early 1900s, this approach also served as the intellectual impetus for new forms of philanthropy and societal organization.

Pragmatism originated in the societal infatuation with science that arose after the Civil War. That internecine conflict challenged Americans' conceptions of themselves as God's chosen people and of the United States as the new Israel. The Civil War created doubt, not only about Americans themselves and their nation, but about humanity's ability to handle democratic freedoms and the idea of history as a story of human progress. In this context, science appeared as a savior, able to solve any human problem. Science became the basis of a new worldview challenging the sentimental idealism of the past, reasserting the possibility of American exceptionalism, and rendering history harmless. Elites used science, together with moral leadership and education, as a building block to construct expertise that, when combined with public service, justified their political, social, and economic status. Social science, not religion or philosophy, simultaneously offered the new preferred method of coming to moral judgments about the human condition and the possibility of improving it.[8] For students such as Mary, pragmatism presented a very empowering message.

Pragmatists contend that the quest for a moral life is an inductive process dependent upon experience. Leading progenitor of pragmatism William James argued that morality is built from both personal and shared experiences. Morals in turn become the bases for asserting truths—those things that experience shows to be in "agreement" with reality and to positively affect human life. From this perspective, a person does not discover truth but creates it through moral judgment, or in James's words, "engenders truth upon [the world]." But the formation of truth has meaning only in its creation of duties to act in accordance with truth—duties to build a society consistent with morality using truth as a constructed justification for social action. This idea defines what pragmatists call a "usable truth."[9]

The rise of collectivist thought in the United States may well owe its greatest debt to pragmatists William James and John Dewey. In *Pragmatism*, William James cites Charles Saunders Pierce for the relatively uncontroversial proposition that "beliefs are really rules for actions." James then proceeds, however, to explain that the idea of thought supporting a belief is of no real value—the value of a belief is solely in the action it produces: "to develop a thought's meaning, we need only determine what conduct it is fitted to produce: that conduct is for us its sole significance."[10] Later in the same text, he issues a value-laden critique of rationalist philosophy:

A pragmatist turns his back resolutely and once [and] for all upon a lot of inveterate habits dear to professional philosophers. He turns away from abstraction and insufficiency, from verbal solutions, from bad a priori reason, from fixed principles, closed systems, and pretended absolutes and origins. He turns toward concreteness and adequacy, towards facts, towards action and towards power. That means the empiricist temper regnant and the rationalist temper sincerely given up.[11]

Truth, then, for James, is clearly not a product of man's reason as exercised in thinking, reading, and dialectic; nor is it objective. Truth is formed only through the experiences of people, acting in groups, as a means of producing value or serving "the good." Using an inductive reasoning model, James argues that people must come to moral judgments from specific social experiences. These moral judgments form the basis for constructing truths that are nothing more than tools used to justify social actions productive of a good consistent with morality. Morality does not derive from truth, nor from the belief in that truth; rather, morality serves as the basis for creating truth and belief. James states that a pragmatist "talk[s] about truths in the plural, about their utility and satisfactoriness, about the success with which they work. . . . Truth, for him, becomes a class-name for all sorts of definite working-values in experience."[12]

The goal, for James, is to create a generally accepted truth within society that is the product of his moral code—a moral code that would become largely consistent with later twentieth- and twenty-first-century conceptions of social justice. As he states, "truth is one species of good, and not, as is usually supposed, a category distinct from good."[13] Truth must result from morality—from conceptions of good and bad. Truth is a value-laden, subjective creation. Ultimately, it must serve as the basis for people acting in service of the social good. Truth is a tool used to motivate. James writes of truth: "it is true because it is useful means the same as it is useful because it is true."[14]

John Dewey, often recognized as the father of contemporary education in the United States, endorses this same value-laden approach to the construction of truths. Knowledge, or belief in a truth, he argues, must be "a product of the cooperative and communicative operations of human beings living together. Its communitarian origin is an indication of its rightful use."[15] Advocating the need for a communitarian ethic, he urges the development of a religiosity rooted not in doctrine or belief in the supernatural, but rather in "the attachment of emotion to [realizable social] ends."[16] He wants a form of religious zeal to mobilize people in the pursuit of a social ideal rooted in morality. "All modes of human behavior are affected with a public interest;" he

writes, "and full realization of this interest is equivalent to a sense of a significance that is religious in its function."[17]

Though holding relativist positions on truth, Dewey and James argue for a normative, and even universal, conception of morality. James even writes of a universal moral understanding forming the basis of a different type or "better" truth—"an ideal. . . . at which all our temporary truths will one day converge."[18] The pragmatists are comfortable, to an extent that no rights-oriented theorist ever could be, with a third party—even one possessing the power of an educator, a governor, or a social leader—prescribing moral judgments for others. James and Dewey assert that people "should" feel, react, think, or even believe certain things in response to stimuli rooted in social experiences. To the degree that these experiences become shared, morality becomes more universal and more likely to function, in Dewey's terms, as a "common faith."

The pragmatic school of thought asserts that truth is subjective, not objective. Humanity creates truths to serve its needs. Pragmatists also argue that there is an identifiable public good that is largely consistent with popular conceptions of social justice. The good is rooted in values and morals that are learned or derived from personal experience rather than from books or contemplation. These moral lessons are perceived emotionally. Pragmatists emphasize the "heart" over the "head" and rely on human empathy as the basis for establishing moral perspectives. Pragmatists rely on inductive reasoning to come to judgment, building from myriad personal experiences a moral awareness that can serve as the basis for creating usable truths.

Pragmatism offered young people a compelling call to action, rooted in an acceptance of people's ability to empathize with their fellows and create social progress from a moral need to do so. Pragmatism is ultimately problem-oriented and moralistically judgmental. It seeks to eliminate poverty, disease, crime, and hatred because they are "evils," without regard to the origin of the evil or the extent to which the means necessary to eliminate it might contravene some ideology or belief. Pragmatism, since the work of Randolph Bourne in the 1920s, if not before, has been linked to social engineering. The underlying assumption supporting social engineering is a belief that experts are best able to determine policy, even policy that depends on moral choices. Pragmatism, therefore, expresses an acceptance of an intellectual or even a cultural elite and of its ability to make decisions for others. Pragmatists also express tremendous confidence in the willingness of the masses to follow the elite. As David A. Hollinger writes, "Dewey's social engineering was only one example of pragmatism's confidence in the responsiveness of nature to human purpose. This confidence was equally hard to miss in James's 'voluntarism.'"[19]

Pragmatism served as the basis for proposed reforms in political and social organization. In the words of one scholar, Dewey advocated nothing less than a "redescription of experience in which individual life is characterized as social and in which social life is described in interactive and cooperative terms that foster ongoing projects of social reconstruction through experimental inquiry and democratic decision-making."[20] People feeling the loss of social intimacy, once found in small towns, workplaces, churches, and even families across the country, often felt confused and alienated in industrialized, urban society. Charles Cooley, the progenitor of primary group theory, argued that people form social values through intimate interactions with small numbers of other people, thereby creating legitimate bases for social order. In other words, Cooley perceived people to construct truth through small group interaction, much as the pragmatists assert. As the United States lost its small personal communities, Cooley argued, it also lost its claim to legitimate forms of social order. Laws and violence interceded in cases once controlled by communal values, morals, and social rules. Formalism replaced informal societal structures to the detriment of human interaction.[21]

Building both on the works of George, Lloyd, and Bellamy and also on the pragmatists' arguments, radical social critics in the early 1900s expressed "a communitarian vision of self-realization through participation in a democratic culture"; self-fulfillment lay in communities that involved one in civic organizations. Morality, created inductively from these experiences, could serve as the basis for social change. But these radical social critics recognized that, for morality to do so, there was a need to destroy the underpinnings of individualism—legal protections of individual freedom among them. Waldo Frank, speaking on behalf of fellow critics Randolph Bourne, Van Wyck Brooks, and Lewis Mumford, noted, "We were all sworn foes of capitalism not because we knew it would not work, but because we judged it, even in success, to be lethal to the human spirit." They believed that industrialization and rapid societal change had robbed people of their identities—their sense of who they were in the context of family, work, and community. These critics believed that an individual reaches self-realization only through the collective enterprise of societal improvement. The new challenge for Americans was to overcome atomism by building a community in which morality, art, and religion had shared meanings.[22] Similarly, Edward Ross encouraged his compatriots to build a new society in which law and social pressure combined to produce a moral public. He saw the United States in the early 1900s as a battleground for the public consciousness with evil at an advantage.[23]

Several leading legal scholars and jurists adapted pragmatism to the law in forming legal positivism, believing law could be used to effect social changes

and promote social justice rather than to re-impose the beliefs of the past. In order to do so, judges and legal scholars had to disregard rights, the basis of the entire legal system, in order to prioritize social interests. Justice Brandeis argued that sociological evidence and conceptions of morality and the public good were as important as legal precedent in judicial decision making.[24] Justice Harlan declared a willingness to sacrifice individual freedoms to a conception of the social good.[25] Roscoe Pound, who would become the dean of Harvard Law School, condemned the defense of property rights as "the same kind of wrong-headed natural rights theory that was found in the Bill of Rights."[26] Most Americans found it harder to ignore the Constitution and its protection of individual rights. In response to the public's reticence, the legal positivists decided not to reject the idea of rights but instead to create new and different rights that served a more communitarian agenda. Zechariah Chafee, of Harvard Law School, argued that the only rights that needed to be protected were those that provided an instrumental value to the society, offering a rationale for recognizing new rights that served the social good.[27] Brandeis was more direct, stating, "Political, social, and economic changes entail the recognition of new rights."[28] Oliver Wendell Holmes found the life of the law in human experience, not in deductive logic from fixed principles. His prioritization of experience comported with the age's endorsement of scientific principles and of the scientific method of using experimentation to construct a truth inductively. Science became the gatekeeper of truth and social science the means of understanding humanity in society.[29]

The study of philosophy, sociology, economics, and history immersed Mary in all of the literature of the day pertaining to social justice. Aware of that literature, she reconceived of her place in society and of new opportunities for women. Mary came of college age just as colleges and universities experienced perhaps the most profound change in their history. The late 1800s not only spawned the social sciences as new courses of study but also celebrated the value of expertise. Professionalism, marked in part by possession of a college degree, became the accepted means of identifying this expertise. Degree programs and professional societies, such as the American Medical Association and the American Bar Association, gained prominence in their ability to grant or verify credentials certifying expertise. Not only did colleges and universities expand their curricula to offer degrees in more varied subjects, they also held out their professors as a new group of experts, verified as such by possessing the degree of doctor of philosophy (PhD). In 1884, Harvard employed only 19 PhDs in its faculty of 189; Michigan employed 6 out of 88. By the close of the 1800s, these faculties were dominated by PhDs, with only a very few holdovers from an earlier era still remaining. Even smaller schools in the Midwest

embraced the change. By 1903, Illinois College employed no professors without PhDs. The new class of professors devoted itself to research as a part of the colleges' duty to expand human knowledge and involved the students in this process. Universities became incubators of knowledge dedicated to research and the exploration of the world. Professors and students shared in the exciting quest for human progress.[30]

Coeducational colleges originated in the 1870s, but early female students suffered from popular perceptions of their peers and the faculty that women were biologically less intelligent than men. By the turn of the century, female scholars in the fields of biology and social psychology had challenged that presupposition and shown that socially imposed gender roles not only inhibited female learning but also imposed a social inequality that mitigated any profession of equality derived from natural law.[31] Colleges and universities stood at the forefront of societal change.

Entering the university at the right time to take advantage of changing attitudes, Mary blossomed both in and outside of the classroom. A pretty young woman, slim with "a classic, oval face, shining dark brown hair, and flashing dark brown eyes," she readily made friends on campus. Men, in particular, liked her long hair—long enough for her to sit on—and her petite yet curvaceous figure. Appearance mattered a great deal to Mary, not only in her college years but throughout her life. She knew she was pretty and her pride in her looks expressed itself in a growing self-esteem and in frequent aspersions of other women who lacked Mary's natural beauty. But she had no money for clothes and felt that she looked "dowdy" next to the other women on campus. Her best friend, Blanche, joined the Delta Delta Delta (Tri Delt) sorority, and Mary followed her lead. They roomed together in the sorority house and Mary worked there for free room and board. The sorority helped her to open up socially; she attended a few parties and went on the first dates of her life. Yet she suffered from an awareness of her own sexual inexperience and was timid, even fearful, around men. She suffered, in her own words, "the kind of loneliness which is never forgotten."[32]

During the summer after her first year of college, Mary went to the New England seashore as a paid companion for Mrs. Preston. Mary could not return to her childhood home in Detroit, and Mrs. Preston welcomed the young woman into her home. The following summer her father had to travel extensively on business and, on her mother's invitation, Mary returned to Detroit. She worked at the Florence Crittenton House for "fallen women," which supported both unmarried pregnant girls and women and those who had recently given birth. Mary heard more about sex that summer than she had in her previous twenty years. With her father out of town, Mary was able to visit

the family house and even to bring along some of the babies on occasion. She loved the opportunity to talk with her mother about her college courses, her life on campus, and her ever-expanding thoughts about her future. Yet Mary had always been closer to Sara than her mother. Sara's company that summer gave Mary a chance to explore her thoughts and hopes in the way one can do only with a best friend.[33]

Two years later, the turn of the century provided another key inflection point in the life of the young woman. Everyone seemed to express excitement about the dawn of the twentieth century. Mary remembered, "We were all aware that the century was turning. A feeling something was going to happen." People spoke in anxious anticipation of new technologies about which they had heard: the automobile, the telephone, and electric lights. For some, the arrival of 1900 "was spoken about as the second coming of Christ."[34]

Yet just as significant to Mary was the marriage of her sister Sara and the opportunity it offered to see the family once again. Their father had not permitted Mary to come home since the summer of 1898, but her sister's wedding so pleased him that he permitted a family reunion. Mary delighted in the opportunity but developed grave concerns about her sister's chosen path. Sara turned eighteen on September 1, 1900, and was married eleven days later. This gorgeous young woman, with her whole life ahead of her, opted to marry a Baptist minister significantly older than herself who shared much in temperament with her father. In fact, George Field found the Reverend Albert Ehrgott "most suitable."

Mary took advantage of her father's generosity and spent the entire summer between her junior and senior years of college back in her parents' home.[35] However, the family reunion proved short-lived. Immediately after the wedding, Sara accompanied Albert to Rangoon, Burma, where he assumed a position as pastor of a Eurasian Baptist Church.[36] The marriage as well as the missionary assignment concerned Mary, who worried that her young sister was making a decision to escape one bad situation for another.

On Sara's eighteenth birthday, the two sisters stayed up all night talking. Among various topics, they spoke of the new century. Earlier that day, George Field, feeling particularly optimistic given Sara's engagement, expressed his view that the country's progress and innovations provided evidence of God's favor for the United States. Mary, too, believed that the nation was on the cusp of greatness and that the discoveries of the recent past would coalesce in an exciting but very different form of society. Yet she attributed the cause less to God than to new modes of thinking. Mary contended that the greatest development of the preceding century had nothing to do with science or technology. Rather, it was "the realization that a woman has a soul, a personality, and

an individuality." She dreamed of a day when men and women would work together, side by side. Mary herself wanted to participate in all aspects of life as an equal to any man. She left unsaid to her dear sister her concerns that Sara's "acceptance of the traditional female role" not only inhibited the full realization of that dream but also constituted a failure of Sara as a human being. By marrying at such a young age, before experiencing life on her own or exploring her potential and interests, Sara was denying herself the possibility of becoming an individual. Mary promised herself not to make the same mistake. "How could I bear the littleness, the barrenness of the flat life of domesticity," she wrote. "No, first must come the independent life."[37]

Mary had come to reject, at least for a while, any thoughts of marriage and domesticity for herself. She had tasted only a small morsel of life's buffet, but she found it had whet her appetite for more. She loved academic study and thinking about social and political issues, even if she also found herself growing callous, toughened—even, in some people's views, somewhat masculine in her outlook. "The truth is," she said, "I have no feeling, I'm just amiable." Her life away from her childhood home had made her more aware of the plights of the nation's less fortunate. She met and spoke with girls and young women at the Crittenton Home and with the migrant workers, but they provoked little emotional response—more an academic sense of injustice than compassion. She reasoned, "Nobody ever gave me any sympathy, not a drop of it in any form; except to blow my nose for me if I cry and my own hands are knuckled on my eyes."[38] Perhaps her father's belt had beaten the sensitivity out of her.[39]

Academia encouraged Mary's dreams of making a difference in the world and an exciting life for herself, but society was not, in the early 1900s, nearly as conducive to their realization. College-educated young people in the early 1890s formed a new class of elites. They possessed that which their culture revered: expertise and professionalism. Yet for women, a college degree created fewer opportunities than it did for men. True, Mary's best friend, Blanche, went on to medical school and became a doctor. But she was an exception. Entrepreneurial opportunities that utilized custom production, especially in millinery and dressmaking, were losing market share to the efficiencies of the industrial system.[40] Most women with college degrees became teachers, secretaries, nurses, or social workers.

Mary graduated from the University of Michigan in 1901 and discovered her only real option lay in teaching. Disappointed but committed to pursuing an independent life, she took a job teaching seven subjects across the ninth through twelfth grades in a two-room schoolhouse in Ovid, Michigan. Denied for so long any attachment to fashion, Mary now took great care in her ap-

pearance. She knew she was pretty and, able to buy some new clothes of her choosing, enhanced her attractiveness with her dress. She continued to wear her hair very long and wore a different hair ribbon every day to draw even more attention to it. She quickly became popular with the students, who seemed just to want to spend time with her. Mary, though, kept her distance, emotionally if not physically. She wrote in her journal: "There they are—four of them—all wanting to hold my hands. And I thought: yes, that's like the world. Five little people. The little people of life all wanting to hold the hands of someone who is bigger and stronger and wiser—someone who loves them all, but who only has two hands for their four after all."[41] She caught the particular attention of one farm boy, who actually proposed to her. Shocked, she unthinkingly expressed her insensitivity by rather mockingly laughing at him.[42]

Even as she worked to develop an emotional sensitivity to the sufferings of the poor, she found it difficult to feel empathy for her students. The faceless unnamed masses were easier for her to love than were awkward teenaged children with pimply faces and runny noses. Yet despite her emotional indifference to them, the children she taught loved her. Mary did not teach for very long, but she made an impression on her students during her time in the classroom. Fifty years after she stopped teaching, she received an admiring letter addressed to "Dear Miss Field" from her surviving students, thanking her for her influence on their lives. She found it hard to believe that they remembered her at all.[43] Perhaps because she never formed connections with her students, despite their adoration of her, Mary felt unfulfilled teaching school and gave more thought to her appropriate place in society. Current events helped point her in a new direction.

In 1902, amid a new prosperity, labor relations issues divided the nation, drawing attention to the societal transformation wrought by industrialization. Labor unrest challenged Americans' ideas of themselves and their law more than anything had since the Civil War. In fact, union organizing in the last three decades of the nineteenth century often had more to do with control—not only of the business, but also of political society—than it did with pay. Trade unionists in the late 1800s had melded labor and social interests in forming radical political ideologies that expressed themselves in various forms, from anarchism to socialism. These group movements expressed a "moral universality" that showed little respect for the nation's law. Law perceived rights as vested in individuals, not groups, and to be distinct from interests. Accordingly, the public frequently perceived the first union organizers as "semi-outlaws," who disrespected property rights and advocated violence.

However, by the early 1900s, unions had abandoned much of their political platform and focused on wages.[44] The coal strike of 1902 serves as a prime

example of this change in orientation. The strike resulted from the demands of the United Mine Workers of America for a 10–20 percent wage increase, an eight-hour work day, and union recognition. The coal industry, led by George F. Baer, president of the Philadelphia and Reading Coal and Iron Company, refused the union's demands, citing a common concern of management. In confronting union organizing, management worried more about a loss of control than an increase in wages. Baer explained: "There cannot be two masters in the management of business." Unions, which sold their services to represent and negotiate on behalf of employees, required commitments of loyalty from those employees. Membership in a union fostered sentiments associated both with brotherhood and class identity. Management feared that employees would obey their union bosses more than their company supervisors. By May, 147,000 miners had traded their picks and shovels for picket signs.

To continue to meet orders for coal, management called in replacement workers. The union battered the replacement workers, scorned as "scabs," as they came to work and hung them in effigy on the adjacent roadways. The violence and the disruption of coal service to Americans converted the strike into a divisive political contest. Charles W. Eliot, president of Harvard University, called the "scab" worker an "American hero." Conversely, the clergy, especially Catholic priests, uniformly supported the strikers.

The resolution of the strike provides evidence of both the growing acceptance of pragmatic arguments about conceptions of justice and the limitations such arguments encountered. On October 3, 1902, with winter chills approaching in much of the country, President Theodore Roosevelt established a commission to investigate and work to settle the strike. Ultimately, he suggested federal arbitration. The union hired attorney Clarence Darrow to represent it in the proceedings. He presented almost 250 witnesses over three months, most of whom testified to the difficulties in doing their jobs: breathing foul air; long days without sunlight; mine collapses; and illnesses caused by coal dust, not only the miners' but also those of their wives and children. Not one of these concerns related to the walkout; the union had made no demands for health and safety improvements. The strike focused instead on union recognition and pay. But Darrow hoped to build sympathy for the miners and, like the pragmatists, assert the need for a new "truth" rooted in emotion that would reshape perceptions of labor relations and compel the arbitrators to grant the union's demands. The approach proved to be only partly successful. In March 1903, the commission's report to the president recommended a 10 percent wage increase, a nine-hour work day, and greater pay for overtime. The report did not endorse either improving working conditions or recognizing the union.[45]

The old free labor ideal still resonated with people in the United States in 1902 and served as a prime reason for the popular support of management. Yet the coal industry, like many industries at the time, repudiated that ideal at least as much as any union did. Owners controlled wages by price-fixing agreements among the mine companies, most of which were oligarchies. J. P. Morgan owned the mines in eastern Pennsylvania as part of his Reading Railroad empire, and Baer worked for him. Oligarchs could hardly claim that their business model comported to the ideals of a free economy. Instead, they too justified their positions using religion and concerns for the social good. Baer wrote that "God, in his infinite wisdom" gave the "property interests of the country" to certain good men who were solely responsible for their businesses, including "the rights and interests of the laboring man."[46] Such expressions only compounded liberals concerns over the state of business in the United States.

Still, Darrow's argument expressed a class consciousness that frightened many Americans who understood their society as classless. Americans generally perceived great dignity in all types of work—even in working for a wage in an industrial factory. Laboring as a free person supported the democratic ideal. But industrialization had corrupted labor, robbing laborers of both their identities as craftsmen and the fair value of their work. Darrow sympathized with the significant numbers of alienated Americans—recent immigrants, factory laborers, and disadvantaged farmers—who found themselves so much at odds with the current economic and political life. Beginning in the 1880s, these Americans formed their own associations for political action. Some of those associations, such as the Granger movement, gained credibility within their communities and effected social change. Even socialist movements elected local politicians to office. Yet the successes of these movements were few, and increasingly radicals turned away from traditional political expressions and toward violence.

The coal strike accelerated Mary's growing class consciousness. Increasingly, she came to identify more closely with working-class individuals than with members of her family or even classmates from school. She wrote in her journal, "I'm an inverted snob—hating [the] rich. I feel so ignorant with all my college education—I don't know how to rob, or whom." Her disillusion provided further encouragement to change her life.

Sexual frustration, building for many years, provided another impetus to change. Mary's upbringing had stressed the importance of Christian morality and female virtue. As a young adult she reconsidered the meaning of both. Mostly, she appeared anxious to enjoy herself—to experience something meaningful to her, possibly to make a difference in the world, but certainly to feel more alive. To do so, she would have to throw off the cultural and moral

restraints imposed on her in childhood. "It is one's virtue," she wrote, "which got him into trouble. I almost feel ashamed at being celibate, at having no illegitimate child. I haven't loved enough. They whose blood runs cold are the virtuous—law, morality is the expression of the lack of courage, daring, love."[47] Mary felt that the world was passing her by as she spent time in Ovid, with no battles to fight and no young men to date.

Increasingly, politics and a concern for the unprivileged reinforced her thinking on moral autonomy and the pursuit of enjoyment. Mary could not help but be energized by the optimism of the age. The Progressive movement exercised a tremendous hold over people like Mary Field. It gave their ideas, attitudes, and dreams a sense of purpose, to be actualized in people's own vocations and in the nation's progress. The movement united them with like-minded young people across the country and recognized them as intellectual and moral leaders able to influence the world around them. Desiring the cosmopolitan life that suddenly seemed so accessible, Mary perceived a world full of promise and hoped to participate in its making.

A new political leader arose with the new century, seemingly confirming Mary's hopes that real progress was possible. McKinley's assassination at the hands of an anarchist in September 1901, though frightening and worrisome, had elevated young Theodore Roosevelt to the presidency. His reelection in 1904, together with La Follette's reelection as governor of Wisconsin, signaled the ascendancy of the Progressive movement as a victory of ideology over party. Even Lincoln Steffens could celebrate the Republican victory as a win for "democracy and representative government."

Roosevelt reconnected the Republican Party to its Lincolnesque roots, committing it to protecting each individual's right to pursue his or her own personal goals. By the early 1900s, corporate power and gross wealth disparities threatened that right. In the words of one historian, "Roosevelt fulminated against the 'small class of enormously wealthy and economically powerful men, whose chief object is to hold and increase their power.' Insisting that America must break up this class in order to return to 'an economic system under which each man shall be guaranteed the opportunity to show the best that there is in him,' Roosevelt called for government to regulate business, prohibit corporate funding of political campaigns, and impose income and inheritance taxes." Rather than serving business interests, the Progressives believed that government power would have to be used to counter corporate power and wealth. Progressives still defined their liberalism as based upon the "inherent worth of individuals" but were newly committed to using government to secure that worth.[48]

Roosevelt promised to regulate corporate power, protect consumers and investors from corporate wrongdoing, secure labor peace, and conserve precious wilderness areas as well as to eradicate "wrongdoers" from public office. In 1905, five senators were convicted of fraud. In 1906, the President secured passage of the Pure Food and Drug Act and the Meat Inspection Act, empowering the Department of Agriculture to take unsafe food off the market. Following judicial successes against Standard Oil and the Northern Securities Company, he took to the "bully pulpit" to encourage the use of the Sherman Antitrust Act to attack corporate ills, and the courts responded by breaking up forty-two of the largest corporations. Business in the United States had entered a new age, as indicated by J. P. Morgan's decision afterward to clear all mergers with the government before proceeding with them. In 1908, the National Forest Act set aside extensive acreage, free from any development, to protect the nation's natural heritage. The Progressive tent grew large enough to hold diverse reformers, such as Roosevelt and La Follette, as well as Walter Rauschenbusch and Herbert Croly. For a time, it seemed able to accommodate them all as factionalism and parochialism receded within the Republican Party.[49]

Perhaps there is no greater example of Progressive ideas in action than the settlement house movement. To settlement house founders such as Ellen Gates Starr and Jane Addams, democracy required more than an equal right to participate in elections and the court system. It mandated the integration of all people into the social fabric of the United States—respecting, listening to, and caring for them. They demanded duties from their society—neighbors, fellow citizens, and the government—to provide the respect, sensitivity, and caring that the settlement house activists perceived all people to deserve.

Mary heard Eugene Debs speak for a second time when he came to Ovid. He convinced the young woman that the capitalist social structure kept working people poor and dependent on those who had power and money. Capitalism led inevitably to exploitation of the workers by the owners. Debs closed his talk by encouraging volunteers to pursue social justice, recommending to young women the opportunities existing for them in the settlement house movement, especially in the work of Jane Addams in Chicago. Historian Robert Crunden notes: "Men and women found that settlement work, higher education, law and journalism all offered possibilities for preaching without pulpits. Over the long term, their goal was an educated democracy that would create laws that would, in turn, produce a moral democracy."[50] Not surprisingly, Mary Field found a home in settlement work. The Social Gospel and pragmatic theories came together for Mary in the movement and pointed her to a major change in her life.

Debs tapped into the sense of Christian duty with which Mary had been raised while also offering an exciting revolutionary course of action to the rebellious young woman. His definition of socialism as "Christianity in action" particularly appealed to Mary.[51] Christianity during the 1880s and 1890s expressed a revitalized Social Gospel, which taught that good Christians should be more concerned with their moral duties to serving the public good than with their own salvation. Christians' duties to supervise morals created an opportunity for them to criticize society and promote social change.[52] A major criticism focused on society's predisposition to individualism. Walter Rauschenbusch, a leader in the movement, claimed that individualism must be replaced with communitarian action: "New forms of association must be created. Our disorganized competitive life must pass into an organic cooperative life." His fellow supporter of the movement, Washington Gladden, spoke even more strongly: "For this human personality, whom we wrongly name an individual, finds its life only in vital union with other lives. To live is not to separate ourselves from our fellows, but to unite with them in multiform ministries of giving and receiving. We are parts of a whole." The movement corresponded to a general condemnation of individualism that percolated within liberal communities. Addams herself noted: "We are passing from an age of individualism to one of association. . . . We must demand that the individual shall be willing to lose the sense of personal achievement, and shall be content to realize activity only in connection with the activity of the many."[53] As Mary's religious inclinations took a dramatic shift toward the Social Gospel movement, her political leanings became even more communitarian. Just as important, a move to Chicago offered more social opportunities for an ambitious young woman.

Immediately after hearing Debs's lecture, Mary returned to her rented room in an Ovid farmhouse and wrote a letter to Jane Addams. A couple of weeks later she received her response. Addams had no positions available, but Dr. Graham Taylor (figure 2.2) needed a teacher at the Chicago Commons, another settlement house in the city, and wanted to meet Mary. Elated, she packed her things and moved to Chicago at the end of the 1904–1905 school year. Hired immediately, she would now be teaching English and parenting classes to young immigrant women.[54]

PROFESSOR GRAHAM TAYLOR.

" SO WE called our household and its homestead 'The Commons,' in hope that it might be a common center where friendship, neighborship and fellow-citizenship might form the personal bonds of that social unification which alone can save our American democracy from disruption, cloven as it is under the increasing social stress and strain, and where that brotherhood of which we talk and sing may be more practically lived out and inwrought."—*Graham Taylor, in a Commons Circular.*

FIGURE 2.2. Dr. Graham Taylor followed the model of Jane Addams in creating a settlement house to assist the immigrant poor in acclimating to the culture of the United States. Courtesy of the Chicago History Museum, ICHi-018046.

CHAPTER 3

The New Women and Life in the Urban United States, 1905–1908

Chicago seemed to many to be the center of the world in the closing years of the nineteenth century and the early years of the twentieth. Railroads had transformed the United States into a dynamic industrial nation and Chicago served as the heart of the national railroad network. By 1910, more than twenty railroads, utilizing six downtown terminals, provided passenger service to or from Chicago. But freight provided the real energy behind Chicago's rail ascendency. Located in the northern part of the world's greatest agricultural plain, Chicago, in the words of Carl Sandburg, became "hog butcher to the world" (figure 3.1). The Chicago stockyards contained 2,300 pens holding livestock from all over the Midwest. At their peak, the stockyards could hold 75,000 hogs, 21,000 cattle, and 22,000 sheep simultaneously. More than nine million animals were slaughtered and processed there in 1890. By 1900, the yards employed more than 25,000 people and produced 82 percent of the meat consumed in the United States. All of this meat entered and left the yards by rail.

The Chicago Board of Trade functioned as the world's largest commodities market. Louis Sullivan used the Chicago sky as a canvas on which he painted breathtaking steel and glass masterpieces that revolutionized architectural design. The Chicago literary renaissance introduced the genre of American realism and made worldwide celebrities of Carl Sandburg, Sherwood Anderson, Upton Sinclair, Willa Cather, and Theodore Dreiser. Jane Addams

FIGURE 3.1. The Chicago stockyards established the city as the "hog butcher to the nation," offering another example of the business growth spawned by railroads and manifested in the building of urban areas. Courtesy of the Chicago History Museum, ICHi-051198.

created the settlement house movement and with it a new professional opportunity in social work.

In 1893, Chicago outbid New York, Philadelphia, and Washington, DC, for the opportunity to host the World's Columbian Exposition celebrating the four hundredth anniversary of Columbus's landing in America. Still generally regarded as the greatest and most influential world's fair ever staged, the Exposition attracted 27.5 million visitors and tremendous investment wealth to Chicago. The Exposition celebrated human progress and looked optimistically toward a scintillating future. In the United States that future would take place in cities.

In 1880, 25 percent of Americans lived in cities; by 1900, 40 percent did. Cities served as commercial and social centers in a society redesigned by industrial technology. They offered grand new buildings such as skyscrapers and the Brooklyn Bridge, streetcars, electricity, modern plumbing, and telephones. The elevated commuter tracks that formed the Chicago "Loop" were completed in the mid-1890s. Most of these accoutrements of modern living had not yet found their way to the rural United States. But cities also housed rats

and disease, polluted air and water, and the incessant stench of closely compacted humans and animals and their wastes. Rapid growth increased all of these problems as well as infrastructure concerns. Chicago had a population of 500,000 in 1880; ten years later it reached 1.1 million. That same year, for the first time, more Americans worked in factories than on farms. By 1900, 77 percent of Chicagoans had been born in foreign countries. Sandburg's "city of broad shoulders" was a place for tough men to earn tough livings—on the trains, in the stockyards, in construction, and in factories. Each looked for a chance to "make it" in the most American of cities.

Ironically, cities also exemplified the loss of community that upset so many Americans in the late 1800s. They created a sense of being alone amid thousands of other people—something unimaginable in farming communities or small towns. One visitor to Chicago called the crowd "the embodiment of isolation." Noted landscape architect Frederick Law Olmstead observed of city dwellers that "every day of their lives they have seen thousands of their fellow men, have met them face to face, have brushed against them, and yet have had not experience of anything in common with them."[1]

Chicago in the Gilded Age has been described as "the most vibrant, if raucous, city in the country."[2] Certainly, it offered two distinct worlds: tenements filled with recent immigrants who worked day and night using their brawn—and mansions, festooned with imported china, wallpaper, and crystal chandeliers, lining streets lit by gas lamps; cockfighting and dogfighting in dark alleys, corner bars smelling of the beer and whiskey that coated the flooring—and private men's clubs paneled in walnut or mahogany with large fireplaces warming those who drank brandy from snifters or wine from goblets; streetwalkers and their pimps dodging the police—and the Everleigh Club, offering courtesans dressed in silks alongside pipes and cigars for those who could afford such luxuries. The social and political tensions engendered by these two worlds erupted in repeated acts of violence and class unrest in the closing decades of the nineteenth century and the first decades of the twentieth. The Haymarket Riot of 1886, the Pullman Strike of 1894, and various bombings and assassinations marked Chicago as a cauldron of social class tension and political strife—the center of anarchism in the United States. Rapid social change always provokes societal unrest, and that unrest is exacerbated when economic disparities and cultural divisions increase. All these conditions existed in Chicago in the early 1900s.

Stanton Coit opened the first settlement house in 1886 in New York. Jane Addams and Ellen Gates Starr opened Hull House three years later. Funded entirely by charity, settlement houses were located in poor or working class neighborhoods inhabited by recent immigrants to the United States. They created a "borderland" between cultures and relied on principles of primary

group theory to build "a higher civic life through social intercourse." The immigrants became "agents of their own cultural transformation."[3] Staffed largely by upper-middle-class, well-educated young women, many with strong Christian motivations, who themselves lived communally in the houses, they offered a clean, safe, and free educational environment to men, women, and children in the neighborhood. The staff taught English, basic home finances, and aspects of cultural and political life in the United States to anyone who came to the houses. Women and children formed the majority of the people who took advantage of the settlement house programs.

While undoubtedly helping thousands of immigrants to find jobs and assimilate to their new society, the settlement houses faced criticism then as well as subsequently. They unashamedly encouraged recent immigrants to jettison their former cultural identities, practices, and even beliefs for those of their new home. In supporting a "melting pot" ideal, the settlement houses reinforced new middle-class values, styles, dress and behaviors as essential characteristics for success in the United States. Victorian elites were committed to social order, social responsibility, and middle-class values. Immigrants threatened these concerns, necessitating efforts to "improve" these people.[4]

Addams endorsed both Cooley's primary group theory and the pragmatism of Dewey and James. She believed that democracy depended on popular participation in civic life, best expressed and developed in small groups of people. The message of Christianity and the superiority of democracy as a political ideal intersected in this vibrant social community as people sought fulfillment in giving to others. Addams believed that a renaissance of early Christian humanitarianism was ongoing in the settlement house movement.[5]

Graham Taylor, who founded the Chicago Commons in 1894 using Hull House as a template, had been a professor of applied Christianity at the Chicago Theological Seminary. He saw his public outreach to the immigrant poor both as fulfilling people's Christian duty and as a field test for the principles of social work that he taught in the classroom. Taylor moved, with his wife and daughter, in 1901 into the house at Grand and Morgan and dedicated the rest of his life to service there. The Commons also exemplified the integration of Cooley's small group theory with Americans' cultural commitment to democracy. Taylor chose the name "Commons" because it signified "the whole people co-operating for the public good." Fundraising material promoted the "Chicago Commons [as] . . . a foothold on the common earth where all may meet, mingle, and exchange values; for what the old world's House of Commons has always stood for—the self-government of a free people."[6]

The architectural design of the Commons further expressed the idealism of Professor Taylor and the civic orientation of his work. Built in the Arts and

Crafts style, the house utilized the handmade products of craftsmen working in wood, iron, glass, and fabric. The Arts and Crafts movement, in the words of one scholar, was rooted in the "belief that a well-designed environment—fashioned with beautiful and well-crafted buildings, furniture, tapestries, and ceramics—would serve to improve the fabric of society for both producers and consumers."[7] Gustav Stickley, himself a major contributor to the movement, described it as a commitment to "better art, better work, and a better and more reasonable way of living . . . an inspiration and an ideal, born out of that sympathy of purpose that makes men of whatever nation brothers and comrades."[8] Though Arts and Crafts houses contained beautifully elaborate woodworking, stained and leaded glass windows, and florid fabrics and wallpapers, they emphasized nature and simplicity in contrast to the more baroque tastes of many Victorians. In this emphasis, as well as in the rejection of mass production, the movement expressed a respect for the working man and woman. Its appreciation of natural surroundings, in contrast to factory labor and blighted urban centers, served as a precursor to Frank Lloyd Wright's Prairie School of architecture. Many Arts and Crafts houses were smaller bungalows, designed as homes for the workers that the movement so revered. Yet the Commons, a five-story mansion, was one of many huge Chicago homes built in the same style (figure 3.2).

The settlement houses expressed a humanitarian progressivism as a complement to the professionally oriented progressivism that dominated so much of society around 1900. Both stressed the role of experts in designing and implementing programs for societal advancement.[9] Hull House, like many of the settlement houses, brought in political, labor union, and religious speakers. In this way, and in directly lobbying for legal changes and an improvement in community parks, sanitation, and education, the settlement houses acted as political centers within their communities. Philanthropy and politics merged so as to be indistinguishable forms of social action.

Mary and the other people on staff at the settlement houses had wonderful opportunities to meet and work with wealthy donors, political leaders, and legal advisers from the community. One of them was Clarence Darrow. Darrow's increasingly regular visits to Jane Addams's Hull House, ostensibly in support of the work being done there, resulted in large part from his desire to spend time with the frequently attractive young women drawn there to participate in social work.[10] His wife, Jessie Darrow, aspired simply to be a good wife and mother. She possessed none of the glamour, sophistication, or erudition needed to enter her increasingly famous husband's social circles—and she had no real interest in doing so. By 1891, the couple began growing apart, and Clarence began the first of many affairs. He had married young and had

Chicago Commons

Grand Avenue and Morgan Street

A NEIGHBORHOOD CENTER

Opens Its Fall and Winter Work for the Season of 1906-7
ON OCTOBER 1st

A cordial invitation is extended to all persons residing in the neighborhood to take advantage of the educational and social opportunities offered.

Thirteenth Year's Announcement

FIGURE 3.2. The Chicago Commons, designed in the Arts and Crafts style popular in the late 1800s and early 1900s, was meant to uplift the tastes and lifestyles of the immigrant people it served. Courtesy of the Chicago History Museum, ICHi-182050.

very little sexual experience before his marriage.[11] In the 1890s, he found himself in Chicago among many beautiful and willing women. Young women were captivated by the handsome and successful young attorney who was well read and passionate about injustice and social concerns. The articulate Darrow easily impressed them with his speech, his looks, and his apparent sincerity—the same tools he used in the courtroom. In 1897, his marriage over, Darrow moved into

what has been referred to as a "Gilded Age version of a bachelor pad" in the luxurious Langdon Apartments near Hull House.[12]

When Mary moved into the Commons, she became one of approximately twenty-five young female residents (figure 3.3). She loved both the city of Chicago and the important, sophisticated and intelligent people she met there—most of whom were men. She very clearly expressed the type of man she found attractive: "I was never interested in a man who wasn't interested in ideas."[13] Men seemed drawn to Mary, a fiery twenty-seven-year-old whose temperament belied her sexual naivete. She dated a number of wealthy young and not so young men who had made names for themselves in Chicago, including the president of the University of Chicago, a Russian diplomat, and the city police inspector. She was engaged twice but broke off both engagements. She terminated the relationship with a noted journalist when she discovered he was already married. After that affair, she confided to Graham Taylor that she "grew to doubt everything." She ended her engagement to wealthy playboy Nathan William Wallace Robert Scott Bruce Argyll McChesney, who had given her a set of pearl-handled golf clubs, when he angrily slapped a cocktail out of her hand at a party and told her not to drink or smoke anymore. She immediately took off her engagement ring, gave it to him, and celebrated her continued independence with another drink and a cigarette.[14] Sara described Mary's tumultuous dating life during these years as "peaks of ecstasy and elation" followed by "descent into the valley of despondency."[15]

Mary's commitment to social reform enveloped both her work at the Commons and her personal life as a woman; in both realms she perceived a strong need for change. Her journal during these years provides evidence of a young woman thinking seriously about her own freedoms, especially as a woman, and social reform. Sometimes these topics intersected, as she reconsidered the concept of virtue from her new perspective. She wrote: "The road back to the community of virtue leads through lies . . . but the community of virtue is itself a lie, a hypocrisy." When she earlier considered virtue as a teacher in Ovid, she perceived it as a religiously derived societal restraint on her own fulfillment, especially her sexual fulfillment. Now, she wrote of the possibility of recapturing virtue but dismisses the option as pointless—virtue is not only an unnatural restraint but a communal hypocrisy of no value. She preferred further pursuit of her natural desires and interests: "We are all potentially natural—not sinful. Back to nature does not mean naturally backward." But while Mary may have felt freer sexually, she still felt restrained, as a woman, from true fulfillment: "Women's brains are like the fashions! Somewhere they are tied in. Baby waist! Infantile mind. Wasp waist! Corseted! Laced!—restrictions. Hobble skirt—a mind can't take a step with-

FIGURE 3.3. Young women working at the Chicago Commons Settlement House. Mary is believed to be in the back row, second from the left. Courtesy of the Chicago History Museum, ICHi-182051.

out tripping." Mary's journal entries from the same time period include passages that question the plausibility of Christianity and the desirability of democracy. She considered the possibility that both philosophies offer unrealizable depictions of the ideal.[16]

Because of where she worked and the people she met, Mary engaged in regular conversations about societal change—discussions of women's rights and suffrage, greater economic equality, and social tolerance dominated her evenings. She frequently felt herself part of a special liberal enclave that perceived justice more readily than others and experienced frustration at the inability to implement this justice. As a result, she and her cohorts became increasingly radicalized, perceiving democracy in the United States as too resistant to change. But years later, the hopes of those days bore fruit:

> What we didn't realize was that society's thinking would parallel our own, that society would change without revolution and without inaugurating a new social system and that we would achieve almost everything we had fought for. Our social concerns became the social concerns of the cities and of the nation because of the constantly expanding conscience of society. As society becomes aware of social wrongs it corrects them—slowly but eventually. The function of young radicals, as I see it now, is to call attention constantly to its evils which need correction and to function as a stimulant to the conscience of society.[17]

In these comments, Mary expresses an implicit endorsement of pragmatism—the creation of a social conscience through inductive reasoning from specific instances of perceived injustice. The settlement house movement,

in which she spent these early years in Chicago, utilized the same method. Ideas and action merged for Mary during her time in Chicago.

Mary enjoyed the work she performed at the settlement houses. She endorsed the prevalent idea of the United States as a "melting pot" and hoped to help people adapt to American culture. She noted, "I came to the Commons in a glow of enthusiasm for service among the plain people. I was so happy."[18] Years later she remembered her attitude: "I felt a great sense of dedication and that I had vowed to do my share. . . . I was worried . . . the poor people would think my clothes too grand—of course I only had a few serge skirts and white shirtwaists and an old raincoat I wore all the time, but I thought perhaps I should have gingham dresses like our hired girl at home. Our whole attitude in those days was one of superiority to the poor, and we worried constantly that we might seem to be showing off our affluence."[19]

Both Mary's indomitable spirit and rebellious tendencies continued to assert themselves in Chicago. Mary thought Jane Addams "very wise," but Addams considered Mary "saucy and irreverent." Her superiors found it difficult to manage the irrepressible young woman. Graham Taylor liked Mary but encouraged her to find a position more suitable to her talents. She became codirector of the Maxwell Street Settlement House, which served the needs of Jewish immigrants in a Russian neighborhood.[20]

One morning in March 1908, policemen came to Mary's home while she prepared to go to work. They asked her about a student of hers named Lazarus Averbuch, a Jewish immigrant from Russia. They referred to him as an anarchist who tried to kill the chief of police with a knife. Mary answered the questions posed to her but knew nothing of the incident. Later, she pieced together the facts from conversations with Averbuch and a private detective named Ostrovski, who was hired by wealthy members of the Jewish community in Chicago to help the young immigrant.

Mary came to the conclusion that "he [Averbuch] determined to try to get a new job and in Russia you went to the Chief of Police for permission when you wanted to change jobs." Averbuch woke early and went to the home of the police chief about 5 a.m. "The idea that he intended to attack the Chief with a knife is absurd—Jews don't use knives." The police chief, asleep on his couch after having come home drunk from a party just a short time earlier, was fully dressed and still wearing his holster and gun. Awakened by a "gaunt, hollow-eyed" young man who pounded on his door, he shot him five times. Later, the chief claimed that Averbuch forced his way into the vestibule to attack him. The newspapers reported the chief's story, not that of the detective, and depicted settlement houses as fueling anarchist conspiracies, referring to them as "nurseries of communism." Mary found herself a part of a

story in which she had no real role. One headline asked: "What is Mary Field teaching the immigrants?" For a while, she feared she might be indicted. Harold Ickes, later secretary of the interior under President Franklin Roosevelt, wrote offering her his legal services. Liberals, meanwhile, saw the entire incident as a police shooting of an innocent man in need of help.[21]

Sometime in 1907 or 1908, Mary Field met Clarence Darrow. Mary remembered that she went to a protest rally ("somebody was jailed or somebody was striking, or somebody wanted higher wages") with her friend Helen Todd, described as "a beautiful rich girl who had thrown herself enthusiastically into social work." Helen introduced the two of them at that rally, and they quickly established a serious relationship.[22] Mary was excited by the life Darrow led but was more impressed by his "infinite compassion." She wrote of him that he seemed to be "sensitiveness and egotism all twisted as the strands of a rope . . . a great character of wonderful sweetness, of profound intelligence, of Godlike patience and tenderness—shot through with queer pettiness—about money, about criticism." His compassion moved her; she found, "the edges of his emotions [as] sensitive as the antennae of insects." Despite his parsimony, Mary turned to him for money, not for herself but for others, and laughed at him as he pulled out bunches of crumpled money, looking like a "dirty handkerchief," from his pockets. She knew of his reputation as a reformer, as a lawyer, and as the frequent companion to many attractive young women, but none of that mattered much to her. She would make her own judgement about this man. Mary soon found Darrow most comfortable alone with her. She learned why his friends, despite his reputation for sociability, referred to Darrow as the "lone wolf." Of course, "he had lots of girls," Mary noted. "Women all liked him. And he understood women." But Darrow never viewed Mary as "just one [of the] girls.[23] He loved to spend time with her away from other people, discussing politics, philosophy, and love. They soon became the very best of friends.

Darrow had remarried in 1903, but the marriage did little to curtail his romancing of young women. His new wife, Ruby, came as a surprise to all of his friends—both for the fact that he remarried and that he married Ruby, a vivacious, auburn-haired liberal journalist, twelve years his junior, who tolerated his infidelities even as she flirted with convention. Asked to explain his choice of a wife and how his marriage lasted, Darrow's standard answer was "Ruby and me, we both like Darrow." Ruby left her career to devote herself to her husband and his work. By 1908, she was well aware that he was squiring young Miss Field to lectures, parties, and dinners but largely seethed in private.[24]

Having dated both older men and married men since arriving in Chicago, Mary had no trouble in seeing Darrow, though he was over fifty years old and she

barely thirty. She always called him "Darrow" (he hated the name "Clarence"); he called her "Mary" or "Moll" or "Molly." Mary's first journal entry regarding Darrow, unfortunately undated, refers to his attitudes on wastefulness, largely influenced by Henry George. She wrote that Darrow challenged an economic system that rewards landlords for their idleness as others work to make money for them. He claimed that people who work should make the money and that ownership of land should be tied to labor.

Unlike previous men Mary had known, Darrow appreciated her mind as much as her good looks. Apparently, he showed all women a similar respect. A former lover, Gertrude Barnum, complimented Darrow in noting his difference from other Victorian-era men in that he valued women for more than sex. "He respected each individual soul," she said. He flattered women by discussing philosophy and politics with them. Mary's intellect at that time expressed itself more in wit and mischievous flirtation than in philosophy. Nonetheless, Darrow referred to Mary as "the cleverest woman I ever knew," and almost immediately their friends took to calling her Darrow's "protégé."[25]

Mary became Darrow's mistress soon after their meeting, and she loved him as she loved perhaps only one other man in her life, her future husband, Lemuel Parton. Mary claimed only to have loved Darrow "like the disciples loved Jesus. He was such a great man . . . yet he was anything but Christlike." Her great friend Ida Rauh added that while Mary may have loved him in that way, "she loved him about nine other ways too."[26]

Darrow provided much more than a sexual partner. He had a remarkable and immediate influence on Mary. First, he provided an intellectual structure for the various disconnected ideas and thoughts that she held. He had read more widely than she and could connect her thoughts to others expressed in philosophy or literature, thereby providing her with confidence in her own thoughts and a body of work to refer to in support of them when she conversed with others. Second, he encouraged her to be more expressive emotionally. He was always ruled as much by his sympathies and his feelings as by his mind; but Mary was coldly rational. He softened her and gave credibility to the feelings that she never quite trusted. Third, he introduced her to a community of liberal scholars, poets, lawyers, and journalists, including Edgar Lee Masters, a law partner of Darrow's before becoming the famous author of *Spoon River Anthology*; muckraking journalist Lincoln Steffens, editor of the *Delineator*; Theodore Dreiser, author of the controversial novel *Sister Carrie*; crusading newspaper editor Fremont Older; poet Carl Sandburg; and old friend John Peter Altgeld. Mary joined a new "salon society" that changed her life. The first decade of the twentieth century experienced the "Chicago Renaissance," a flourishing of architecture, literature, and political philosophy stud-

ied around the world. Mary participated in this movement. Fourth, Darrow introduced her to the free love movement and encouraged her to promote the rights of women to free themselves from the constraints on their sexual needs and desires imposed by religion and society's promulgation of gender roles.[27]

Darrow developed in Mary a greater appreciation of cosmopolitanism. Each of them aspired to escape a parochial environment—in his case a small town, in hers a domineering paternalistic household—to experience and even influence life on a grander scale. Darrow had expressed his cosmopolitan longings in a somewhat autobiographical novel he wrote in 1903. A condemnation of life in the small towns and rural areas of the United States, the novel has been called by some literary critics a forerunner of the "anti-village school" of literature, notably developed in Sherwood Anderson's *Winesburg, Ohio* and Thornton Wilder's *Our Town*.[28] Darrow characterizes small towns as populated by small minds, preserving their own minimal existences by rejecting any new ideas and imposing rigorous systems of order. People live in "quiet despair" with "unfulfilled dreams," he contends, assuaging their miseries and failures with "prejudices and conventions." As the book ends, the lead character expresses regret for having wasted his life:

> All my life I have been planning and hoping and thinking and dreaming and loitering and waiting. All my life I have been getting ready to begin to do something worth the while. I have been waiting for the summer and waiting for the fall; I have been waiting for the winter and waiting for the spring; waiting for the night and waiting for the morning, waiting and dawdling and dreaming, until the day is almost spent and the twilight close at hand.[29]

Cosmopolitanism endorses the rejection of self-limiting cultural impositions in favor of the pursuit of universal values that promise personal and societal enrichment. The free love movement challenged Victorian attitudes regarding sex not only by rejecting the prevailing Christian view limiting sex to married couples but also by asserting that sex, as a pleasurable experience for men and women, should be a regular part of everyone's life. But Mary sought more than sexual pleasure. She found in the early 1900s that "love as usually practiced and understood means possession—the obvious possession of the wife's person, all the way . . . to the possession of her mind."[30] The movement certainly considered monogamy unrealistic but, further, challenged laws and cultural mores that limited women's political, social, and economic freedoms as well as their sexual options. In consideration of the uproar that free love caused among evangelicals, Mary referred to the movement as "the most boiling pot on the Devil's stove." She openly embraced its teachings in

hoping for a more natural environment for women's sexual expression that might lead to a greater societal acceptance of women as social equals. The acceptance of society's power to regulate, officially or unofficially, a woman's sexual behavior grants an inherent power to control other aspects of her life. The double standard regarding women's sexual behavior went hand in glove with restraints on women's ability to borrow money, buy real estate, pursue a full range of careers, or—until 1920—vote. Teaching girls and young women to deny the most basic and natural of their desires in order to conform to society's conceptions of propriety engendered an attitude of self-denial, subordination, and inferiority that would be hard to eradicate.

In openly endorsing free love, as well as in her pursuit of a career and an intellectual life outside the home, Mary identified herself as one of the "new women." Popular culture in the early 1900s became fascinated with "new women," who challenged the gender stereotype and sex roles of the Victorian age. These women craved opportunities to participate independently of men in all aspects of society; to enjoy their sexuality without the restraints of convention; and to develop their talents in the arts, business, or politics. Randolph Bourne, himself a crusading author in support of social change, defined this apparition while simultaneously providing insight into the near wonder it provoked:

> They are all social workers, or magazine writers in a small way. They are decidedly emancipated and advanced . . . thoroughly healthy and zestful. They shock you constantly. . . . They have an amazing combination of wisdom and youthfulness, of humor and ability, and innocence and self-reliance, which absolutely belies everything you will read in the story books or any other description of womankind. . . . They enjoy the adventure of life; the full, reliant audacious way in which they go about it makes you wonder if the new woman isn't to be a very splendid sort of person.[31]

The social commitments, professional employments, and sometimes radical political attitudes of the new women are, to later generations, sometimes difficult to integrate with these women's emphasis on fashion, attention to their appearance, and dedication to femininity. At the time however, the complexity of the new women was wonderfully captured by Charles Dana Gibson in his Gibson Girl cartoons. The Gibson Girl was intelligent, confident, and always in control in relations with men. Gibson's caricatures emphasized at once the independence of the new women and their unrestrained flirtatiousness; the cartoons celebrated, much more than they lampooned, this new cultural phenomenon (figure 3.4).

FIGURE 3.4. Gibson Girl cartoon. Charles Dana Gibson captured the essence of the "New Women" in his cartoons depicting young women of the early twentieth century as very self-possessed and capable, as well as beautiful and feminine. As shown here examining a man on his knees, they were in control of themselves and the men around them. Courtesy of the Library of Congress. "The weaker sex. II" (1903) by Charles Dana Gibson (1867–1944), https://www.loc.gov/pictures/item/2010716170/.

Prominent author and reformer Charlotte Perkins Gilman saw in the Gibson Girl drawings a depiction of "the new woman . . . a noble type, indeed . . . honester [sic], braver, stronger, more healthful and skillful and able and free, more human in all ways."[32] Certainly, these women seemed more human in the open expression of their sexuality and their repudiation of Victorian mores. Emma Goldman spoke for thousands of single young women when she wrote:

> Can there be anything more outrageous than the idea that a healthy, grown woman, full of life and passion, must deny nature's demand, must subdue her most intense craving, undermine her health and break her spirit, must stunt her vision, abstain from the depth and glory of sex experience until a "good" man comes along to take her unto himself as a wife? [33]

The new women repudiated and threatened prevailing attitudes regarding women. Society generally considered women to be morally superior to men but limited physically, emotionally, and intellectually. From this perspective, women's proper roles were as housemates and mothers; in these roles they

could shape the home into a moral and comfortable retreat and foster the values and attitudes necessary for a republic of free citizens.[34] However, outside the home, their weaknesses would prove their undoing. Philanthropy had provided earlier generations of women an opportunity to work in ways that utilized, or even amplified, their presumed tenderness, compassion, and sensitivity in caring for others. Many of the new women, such as Mary, accepted jobs and even built careers in philanthropy. But their priority was usually their own fulfillment, happiness, and expansion of opportunity. To them, sexual freedom, economic freedom, and political freedom were integrated parts of a full life. The new women tried to live their lives as expressions of those freedoms.

Certainly, the new women expressed an early form of feminism. Though the *Century Magazine* in the early 1900s claimed that the word was so new that it was not yet in the dictionary, "feminism" appeared poised to restructure social life in the United States by radically altering the attitudes of both men and women. Feminism was being hailed as a "world wide revolt against artificial barriers which laws and customs interpose between women and human freedom," compared in importance to the Enlightenment and its progeny, democracy. The feminist movement at the turn of the century built upon the philosophical tradition of the Enlightenment in valuing individualism and asserting a private right of each woman to develop her natural potential in pursuit of her desires. As historian Nancy Cott notes, the "new Woman stood for self-development as contrasted to self-sacrifice or submergence in the family. Individualism for women had come of age" in the person of the new woman. These early feminists also understood economic and political freedoms to embrace heterosexual attraction and intimacy. Free from arbitrary and artificial societal restraints, men and women could meet as equals and pursue their sexual interests as such. But prevailing bourgeois notions of marriage depended on an economic and intellectual subordination of women and therefore promoted "male tyranny" as well as "dull predictability and emotional barrenness" in sexual relations.[35]

In the early 1900s, sex became a cultural, and even a political, concern as well as a personal one. Women not only argued for the right to vote but also for other personal rights and freedoms. Well before the "flapper era" of the 1920s, sexuality made its way from Victorian bedrooms to the public streets. Every city had an amusement park, and nearly every one of those featured both exotic—or "hootchi-kootchi"—dancers and also tunnels of love. Movies featured gorgeous women, scantily dressed, in love scenes with men who, in many of the plot lines, were not their husbands. Magazines celebrated the openness of the country's interest in sex. *Current Opinion* reported that it was

"sex o'clock" in the United States; *Good Housekeeping* noted that the only way to control sexual desires is through satisfying them. As many young women flocked to large cities, those willing to exploit their natural charms found jobs as cocktail waitresses who earned cuts on each drink served to gentlemen patrons or in environs offering more lurid sexual activities. Most of these new urbanites, however, found jobs as "shopgirls, clerks, and factory hands," whose small wages made them vulnerable to men with money who blurred the already "fine line between courtship and promiscuity."[36]

In what seemed to many a highly charged sexual environment, the number of unwanted pregnancies increased and thousands of women turned to back-alley butchers who took not only the women's money, but sometimes their lives as well, in performing illegal abortions. Margaret Sanger headed a widespread campaign for the legalization of contraceptives, publishing an article entitled "What Every Girl Should Know" in a New York newspaper in 1912. She coined the phrase "birth control" and argued for women's freedom to enjoy sex without the worry of unwanted pregnancies.[37] "Enforced motherhood," she asserted, "is the most compete denial of a woman's right to life and liberty."[38] Yet Americans divided sharply over the openness of sexual discussions. Mary attended a speech Sanger gave and witnessed her arrest for merely addressing contraception in public. Sanger's talk was entitled "Birth Control—Is It Moral?" The law provided an answer on that day.[39] But by openly addressing subjects considered taboo, people such as Sanger challenged contemporary moral understandings and the law's reliance on them.

Sanger, too fell victim to the liberal proclivity to social engineering. She endorsed eugenics in 1921, writing that "the most urgent problem today is how to limit and discourage the over-fertility of the mentally and physically defective." Throughout her life and afterward, many interpreted her endorsement of birth control as, at least in part, having racist origins.[40]

Mary saw herself serving on the front lines of the battle for sexual freedom and female social opportunity. But she also believed that women were not doing enough to help themselves, succumbing to the comforts that men provided for women to keep them in their place. She argued that women had "to understand the value of suffering and that women have not suffered enough; that they are too lazy, cat-like, love the couch, the cozy corner."[41] Women, she believed, would not be moved to fight for their rights so long as their subjugation remained comfortable. Female docility contributed to Mary's lack of enthusiasm for women's suffrage. The issue seemed so tame in comparison with economic inequality, birth control, and prostitution. Mary noted that "it [suffrage] had become so darned respectable, with all the society women marching into the parlor and therefore it wasn't interesting." More important, she

thought women would generally vote as their husbands did, merely doubling the vote, not changing it. In this supposition, she was proven correct.[42]

Men, too, experienced tensions regarding their sexuality in the Victorian age. Certain segments of the population attributed the Civil War to a feminization of society in the antebellum period in its focus on benevolence and humanitarian duties. Many asserted that the problem had continued in the postwar era. Bemoaning a lack of toughness in the men of the day and claiming that luxury, prosperity, and urban living had emasculated young men and rendered them unfit for leadership, these critics argued for living a "strenuous life," revering martial valor, ruggedness, and strength. Theodore Roosevelt embraced and became a model for this new ideal. But not all men embraced this conception of masculinity, and many felt threatened by it. Some of these men, especially intellectuals, welcomed the "new women" because they perceived that as women changed, men could too. A greater equality between the sexes would relieve men from the pressures of being strong, assertive, protective providers and allow them to develop relationships rooted in mutual affection rather than the fulfillment of expected roles.[43]

Yet as much as liberals hoped to refashion society, they were themselves both products of and participants within it. Mary may have endorsed free love and rationalized her devotion to a married man, but she ached for Darrow to come home to her at night. Both she and Clarence had to be somewhat cognizant of prevailing morals and social judgments and tried to be somewhat discreet in their relationship. But in that discretion lay pain, for they could not go out with each other in public as often as either would have liked. Moreover, Clarence needed his wife by his side at certain functions.

Both the rise of the new women and the increasing openness of sex provoked a reaction from religious conservatives. Sexual freedom constitutes an important part of the freedom to be an individual. In denying women sexual freedom, society expressed a power to limit them intellectually, culturally, and politically as well. Religious conservatives successfully reinforced this power in a series of laws. The Comstock laws, named for evangelist Anthony Comstock and first passed in 1873 to prohibit the use of the mail system to distribute "obscene, lewd, or lascivious" materials including contraceptives, came to refer to a broad state and federal network of restrictions governing morality in the early 1900s. Mary found the patronizing concern for female virtue all too similar to the restrictive values her father had imposed. She believed that women should be able to express their sexual natures and desires freely, without social judgment or personal ramifications. She committed to working for sexual equality. However, she soon found herself arguing over the meanings and sources of morality. As a Christian, as well as a pragmatist, she perceived

morality to derive, at least in part, from her faith; but her faith had become different from that of her father and of men like Comstock. She rejected the idea that men could tell women what they could not do on the basis of faith and its moral precepts. Yet she also used her own morality to criticize industrialists who exploited wage laborers and politicians who relegated immigrants to tenements in urban slums. Was morality absolute or relative, and from what source did it truly derive?[44]

Finding herself equally conflicted in her personal life, despite all of her intellectualization of sex and love, Mary recognized her behavior as frequently that of a surprisingly traditional female who found her value in the eyes of a man. She became increasingly resentful of Ruby—even jealous of her—and more inclined to emotional outbursts. On a particularly hot day in July 1909, Mary fainted from the heat. Rather than rise right away, she stayed down and cried. Darrow was not there to pick her up; he was likely home with Ruby. Mary was alone—recording in her journal, "my life meant nothing to anyone."[45]

CHAPTER 4

The Trials of Progressivism, 1909–1914

Mary had met, and even dated, some very impressive men in Chicago. Few could rival Darrow for his mind, his charm, and his endearing passion for apparently lost causes. Few also could rival his fame and his success. In the early decades of the twentieth century, Darrow became the most famous lawyer in the United States and, according to one author of legal studies, remains "the most famous lawyer known principally as a lawyer."[1] But as much as the public loved him, Darrow evinced little regard for the public. Suspicious of democracy, he said: "I never admired politicians . . . their constituency is that mysterious entity known as 'the people'—with all its ignorance, its prejudices, its selfishness, and most of all its insincerity as to either men or principles."[2] In late 1908, he even came out against the new direct primary election law, the frontispiece of Progressive reform. The *Tribune* commented that Darrow had "permitted himself to fall into a condition of skepticism." The writer failed to notice that Darrow's position was consistent with his long-standing liberal elitism.[3] Not only did Darrow not really like most people, he also did not value them. Mary said of him: "His position is that only those men and women, who bring light to man's darkness are important: the great men of science—Darwin, Pasteur, Pavlov—men of knowledge who dispel superstition, fanaticism, disease, cruelty, who make the human race more intelligent."[4] Democracies, however, are not created to empower scientists and scholars.

Rejecting most of the people he encountered, Darrow reveled in a few close relationships and especially his time with Mary. They attended lectures together, and he introduced her to his closest friends, but both of them wanted to keep their relationship somewhat secretive. They spent hours discussing philosophy, politics, love, poetry, and literature. They shared their likes and dislikes, their hopes, goals, and fears. He found her to be a naturally gifted author and encouraged her to devote herself more fully to writing. He believed that she was wasting her talents in social work; the work she was doing was for the foot soldiers, and she was capable of leadership—intellectual leadership.

They shared an especially strong commitment to organized labor. Organized labor expressed an implicit endorsement of primary group theory and seemed to embody the anarchists' commitment to governance by freely associating people committed to mutual benefit. Darrow contended that labor "will have done its work [when] . . . this world will be united in one grand universal brotherhood."[5] Labor unions, rising organically from among the workers, could challenge capitalism and provide an alternative means of social governance. Yet the laws in the early 1900s still respected individual rights, not group interests, and generally treated union organizers as threats to the social order and unions as illegal combinations in restraint of trade. Popular thought linked unions to anarchism or, just as detrimentally, perceived them as forming monopolies of labor—coercing individuals to give up their rights to freely sell their labor on the open market on whatever terms the individuals found fair. Unions denied workers their freedom of action, operated outside the laws of supply and demand, and sought unrestrained power equal to the power that robber barons exercised over land and materials.

Understandably, the value system pervasive in the United States, rooted in a strong individualistic spirit was felt less strongly among wage laborers. Journalist Herbert Croly wrote, "The American laborer . . . is . . . far more aggressively preoccupied with his class, as contrasted with his individual interests, than are his employers. He has no respect for the traditional American individualism. . . . His own personality is merged in that of the union." Still, even this class identification frequently proved insufficient to overcome ethnic and religious divisions between workers, and less than 10 percent of the workforce had organized by 1901.[6]

Organized labor was not Mary's only political interest—far from it. But labor complemented her other concerns—economic inequality, immigrant rights, and women's rights. The early feminists sought "a complete social revolution" through which women would gain "freedom for all forms of . . . active expression." The rebellious spirits involved in the feminist movement in the early 1900s "by and large . . . welcomed the idea of radical and irreverent

behavior in the labor movement, arts, or politics." Mary's good friend Gertrude Barnum was typical of many settlement house workers who combined feminist sensibilities with a devotion to labor organizing. Barnum worked as an organizer for the Women's Trade Union League (WTUL), which depended on Greenwich Village radicals and intellectuals, among them Ida Rauh, for support. As the new women who spearheaded the feminist movement became more involved in union activities, they moved away from a natural rights justification for their agenda to a broad assertion of social obligations for communal improvement.[7]

The wave of strikes that disrupted the country's major cities in 1909 began among women shirtwaist laborers in New York and Philadelphia. No event united the interests and goals of feminists and labor organizers more than the Triangle Shirtwaist Company factory fire in 1911, in which 240 mostly immigrant girls and women, locked in rooms on the ninth, tenth, and eleventh floors of an old building in New York so that the workers would be disinclined to leave their workstations, burned or jumped from the windows. More than 140 of them died, and the survivors suffered terrible injuries.[8] Feminist responses to the plight of working women were largely rooted in collectivist attitudes. Historian Nancy Cott notes that the individualism, rebelliousness, and embrace of heterodoxy that characterized the early feminists was in tension with their goals for "all women" and their support for organized labor and communal welfare. While these positions can be explained, in part, by women's feelings of disenfranchisement, which fostered an identification with the deprivations and lack of opportunity of lower-class people, the intellectual inconsistency remained.[9] Mary confronted a philosophical dilemma.

The tensions that Mary and Darrow experienced in their political philosophies came to the forefront in 1908 and 1909. Their ideological evolutions during this time evince the influences of each upon the other. Darrow had always harbored intellectual inconsistencies. His distrust of the electorate undermined his support for popular politics; his commitment to an increased role for government in securing better lives for the poor and the disadvantaged was irreconcilable with his libertarianism. Mary debated within herself her commitment to the common good versus her individualistic tendencies; she resented religion's proscriptions of natural human behaviors but could not entirely escape her belief in God; she adamantly crusaded for women's rights but could not identify with the suffrage movement. Liberals nationwide faced similar issues as they searched for identities in a world in transition. Feelings, beliefs, attitudes, and even ideas came easily, but harnessing them into a consistent ideology supportive of action proved more difficult. Classification of one's worldview proved equally elusive. Socialism, anarchism, populism, communism, and pro-

gressivism each presented a somewhat unique liberal reform movement, but the overlap and contradictions among them stymied group efforts to work together or form political identities. Compounding the difficulty, various expressions of liberal ideology predicated these positions on conceptions of morality; child labor, workplace safety, eliminating political corruption through direct elections, and a myriad of other policy initiatives contained an implicit or explicit moral sanction. Liberals learned that morality meant different things to different people, even within their own political communities. Darrow noted that social reformers were divided among themselves: "There was a profound cleavage between us as to the meaning of the word 'reform.' To some it meant closing the theatre and saloons on Sunday. To us it meant nothing of that kind."[10] Intellectual consistency could resolve some of the differences, and he and Mary worked on that together. He challenged her on her failure to support suffrage, and she worked to temper his libertarian sensibilities. More significantly, Mary's rationalism challenged the emotions that, for Darrow, minimized the significance of intellectual inconsistency. Conversely, he encouraged her to give greater importance to her feelings. They each tried to resolve an inconsistency in thought and in doing so were far from alone. As historian John L. Thomas asserts, intellectuals of the time attempted "to reconfigure fragments of a shattered ideology to fit the needs of a modernizing society."[11]

The ideological conflict that the two great friends confronted arose from the desire to protect individual rights and freedoms while simultaneously creating a culture in which moral compulsion dictated appropriate social behaviors. Such a culture necessarily limits freedom of conscience and censors certain individualistic sentiments. The Progressives faced the same dilemma. Both moralistic initiatives, such as Prohibition and attacks on prostitution, and also those introduced to curtail monopolistic business practices and dangers to public health, confronted the tension inherent in regulating behavior so as to preserve freedom. President Roosevelt himself saw the conflict in some of his own policies and programs, though his public pronouncements attempted to minimize it: "Some persons speak as if the exercise of such governmental control would do away with the freedom of individual initiative and dwarf individual effort. This is not a fact."[12]

More radical expressions of liberalism in the early 1900s addressed this tension by demeaning individualism—not helping to resolve the tension so much as putting it aside. John Dewey argued that democracy depends on people recognizing their freedoms as integrated with and dependent on their social responsibilities. He advocated programs of moral enculturation, educating young people in their social responsibilities to "unshackle them from a *false*

individualism."[13] Building on pragmatism, Randolph Bourne, Charlotte Perkins Gilman, Van Wyck Brooks, and Lewis Mumford pilloried the shallowness of Americans' atomistic individualism which, these writers claimed, led only to destitution. They called for cultural experimentation to engender a revolution in values that would transform the country into a more communitarian society.[14]

Many of these intellectuals lived on the periphery of society, largely alienated from working people (see figure 4.1). They sought power both as a means of finding meaning in their own lives and to impose their values upon others.[15] Certainly, it is easier to diminish the importance of individual rights and freedoms when one has little respect for either the thoughts of individual people or the laws and institutions that protect them. Darrow periodically evinced a disrespect of both. Though firmly committed to the cause of organized labor and professionally dependent on its patronage, he wrote: "I had no feeling that the members of labor unions were better than employers. I knew that like all men they were often selfish and unreasonable, but I believed that the distribution of wealth was grossly unjust, and I sympathized with almost all efforts to get higher wages and to improve general conditions."[16] In other words, he had little respect for the perspectives and judgments of workers and believed that he knew best what they needed and what served the broader societal interest. His advocacy for empowering workers derived from his conviction in the cruelty of capitalism and of the law that supported it. In a letter to Mary, he retold a story told to him by the father of Ellen Gates Starr. The man remembered, as a young boy, asking his successful uncle how to become rich. The answer he received was to "take advantage" of your friends and neighbors, "squeeze the last cent out of them . . . you will be[come] mean as hell and you won't have a friend on earth, but you will be rich."[17] Mary agreed with both the sentiments and the social prescriptions they fostered.

A rejection, by leading liberals, of the need to protect individual rights, compromised their ability to endorse a major pillar of the civil rights movement. Mary's racial sensibilities arose more from an emotional sympathy than a rights-oriented legal approach. She saw Blacks and other minority peoples not as equals who lacked opportunity but as unfortunates unable to remediate their own suffering. Class concerns always dominated Mary's political thinking, but in the United States race and class issues frequently became enmeshed. And while Jim Crow may have shaped the existences of many southern Black Americans, racism often expressed itself in the North as fervently as it did below the Mason-Dixon Line.[18] Race riots arose with some frequency in the late 1890s and the early decades of the twentieth century, and two major conflagrations occurred in Illinois. When Springfield, the capital of Illinois, erupted

FIGURE 4.1. Prairie Avenue in Chicago in the early 1900s, showing homes in the Arts and Crafts style. Clarence Darrow moved to one of the mansions on the street after his marriage to Ruby. Courtesy of the Chicago History Museum, ICHi-182052.

in 1908 over an alleged rape of a White woman by a Black man, Darrow said, "Time was when [events in] the South awoke the righteous indignation of the North. But, those days have passed. The friends of the Negroe have gone to their last long sleep and in this question of color, the North and South are one."[19]

Race had proven problematic for Progressives for decades. Despite their best efforts to disguise them, Progressives harbored paternalistic sentiments that were inconsistent with securing equal rights. Issues of race brought these to the forefront. The international forays of McKinley and Roosevelt were rooted less in a cosmopolitan desire to interact equally with the people of the world than in jingoistic condescension and Christian duty that together fostered a desire to share the cultural advantages of White Western society with the less fortunate—and of course to build an empire at the same time. Domestically, many liberals, even in the North, argued that segregation could limit social conflict while allowing "weaker" or less capable people to flourish in their own communities without the need to compete with stronger and more competent individuals. Eventually, these liberals hoped that education, health care,

and greater economic opportunities might make racial integration possible, but achieving such an eventuality required patience. Clarence Darrow saw this argument for what it was—racism—though Mary remained strangely quiet on the subject. In attacking the lack of civil rights for Black people in the United States, Darrow expressed a cosmopolitan attitude uncommon for the day. Speaking at an African American church in Chicago in the early 1900s, Darrow said that there can be no compromise with or retreat from a commitment to teach each person "his own integrity and worth: you must make each man and each woman understand that they are the peer of any human being on earth." Both Clarence and Mary supported the more confrontational positions of W. E. B. Du Bois over the moderate acculturation advocated by Booker T. Washington; yet only Darrow openly denounced liberals who remained silent amid race-based brutality. He said that lynchings, "intended to keep the Negroes in their place," confirmed Americans' worse suspicions that the "South never means to recognize any such thing as social equality."[20]

Various factors came together in the fall of 1909 to prompt Mary to leave Chicago. The Averbuch incident from the previous year had taken a toll on her. She resented the attention it had drawn and made her see the limitations of the work she did. Then an article in the *Daily Socialist*, describing a young immigrant of Polish and Russian descent who was to be returned to Europe because he had consumption (tuberculosis), quoted Mary and referred to her as a socialist. Mary had no problem bringing attention to causes in which she believed, but she did not like the attention focused on her.[21] Darrow had, for some time, encouraged her to leave social work and start to write, and his encouragement helped her to consider a new career. She decided to begin again.

Mary initially worked in a secretarial role in Darrow's law firm, but both of them knew the arrangement would not last for long. He immediately sifted through friends and professional contacts to gain a writing position for Mary. In short order he heard from Theodore Dreiser that she could go to work for him in New York. Dreiser had achieved some fame as an author for his novel *Sister Carrie*, published in 1900. By 1909, he had become the editor of the *Delineator* magazine and was converting it from a periodical largely devoted to women's fashions to a serious journal addressing contemporary social issues. Mary's job would be to research and write articles for the magazine. While Dreiser's greatest commercial success lay before him, his work had already marked him as a leading author, and Mary, who had never had a writing job previously, experienced some nervousness as she met him. Her nerves were not helped by Dreiser's pacing or his folding and refolding of his handkerchief during their first meeting. She suggested two articles, based on interviews she proposed to conduct with Chicago immigrants, that seemed to please him.

"Well," he said finally. "Go get it. Go get it!" And he gave her a check for $100 to cover expenses.[22]

Mary moved once again to a big city in which she knew nobody, seemingly drawn there by an employment opportunity. But the move resulted at least as much from her realization that it might be time to redefine her relationship with Clarence Darrow, something that would be very hard to do in Chicago. Ida Rauh, her eventual roommate in New York, stated that Mary left Chicago "because of that lawyer fellow . . . the one all the women were in love with. . . . I think she was unhappy about him and wanted to get away, so she came to New York."[23]

Darrow was right in one regard: Mary's writing on issues that mattered to her—the country's treatment of poor immigrants and the plight of the nation's laborers—would reach far more people than her work in the settlement houses ever could. She moved from making incremental improvements in the lives of a few people to influencing policies that might help thousands or even millions. Yet she, herself, remained dependent upon others. Darrow set her up with money and a place to live and provided her with a ready network of friends, all drawn from New York's liberal and artistic communities. He introduced her to Eugene O'Neill, John Reed, Max Eastman, Emma Goldman, Ben Reitman, Hutchins Hapgood, and Mabel Dodge. Mary became a vital member of the Greenwich Village community soon after arriving in New York.[24]

One author describes Greenwich Village before the Great War as a "kaleidoscopic bohemia" that promised a final "sweeping away of Victorian strictures."[25] Mary found a home in the Village, the center of a new feminist movement where educated young single women, desirous of sexual freedom, careers, and a public voice, came together to express their demands for social change. Actresses, playwrights, and businesswomen, they sought a "single sexual standard for men and women" rooted in pleasure gratification, which they hoped would replace "renunciation and regulation" as a basis for public morality. Mary enjoyed late-night debates over wine and coffee; evenings with members of the Heterodoxy Club, devoted to women's rights; and weekends in Provincetown, Massachusetts, with her friend Gertrude Barnum.[26] She also joined the old Liberal Club and came to know Sinclair Lewis and socialist Norman Thomas, both of whom were members. Romanticizing her involvement in the causes of the day, Mary noted, "We were like the early Christians. We just got together." Generally, they all shared at least a minimal commitment to socialism. Her roommate, actress Ida Rauh, who would marry Max Eastman, once confronted a burglar in their apartment with an apology rather than a condemnation: "You wouldn't have to do this for a living if we had a socialist revolution." Only years later, when the political movements had faded,

did Mary reconceive of her Greenwich Village years as "a stupid period" of her life: "Most of these people were wastrels. They wasted their talents in talk—and what's become of them? So gay and so full of hope and so determined to save the world. We called ourselves intellectuals and radicals, and Bohemians, but really we were playboys and girls."[27]

In leaving Chicago and the settlement house movement for a writing job, Mary did not feel as though she were leaving a career serving the public good. Rather, she simply found a new form of political action. Still, she had no professional experience as a writer. Mary dedicated herself to developing writing skills, practicing by describing friends, parties, and liberal heroes in notebooks, focusing not only on grammar and construction but also on the use of evocative language. She hoped to use her written work as a tool to move readers, inciting a passionate desire to correct social ills. She modeled her writing style on Darrow's courtroom addresses, playing to people's emotions. Her initial efforts evince a tendency to overwrite, but she worked hard to be clear, concise, and descriptive.[28]

Mary received about $300 for each story published in the *Delineator*, but Dreiser permitted her to sell her stories elsewhere as well. She earned commissions from the *American Magazine*, *Everybody's Magazine*, and *McClure's*. Success brought higher commissions but did not create much confidence in the novice writer. Upon selling three stories for a total of $1,200, she told her sister Sara, "This is a precarious living, off the fruits of one's pen, yet there are always the friends who come to one's help. I know I can always ask Clarence Darrow freely for aid."[29] When she earned $600 for her story "The Wine Press of Poverty," she allowed herself to spend the entire month of June in Provincetown. Her success prompted a letter from Darrow teasing her: "Meanwhile I watch you on your road up . . . you have gone so far I can't see you any more—you never were large. I am glad you made such a hit at Nantucket. We will have to stop praising you pretty soon or you will lose your head—poor little Miss Field."[30] People throughout the industry took note of Mary's work. An article in the September 1910 edition of the *Delineator* prompted tremendous popular response and praise from her new peers. John S. Philipps, editor of the *American Magazine*, wrote to her: "That piece of yours in *The Delineator* was a beautiful thing. I wish we could have it for *American Magazine*—and I may tell you that it is only now and then that I feel envious of what I see in other magazines."[31]

Mary did not take long to develop her own style of writing. She employed the pragmatists' model of using inductive reasoning to create truth. Mary found compelling stories of individuals experiencing hardships, from a strike, filthy living conditions in tenement housing, arduous working conditions in a mine, or children's illnesses, without resources to alleviate them. She used

these vignettes of suffering to tell a broader story of poor or working people to create an emotional reaction, compelling readers to moral outrage and eventually, she hoped, to action. Union organizing issues became her passion, and her stories were frequently published in labor newspapers and bulletins. Not only did she find real acclaim for the work she did, she also felt as though she was making a difference in people's lives.[32]

In one story, she attempted to convey the difficulties of nearly forty thousand garment workers on strike in Chicago through a depiction of one couple. She wrote:

> I went to the bedroom. At first I could not distinguish the yellow face of the sick woman from the musty bedclothes. Gradually, a face, wrinkled and crisscrossed, seemed to gather out of the folds and creases of the pillow. I thought she was sixty years old, but she told me she was thirty. Very softly she spoke. I had to bend down to hear her. Eggs she said she needed; and milk, meat, and air. And the fumes from the soft coal mine were hard for her. Her husband folded his arms on the foot of the bed while tears dropped onto the tumbled bedcovers. On his coat, a little red and blue button gleamed—the Union button—for which tiny speck of color, with its great symbolism of brotherhood, he had been on strike for three long months.[33]

Economic equality throughout society, not a fair economic bargain premised on the supply of or demand for the labor in question, drove Mary's perception of the strike. Mary told nothing of the demands of the union or the economic competition facing the employers; in short, the merits of the strike, for Mary and her readers, rested only in the sorrows of a family of a striking laborer.

In another story about immigrant teenage girls from Galicia who worked in an industrial bakery and lived in a dirty tenement room next door to men from all over Europe, Mary recounts that they wanted only to tell her stories about their childhoods and the lovely fields of Galicia:

> But I did not hear about girls in the fields of Galacia (sic). I was thinking about girlhood in the pie factories of Chicago. I was thinking that some of the ingredients of pies, ingredients unknown to the devouring public, were youth and strength and beauty, which Nature had intended for a deeper profounder purpose than the mixing of custards or the rolling of crusts.[34]

In each of her articles, Mary told a story that she intended to provoke predictable emotional reactions among her readers. These readers formed a

community, of sorts, united in their sympathies. This sympathetic response led to judgment—"this is wrong"—which formed the basis of a new truth built inductively from limited data points. This socially derived truth would, Mary hoped, be the basis for calls for political change. Mary's writing style matched precisely the model for creating truth espoused by John Dewey and William James.[35]

Mary did not write only about labor issues. Her world was expanding, and she used her writing position to express her developing cosmopolitanism. In the 1920s, she developed concerns about the conservative influences of religion on societal change, both domestically and abroad. In two pieces she wrote about the problems of bringing communism to India, Mary contended: "Communism in India meets a formidable foe. Call it religion or ignorance or superstition, the accent of millions and millions of Indian lives is upon the substance of things hoped for; the evidence they accept is of things not seen."[36]

Mary's travels to work on writing projects exposed her to the world she had dreamed of exploring while ensconced behind the white picket fence in Detroit. She explored her sexual, intellectual, and cultural interests as fully as she desired. Yet she also reveled in life in New York, highlighted by Clarence's visits. He seemed newly committed to courting her, taking her to fine restaurants, Broadway shows, and even picnics in the park.[37] They could be much more open in expressing their affection in New York than they could be in Chicago. In March 1910, Mary received what she referred to as "the only sentimental letter I ever received from Darrow." She kept it, as she did all of his correspondence, noting on its envelope: "Precious letter." In that missive, Darrow wrote: "I miss you all the time. No one else is so bright and clever and sympathetic to say nothing of sweet and dear, and I wonder how you are and what you are doing in the big city. I don't here [sic] from you . . . please write. am tired and hungry and wish you were here to eat and drink with me and to talk with me in your low, sweet, kind, sympathetic voice."[38] Still, he reveled in her success even as he worked to inspire her to see him more often: "Dear Moll: Just a line to tell how glad I am of your success and how glad I will be to see you here at any time. I believe I will be able to borrow money 'off you' soon. Ever, D."[39]

Aside from the "precious letter," Darrow's correspondence conveys an intellectual longing more than an emotional or physical one. Sex he could find with various women; he missed Mary's mind. When he had finished reading a book, *The Thief of Virtue*, he wrote to her, "You are in it; some of my thoughts and feelings are in it. Hull House is in it, all the hypocrisy and cant is in it. The bad are all good and the good are all bad. I wish we could have read it together[;] perhaps we will the second reading or the third."[40]

While forming new friends during 1910, Mary missed those closest to her. Then Sara, shaken by her experiences abroad, ill and questioning her faith in both capitalism and Christianity, came back to the United States. Sara had seen the ravages of colonialism's effects on indigenous populations. She perceived the church to be just as guilty as the businesses that sought to exploit people for their own gain. Mary delighted in a reunion with her sister and, fortunately, Sara regained her health shortly after arriving in the States. She soon gave birth to a daughter, and her husband, her young children, and she settled in Cleveland, where Reverend Ehrgott assumed a new pastorate. Sara enjoyed the opportunities to see Mary and to be close to their mother but remained discontented. Mary had given Sara some books to read and told her about the experience of working in the settlement houses. On a visit to New York, Sara told Mary she had become convinced of the moral correctness of socialism. To Mary's great surprise, Sara even converted her husband to her political views.[41]

Sara recognized that Mary missed Darrow more than she liked to admit. Mary seemed to speak incessantly of Darrow when the sisters were together. The younger sister came to both appreciate and resent the influence of this man on her best friend. Sara noted that Mary "had a first class mind until she met Clarence Darrow. After that, she had a second-class imitation of Darrow's mind." Mary wrote of Darrow in her diary at about the same time: "a personality can be more impregnating than literal sperm."[42] He missed her as well. After writing that he loved receiving her letters, he commented that "if you are pessimistic, I like that too for I thrive on pessimism. No one [sic] but idiots and dope fiends are optimists." He told Mary that he frequently found life lonely and empty, finding respite only in work and sex: "Even as I have fought for freedom, I have always had a consciousness that I was doing it to keep myself occupied so I might forget myself. Sex [is] the only feeling in the world that can make you forget for a little while."[43]

While Mary worked in New York, Darrow undertook the construction of a free love commune in Los Gatos, California, just southwest of San Jose in Santa Clara County. Darrow envisioned a locale where like-minded people could be "surrounded [by] congenial friends." The commune provided homes for each couple or individual but encouraged attendees to spend time in the group, in order to enjoy greater discussion, debates, and sexual opportunities with one another. Darrow enlisted the support of several friends for this endeavor, including Fremont Older, Lincoln Steffens, and Helen Todd. Mary endorsed and contributed to the project. Charles Erskine Scott Wood, a graduate of West Point, a veteran of the Indian Wars, a wealthy attorney practicing in Portland, Oregon, and the son of the first surgeon general of the US Navy, also participated in the commune's creation and became a frequent attendee.[44]

As Darrow began work on the commune, the leaders of Reverend Ehrgott's church tired of the political views that came to permeate his preaching and dismissed him. He found a new position in Portland, Oregon, which Sara considered the end of the earth. No longer the impressionable young woman once willing to move to Burma for love, adventure, and service to God, she resented leaving a major midwestern city and her friends and social connections. Aware of her sister's discontent, Mary, with Darrow's help, set up a dinner to introduce Sara to their friend in Portland, Erskine Wood. Wood showed little interest in meeting a Baptist minister and his wife and expressed his discomfort by coming with a woman who was both secretary and mistress rather than with his wife. However, Wood changed his mind about the evening on meeting Sara. After dinner, bored and distressed, Albert went home while the others went to Wood's beautifully decorated office to read short stories. The charming millionaire, though thirty years her senior, swept the still beautiful Sara off her feet. They seemed to fall in love instantly, and both of them left their families soon after meeting, even though he never led her to believe that marriage was a possibility.[45] Wood endorsed a free love doctrine; "despis[ing] marriage as an institution," he "consider[ed] it a superstition and a bond absolutely hurtful to society and obscuring [of] the true relation of sex."[46]

Mary first led Sara to socialism and then to free love. Firmly committed to both as proper courses of action, she perceived no risks in encouraging her sister to make these choices. In fact, Mary hoped that their alliance on such social and political matters would further deepen their already close friendship. But Mary's career also commanded her time and attention.

Darrow and Mary became increasingly involved in the labor movement in 1910, he as a legal representative for union officials and she as a crusading reporter, forcing them to confront the extent to which they condoned the use of violence to achieve sociopolitical goals. Violence seemed inevitable in many instances of labor strife. Workers in support of unionization frequently attacked the persons or vandalized the property of those who were not; management usually hired private detectives or called on the police or the National Guard to protect their property from union organizers or strikers; union organizers increasingly turned to bombing the property of companies that refused to recognize them; striking employees battered replacement workers who attempted to cross picket lines to perform their jobs.

Both Mary and Darrow worked on the Hart, Shaffner, and Marx strike in September 1910. The clothing company had reduced piece rates for factory laborers, and the United Garment Workers walked out. The strike became bloody when nonstriking regular employees and replacement workers tried

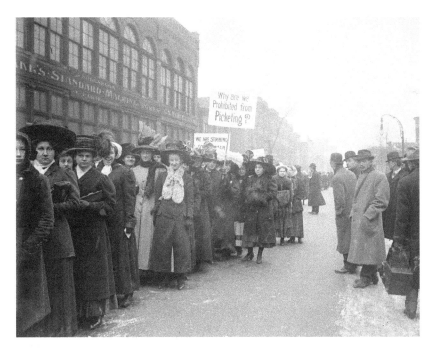

FIGURE 4.2. Striking garment workers in front of Hart, Schaffner, and Marx. Mary sympathized with the strikers and presented their side of the dispute in her reports. Courtesy of the Chicago History Museum, DN-0056264, Chicago Daily News collection.

to cross the picket line. Mary covered the strike for the *Delineator*, and Darrow represented the union.[47] The strike brought several of Mary's most prominent concerns and attitudes into public debate. Female immigrants from eastern and southern Europe constituted fully one-half of the striking garment workers (see figure 4.2). While they presented higher wages and better working conditions as keys to their return to work, the strike itself expressed a more vital concern. At a time when women were still unable to vote, the strikers saw themselves as engaging in "industrial democracy." They formed a community of workers banding together to pursue desired social change—a small group acting politically in a business context.[48]

Writing on labor relations issues in the second decade of the twentieth century placed Mary at the center of the nation's most polarizing political issue. Mary came to see labor conflict as part of a broader class war, with the government and big business jointly responsible for political crimes against humanity. Those crimes justified a violent reaction. Mary's columns reflect her support of the strikers. As Darrow wrote: "people cannot live at the point of want without some acts of violence. . . . Strikes often use violence . . . you cannot make a revolution out of rosewater." But the law recognizes no place for

violence in society, offering courtrooms as the means of resolving disputes. Darrow's acceptance of union violence led to the biggest crisis in his professional life and, at least temporarily, diminished his stature as a lawyer.[49]

Clarence Darrow's and Mary Field's work on the garment workers' strike served merely as a prelude to a much larger conflagration that arose late in 1910. At that time, unions in Los Angeles had called a general strike in pursuit of making the city a "closed town," which would mean that anybody who had not joined a union and applied for work through the union's hiring hall could not be employed. The *Los Angeles Times* newspaper supported open shops, recognizing the right of employees to unionize but recognizing the right of nonunion employees to work as well. An open shop prohibited any agreement between labor and management to make union membership a condition of employment. Darrow and Field endorsed closed shops as necessary to create powerful unions. Darrow wrote, "with an open shop, the employer has all the advantage."[50]

The battle over the closed shop presented a clean delineation between rights-oriented liberals and class-conscious liberals. People valuing the individual rights of each worker supported open shops, which recognized the freedom of employees who chose not to associate with a union, pay dues for the chance to work, and be subject to union discipline to still hold employment. Conversely, people perceiving labor issues as battles in a larger class war for power in society readily subordinated the autonomy of individual workers to broader social goals. These liberals came to see individual rights not as legal protections for workers, but as tools established by owners to manipulate and restrain the poor. Sometimes these more radical liberals could be quite dismissive of their more libertarian counterparts. By 1910, Mary had clearly joined the more radical ranks. She endorsed Lincoln Steffens's assertion that "the only class division . . . [is] between those who see and those who do not."[51] Labor issues in the early 1900s threatened Americans' traditional self-image as a classless people and provoked a cultural anxiety greater than any since the Civil War. A visiting writer from Europe remarked, "Never has there been such an example of a nation sitting in judgment on itself as America."[52]

The leadership of the Structural Ironworkers Union, dependent upon dues for its sustenance, had no respect for laborers who sought to work without joining the union. The union's leadership further perceived the open shop as solely a means to curb the power of working-class people organizing through unions. The *Los Angeles Times* became a target for the union after the newspaper endorsed the open shop. On October 1, 1910, James B. McNamara, an officer of the union, built a bomb from stolen dynamite, placed it in the alley alongside an exterior wall of the *Times* building, and walked away. The explosion of the bomb caused a partial collapse of the structure, a huge fire, and

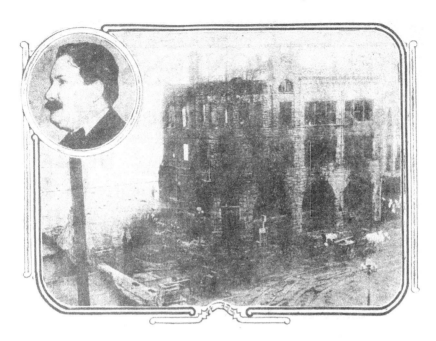

FIGURE 4.3. The Los Angeles Times Building after the bombing, one of hundreds planned and executed by the Industrial Ironworkers Union. Courtesy of the Library of Congress. The San Francisco Call. [volume] (San Francisco [Calif.]), 24 April 1911. Chronicling America: Historic American Newspapers. https://chroniclingamerica.loc.gov/lccn/sn85066387/1911-04-24/ed-1/seq-2/.

the deaths of twenty people (figure 4.3). Shortly thereafter, the authorities discovered that three men had stolen dynamite from a quarry near San Francisco. Some of the dynamite was found in the headquarters of the Structural Ironworkers Union in Indianapolis; some was found in a barn in Indianapolis owned by a teamster who leased it to James's brother Joseph J. McNamara, secretary of the Structural Ironworkers Union. The government already suspected the union in more than one hundred bombings between 1906 and 1911. Federal prosecutors had evidence against union officials for as many as eighty of those bombings, but none of these cases was as solid as the case against the McNamara brothers for the bombing in Los Angeles.[53]

By 1911, Darrow had become a relatively wealthy man and could be quite particular in choosing his cases. At age fifty-four, for one of the few times in his life, he could state, "I have enough money." He considered the McNamara case a lost cause, and in fact both brothers confessed their guilt to Darrow before the trial. Yet he took on the challenge of defending them and welcomed the chance to participate in what some in the media referred to as the trial over the "crime of the century."[54]

The defense proved problematic from the outset, as several outside forces attempted to influence Darrow's conduct. The American Federation of Labor (AFL), headed by Samuel Gompers, paid Darrow's fee. The AFL, in the early twentieth century, sought to improve popular perceptions of unions and to that end had condemned any and all recourse to violence. The McNamara trial threatened the image of unions that the AFL hoped to construct. On the eve of trial, Gompers said, "The greatest enemies of our movement could not administer a blow so hurtful to our cause as would be the stigma if the men of organized labor were responsible for it."[55] Meanwhile, radicals encouraged Darrow to defend the bombing as a legitimate political act, taken in protest of an unfair society in which labor and capital were at war. For them, violence served as the only recourse of the working class against the machinery arrayed against workers by corporate and political powers. Anarchists, socialists, and officials within the Industrial Workers of the World ("Wobblies") advocated using the trial as a means to present the case for class warfare to the people of the United States. Radical newspaper editor E. W. Scripps of San Diego aligned himself with these voices. He invited Darrow to visit his 2,000-acre ranch, named Miramar, just north of the city, and told Darrow that the McNamara brothers should be treated humanely as prisoners of war. Scripps advanced the argument for "belligerent rights" and gave a paper he had written on that topic to the attorney. In it, Scripps argued that "in nearly all civilized countries there is going on to a greater or lesser extent a revolutionary warfare between the classes." In that context, he argued that the victims of the bombing "should be considered what they really were—soldiers enlisted under a capitalist employer whose main purpose in life was warfare against the unions." The union officials were "guilty of no greater offense than . . . [any] officer of any band . . . of soldiers who ordered his men to fire upon an enemy and killed a great number of them."[56] Scripps was hardly alone in his views. Even Louis Brandeis, soon to be appointed to the Supreme Court by President Woodrow Wilson, said that the real issue in the case was why men like the McNamara brothers "believe that the only recourse they had for improving the condition of the wage-earner was to use dynamite against property and life? . . . Was it not because they, and men like them, believed that the wage-earner, acting singly or collectively, is not strong enough to receive substantial justice?"[57]

Darrow's own goals were significantly more modest than those of Gompers, the Wobblies, or Scripps. He only hoped to save the brothers' lives. "I can't stand to have a man I'm defending be hanged," he said.[58] Legally, he argued that a lack of intent to kill should exculpate the defendants from the capital crime of which they stood accused. Yet he longed to make the sociological

and political argument advanced by his radical friends. He believed that society was wrong to accord power to capital over labor—that was the true injustice. The trial could serve as the vehicle for informing the public of this wrong. The media, from all over the country, came to Los Angeles for the trial, and Darrow hoped to speak through it.

The *Delineator* sent Mary to cover the McNamara case. Hurriedly finishing her piece on the garment workers' strike, she boarded a train in Grand Central Station and headed for Los Angeles in February 1911. "I went to L.A. to cover the McNamara trial and to help Darrow," she noted. But Darrow did not initially perceive Mary's presence as helpful, and he discouraged her from coming, claiming that she might "expose or divert" him from his work. He added that "any, even purely friendly intercourse of a formal nature would be out of the question." Clearly, he was feeling a great deal of pressure in handling the case. However, by the time Mary arrived he had mellowed, meeting her at the station and taking her to dinner.[59] They were joined at that dinner by Sara and Erskine. Erskine said that once Darrow saw Mary, he experienced "a spasmodic return of physical passion."[60]

Erskine Wood possessed tremendous influence in Portland and convinced two local publications, the *Pacific Monthly* and the Portland *Oregonian*, of their need to cover the McNamara trial and to hire Sara, who had absolutely no journalistic training or experience, as their correspondent. While in Los Angeles, she lived with Mary in a prime part of the city at 1110 Ingraham Street, a block south of Wilshire Boulevard, and borrowed extensively from Mary's work. They were the only two women journalists at the trial. Meanwhile, Darrow leased an entire floor in the Higgins Building downtown to serve as his base during the trial.

Sara felt truly free for the first time in her life. With some pride, she described herself to Mary as a "hungry little mistress," only too eager to dine on the fine sex and high lifestyle offered by Erskine Wood.[61] Left unstated at the time was Sara's transformation from Mary's little sister to an important political figure in her own right. Her lover's support brought out a side of Sara that had been sublimated in her role as a preacher's wife and a mother. Beginning in 1910, she devoted herself to the cause of women's suffrage, canvassing the entire state of Oregon. Newspaper accounts repeatedly remarked on her unusual beauty and the power it gave to her political appeals (see figure 4.4).[62]

The four friends, Darrow, Wood, and the Field sisters, spent as much time as they could together and even escaped to Los Gatos for weekends. They were happy; but Mary began to worry about Sara. Her husband was unlikely to take her repudiation of him and of their marriage with gentle understanding, and

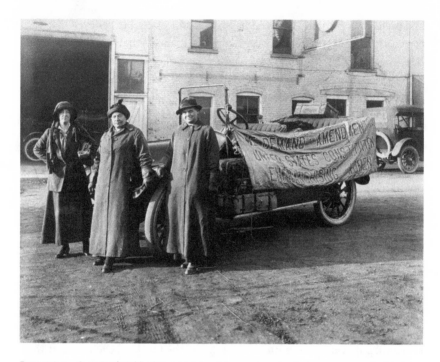

FIGURE 4.4. Sara Bard Field, shown with her driver and mechanic on a cross-country trip to Washington, DC, in 1915 to deliver petitions to President Wilson demanding female suffrage. United States, Washington, DC, 1915. [Sept.–Dec] Photograph. https://www.loc.gov/item /mnwp000424/.

Sara might lose her two young children forever.[63] Regardless of the consequences, Erskine, himself still married, and Sara built a house of their own in Los Gatos, and Sara decided to seek a divorce.[64]

The circle of friends gathered in Los Angeles for the trial offered Mary a chance to meet many of the nation's leading labor organizers. She grew especially close to Anton Johanssen and O. A. Tveitmoe, labor leaders from San Francisco who advocated the use of violence and terror to bring down capitalism. Darrow's journalist friends tried to help the defense counsel put the trial in a broader social context. Fremont Older disclosed both his own sentiments and the popular opinion in Los Angeles in noting, "it is difficult for me to convince any large number of people here that any trial of McNamara that does not bring the great background into the case is not a fair trial." In his report published in the *San Francisco Evening Bulletin*, he wrote:

> To this dispossessed in the rear of the courtroom, McNamara is a perse-
> cuted man, a martyr; Darrow is a hero; the District Attorney is a very
> devil, the judge a monster. Among them are many potential bomb throw-

ers. If the McNamaras' life [sic] goes out on the scaffold at San Quentin, a white flare of hate will develop over the land. It will burn hottest where society's outcasts gather in squalid rooms and make bombs, dreaming of revolution.[65]

Similarly, Lincoln Steffens, though believing the McNamara brothers guilty, became persuaded that the unfair, even criminal, actions of management might well have not only precipitated but also justified the bombing: "I want to assume that organized labor has committed the dynamiting and other crimes charged against it, and raise the question: Why? Why should human beings, as they are, feel so hateful that they want to kill? I have been working [to gain] the consent of the big labor leaders to my making this assumption in print, and then expressing their defense of the criminal."[66]

Whatever the press wrote could not change a simple fact—the McNamaras planted the bomb. Darrow confided to Mary that they were "guilty as hell," and he had "not a shadow of a chance" of acquitting them.[67] This fact made the trial more of a political show than a legal matter. Rejecting the judgment of the AFL, the defense intended to present the use of violence in support of labor organizing as a legitimate response to the figurative violence of the laws and police powers defending property. This defense stopped short of justifying the use of terror to bring down a corrupt regime but certainly leaned in that direction. Across the nation, union sympathizers used the trial to build support for their cause, wearing buttons depicting either the brothers' faces or messages of support. A film about the McNamara brothers, *A Martyr to His Cause*, released at the start of the trial, drew fifty thousand people to theaters in Cincinnati alone in just one week.[68]

During the McNamara trial, Mary began taking regular trips up the coast to San Francisco. Her relationship with Tveitmoe and Johannsen and with Fremont Older from the *Bulletin* had resulted in more labor-oriented assignments, and she consistently produced sympathetically constructed human interest stories promoting working people and union organizing. Darrow encouraged her to move to California to work exclusively in labor organizing, even offering her money to help cover moving expenses. Selfishly, he thought her presence there would facilitate their meeting in Los Gatos. In October 1911, Sara joined Mary and Darrow for dinner and noted that he "seemed tickled to death to have Mary there and she, poor little dear, forgot the past and soaked in the present." Darrow could not stop talking about Mary's success, and really seemed to believe that he "had made Mary." Mary conceded "in a sense . . . that he had."[69]

Unbeknown to Darrow, Mary had a new love interest by late 1911. Because of her regular work in San Francisco, she had rented a room in a boardinghouse

in the Russian Hill neighborhood that was home to artists and writers. There she met an accomplished newspaperman, Lemuel Parton. Thirty-one years old, Lem had worked for the *Chicago Tribune* and the *Los Angeles Herald* after graduating from the University of Colorado. By 1911, he had become a prominent columnist for San Francisco's *Bulletin*. Fremont Older described Parton as "one of the very best feature writers in America." Mary had always considered newspaper writers to be "buglers for the money trust." However, she saw Lem reading Swinburne's poetry and sat down with him to discuss it. She found him erudite, kind, gentle, and compassionate. Lem, too, wrote poetry, which Mary very much appreciated—almost as much as his good looks. Lem was tall, dark-haired, with tender brown eyes and, as Mary recorded in her diary, "has the heart that Darrow hasn't." She meant that Lem was open to monogamy, while Darrow was not. He described her as a "sparkling sloe-eyed lady with a devilish little pagan smile." Mary wrote to Sara of an early date with her new love:

> I want to tell you of a lovely day I had with my friend Lemuel Parton. We started with lunch at that palace of color, Lechau's, then walked along the shore from the Ferry station to Cliff House, watching the men load wheat on great freighters, then down the wharf to the fishermen, on past great houses and under Telegraph Hill where the early settlers used to watch for the boats that came round the Horn with supplies. We reached Cliff House by six o'clock and had a bang-up dinner with the sea splashing at our feet—and then a dance in the evening. It was one series of pictures, one fading into another as on a magic lantern screen.[70]

Lem had lived the life of an adventurer, taking leave from his employment to prospect for gold in Nevada and to explore South America. His rugged masculinity appealed to Mary, but she saw more than that as well. Lem and Mary shared interests in poetry, dancing, and hiking California's foothills and waterfronts. Despite her attraction to Lem, Mary hesitated to commit herself, fighting the feelings growing within her. Marriage would inevitably require compromise, and women's nature, cultural conventions, and the laws all encouraged the greater compromise to come from the wife. Yet Mary could not avoid her love for Lem. To Sara, she admitted that a woman's "purpose is Man. In him—always to all women some man is Man— . . . [he] moves and breathes and has her being. I include myself, damn it!"[71]

Still, Mary was in Los Angeles for much of the fall. The McNamara trial itself seemed interminable at times; jury selection alone took almost two months. Darrow, by the questions he asked on voir dire, signaled to everyone in the courtroom and those following the action through the newspapers his

plan for the defense: "I presume you have heard about the bitter war that is going on in this country between labor and capital?"; "You know that most men have taken sides in that war?" In these early questions, Darrow defined the trial for the jurors. If anyone remained unclear, his opening argument attempted to shift guilt from the terrorists to the industrialists. He claimed that his clients were not "morally guilty." The truly guilty parties, he claimed, were "the men who reached out their hands and taken possession of all the wealth of the world; it is the owners of the great railroad systems; it is the Rockefellers, it is the Morgans, it is the Goulds; it is that paralyzing hand of wealth which has reached out and destroyed all the opportunities of the poor." Listening to Darrow on that day, Mary turned to fellow reporter Edward Hamilton of the *San Francisco Examiner*, a Hearst newspaper, and said, "How many see in this trial a vast historical and sociological significance? How many realize that the wheels of revolution move a little faster today?"[72]

Darrow, through courtroom showmanship, hoped to win support for the union cause and to save his clients' lives. To do so, the show in the courtroom had not only to persuade Americans of the need to fight back against economic domination but also to convince the prosecution that Darrow just might succeed in convincing the jury to release his clients. By Thanksgiving, Darrow succeeded in bringing the prosecution to the settlement table. The McNamara brothers pled guilty to the bombing in exchange for prison sentences rather than death. James B. McNamara pled guilty to murder in the bombing of the Los Angeles Times Building and received a life sentence at San Quentin prison. He died there. Joseph J. McNamara pled guilty to blowing up the Llewellyn Iron Works in Indiana and was sentenced to fifteen years in San Quentin prison. His release came in 1923. Darrow had saved the lives of his clients and made his sociopolitical argument to the national media. But he angered union leaders and many of his more radical friends.

Most union leaders believed that the confessions and sentences harmed their cause. They hoped for acquittal but were willing to sacrifice the McNamaras—to make martyrs of them—in order to generate sympathy for their class struggle. Instead, the public saw unions as no better than bomb-throwing anarchists; to many, the trial confirmed suspicions that unionists and anarchists were one and the same. The AFL became so angry that it stopped payment on its last check to Darrow. Both Debs and Gompers turned on their one-time friend, with Gene Debs telling Darrow that Gene was sorry ever to have placed his confidence in Darrow: "You loved money too well to be trusted by the people."[73]

The sentencing of the McNamaras began a string of successes for the federal government in prosecuting union terrorism. Moreover, the trial and its conclusion constituted a watershed event in shaping public opinion on issues

related to class conflict. For the first time, a majority of the public gained an accurate perception of the national strategy of organized labor to use violence to provoke terror, hoping ultimately to undermine public confidence and trust in law, government, and capitalism. The convictions, and the public attitudes they engendered, prompted radicals to separate themselves from the use of violence. Samuel Gompers pursued an even more conservative course for the AFL, and at its 1912 convention the National Socialist Party rejected violence as a means of securing economic and social reform.[74] Law largely had triumphed over domestic terrorism.

Frustrated, many liberals by the second decade of the twentieth century had lost some confidence in the law. Liberals' cynicism combined with their sense of intellectual and moral superiority to form an attitude among some of them that they were right when all others were wrong. This attitude fostered a willingness to act outside of the law—to pursue vigilante justice. These more radical liberals came to justify or defend violence even if they did not resort to it themselves. Supposedly committed to democracy as an expression of the popular will and the right to self-government, these people undermined the very pillar on which democracy stood—the rule of law and faith in the people to uphold it. Even La Follette came to the conclusion that "the individual criminal is not always to blame; that many crimes grow directly out of the sins and injustices of society."[75] The degree to which Darrow's cynicism toward the law prompted him to consider breaking it to save the lives of the McNamara brothers may never be fully known.

Darrow's problems after the trial arose from his investigation of veniremen: people summoned to the courthouse prior to the trial to be considered as jurors. Lawyers typically researched the backgrounds of these people, and even Mary, acting on behalf of the defense, had met with a few of them. Darrow had brought three investigators with him to help prepare for the trial in Los Angeles. Two of these men had good reputations and credentials. John Harrington had spent years working for railroads in Chicago, and "Captain" Tyrrell had served in the district attorney's office. The third, Bert Franklin, fit the classic stereotype of a private detective, developed decades later in crime stories and movies, as a short, stocky, heavy-drinking, cigar-smoking, mustachioed tough guy. Darrow assigned to Franklin the task of interviewing prospective jurors about their finances, employment, religion, nationality, reading habits, and attitudes regarding labor organizing and class conflict. In his meetings with prospective jurors, Franklin distributed thousands of dollars in attempts to bribe them. The money almost certainly came from one or more union officials, with Gompers most frequently identified as leading the scheme. But the question everyone asked was, What did Darrow know about the plot to buy the jury? The

police arrested Franklin in the act of giving money to a potential juror while Darrow stood some distance down the street, clearly observing the conversation if not the transfer of money. Franklin cut a plea bargain to testify against Darrow, who was indicted for bribery on January 29, 1912. The charges carried a potential sentence of thirty years in prison. Darrow easily paid the $20,000 needed for his bail, but his friends rallied to raise money for his defense. Erskine Wood wrote a substantial check, and Mary contacted people nationwide on Darrow's behalf.[76]

Just before his indictment, on a rainy winter night, Darrow showed up at Mary's apartment dressed in an old coat that sagged over his shoulders. Mary recorded the events of that evening in her journal:

> He slumped down in a wooden chair at the kitchen table, under a bare overhead light hanging on a cord. Then he pulled a bottle of whiskey out of one pocket and put it on the table. I was surprised because I knew Darrow didn't drink, but I brought two glasses and he poured a shot in each. "Mary, I'm going to kill myself," he said. He pulled a revolver out of the other pocket and put it beside the bottle. I asked him why. "They're going to indict me for bribing the McNamara jury," he said. "I can't stand the disgrace." And then, well, he started to cry.

Mary talked him out of suicide, though most likely Darrow simply wanted to share his despair and used the threat of suicide to convey its depths. Mary relied on old religious arguments, unlikely to have had any effect on the lifelong atheist, as well as speaking of her affection for him and his need for bravery and courage, to dissuade him from ending his life. As he departed, he simply said, "Mary, maybe you're right," and he left the half-full bottle and the gun on the table.[77]

The prosecution believed it had sufficient evidence to sustain guilty verdicts for two counts of bribery but, instead of combining the two counts in one trial, opted to try them separately. The first trial, on the bribery of George Lockwood, began on March 15, 1912. The second, concerning Robert Bain, would follow. Many of Darrow's friends considered him to be guilty but really did not care; they supported him regardless. Some of them came to cover the trial; others to lend their support. Mary did both, filing stories for *Organized Labor*, a pro-union newspaper. Mary's early report read as follows:

> Clarence Darrow has finally come to trial . . . The clerk, a white haired man arose. His voice clicked as he read in mechanical tones, "The People against Clarence Darrow . . .
> "The People, the State, against Clarence Darrow."

That phrase rang and rang through my brain like the monotonous beat of a gong. . . . I wondered if that was the form of the indictment in the case of other famous men who broke Society's laws.

Did Pilate read in the judgment halls, "The case of the State against the Carpenter of Nazareth?"

Was it written in the documents, "The State against Socrates?"

The State against Clarence Darrow!

Suddenly, the empty mechanical phrase became to me luminous and real.

The State is against him. The wording of his indictment is exact. In the eyes of the state Clarence S. Darrow has long been an outlaw. . . .

The State was against him in the great railroad strikes . . .

The State was against Clarence Darrow in the anthracite coal strike . . .

The state was against Darrow when he espoused the cause of the outraged miners of Idaho . . .

That is why today there is rejoicing in stock markets, in business offices, in financial circles, in wealthy clubs . . . because men of property, the Lumber Trust, the railroads, the Merchants and manufacturers and now the Steel Trust have indicted Clarence Darrow.[78]

Generally, his friends had little regard for the law and considered it nothing more than a tool in the hands of rich and powerful people. Darrow, they believed, had only tried to balance the scales of justice through bribery. In two different journal entries written during the trial, Mary wrote:

Darrow believed in saving lives. I think that if he thought bribery was the only way to keep these two boys from being killed, he would have felt justified in using it.[79]

Bribing a juror to save a man's life? He wouldn't hesitate . . . If men are so cruel as to break other men's necks, so greedy as to be restrained only by money, then a sensitive man must bribe to save.[80]

Similarly, Lincoln Steffens wrote to his wife: "Well, then, what do I care if he is guilty as hell; what if his friends and attorney turn away ashamed of him and of the soul of man—Good God, I'll look with him, and if it's any comfort, I'll show him my soul as black as his."[81]

When Darrow conducted his own defense, he spoke to the jury of the class conflict dividing the nation as comparable to war. The private armies of industry, he said, are using their wealth "to crush the unions, bribe, cheat, and

spy." Common people, he asserted, are powerless pawns in a game, not of their own making, in which the rules change to fit the whims of the powerful. In such a situation, true justice is chimeral. Mirroring the arguments of the populists more than a decade earlier, Darrow said, "No man is judged rightly by his fellow man. We go here and there, and we think we control our destinies and our lives, but above us and beyond us and around us are unseen hands and unseen forces that move us at their will."[82] Mary cried while listening to Darrow's address and then picked up on his theme in reporting for *Organized Labor*, writing: "Whose justice is it? And as if in answer, I thought I could see on the shoulder of [prosecuting attorney John] Fredericks, the heavy dominant hand of the Lawgiver of Los Angeles, General Otis."[83] St. Louis newspaperman Bill Reedy also defended Darrow in the *Mirror*. He wrote that Darrow perceived "capitalism as a monster devouring the men slain in manufacturing and transportation, as killing them in slow starvation. If he tried to save the McNamaras by fixing the jury, he did it under the conviction that the trial was but a battle . . . and . . . he was only doing what the other side would do."[84]

Mary tried to help by means other than writing or raising money. On the first day of trial, the *Los Angeles Herald* reported that Ruby Darrow walked into the courthouse alongside "Miss Mary Field of San Francisco, who is making her stay in this city and spending most of her time with Mrs. Darrow" (see figure 4.5). How little the press knew or understood! Of course, the women could not even sit together for very long; Ruby sat in the front of the courtroom, and Mary sat in the press section in the rear. Darrow frequently turned to Mary for what she referred to as "the need of physical nearness" of a woman to whom he could also "tell secrets, troubles, joys."[85] Ruby was not that woman; Mary was. But during the trial the tension between the two women grew, and Mary realized that she could not continue to live as she had. After the trial, she would leave Darrow to Ruby.

As much as Mary's antipathy to sharing Darrow with Ruby contributed to the decision to leave him, the trial itself also took its toll. Although, in intellectual abstraction, she and Darrow could blithely discuss the law as a corrupt tool of the ruling class, Mary had real difficulty in accepting her friend's own illegal actions. The law served not only as the basis of national culture but also as an expression of the freedoms Mary enjoyed. Mary respected Darrow as a lawyer, and that respect diminished in light of current events. As the bribery trial began, Sara said of her sister that she was as if "widowed, the widowhood of the living death of all she held dear. Slowly her idol has crumbled into dust before her eyes." Perhaps equally troubling to Mary was that Darrow made sexual overtures to Sara, who not only repudiated them but also shared the details of his approaches with Mary. Yet it was not only Darrow's supposed

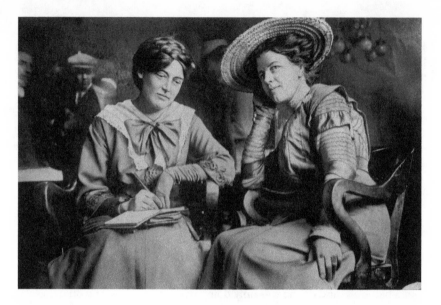

FIGURE 4.5. Mary Field Parton shown with Ruby Darrow at Clarence Darrow's trial for bribery. A downcast, almost sullen Mary resolved, during the trial, to end her sexual relationship with Darrow and "leave him to Ruby." Courtesy of the Chicago History Museum, ICHi-182049.

misdeeds that eroded his stature in Mary's eyes. She continually saw Darrow as unable to stand up to his wife. Mary and Helen Todd spoke of "the curious fear . . . [Darrow had] of Ruby, [and] the power she had to humiliate, to betray." They felt her to be undeserving of him and lacking in intellect, judgment, and emotional understanding. Both members of the free love commune in Los Gatos, they resented Ruby because by threatening to leave her husband if he continued to participate, she exercised an unworthy influence over the man they so respected. When Darrow chose to stay with Ruby, Mary wrote to Sara, "Isn't she awful? It is she—the revelation that she was the woman he loved—that stabbed me to the very quick. And he loves her yet—best of all—I believe. Poor, ignorant, cheap tawdry little creature." Still, Mary doubted her own judgment, preferring to view Darrow as frustrated in his relationship with Ruby but unable to leave her. If true, this frustration and resentment could explain his recent tendency to denigrate women, which only further alienated Mary.[86]

Because the prosecution separated the two charges against him, Darrow faced consecutive trials. He won the first, and the second resulted in a hung jury. As Darrow waited to learn whether there would be a third trial, he wrote a letter to Mary. In it, he presented himself as one of many persecuted liberals or social activists and clearly hoped that she would once again see their com-

mitments, and even their futures, as linked: "We just have to stand things and you are doing more than any of the rest. The further they go now the greater the reaction will be. Suppose they get me—I am not different from all the others who have been persecuted by the world."[87] Shortly thereafter, the prosecutor chose not to retry the Bain case and dismissed the indictment. Mary planned not to attend the victory celebration, writing to Erskine: "I don't want the crowds, the psalms and Hosannas are for the multitudes. When it's all over, I skidoo—Ruby's too much for me. . . . I shall all my life avoid her. . . . I hate to lose Darrow's presence, but I hate more to be out of harmony with my environment." At the last minute, she changed her mind and went.[88] Subsequently, she read and kept all of Darrow's writings defending his actions and seeking support for them; but their relationship had changed.[89] In the next few years, even greater stresses on their friendship prompted Mary to impose a distance that had never existed previously.

CHAPTER 5

Liberalism's Decline during and after the Great War, 1914–1924

The second decade of the twentieth century opened with tremendous hope and enthusiasm for liberal Americans. However, by the close of the decade, Progressivism appeared to be dead, as the United States turned sharply to the right and the always tenuous alliance between liberals of somewhat different orientations fractured under the weight of war and inconsistent policy goals. As if mirroring the divisions among liberals, the friendship between Mary Field and Clarence Darrow experienced its greatest tensions and almost came to an end.

Mary experienced a very stressful few years beginning in 1912. In addition to Darrow's bribery trial, her commuting between Los Angeles and San Francisco, and the tension with Ruby, Mary's sister Alice suffered a nervous breakdown and went into a sanitarium, and their sister Sara contracted "incipient tuberculosis" and also entered a sanitarium. Mary made regular visits to each. The younger sister's lifestyle also continued to worry Mary, and she finally disclosed her concerns to Sara. Now thirty years old and a mother to two children, married to a man she did not love, Sara wanted only to be with Erskine Wood. She led a life completely apart from her husband and family, working on women's suffrage, editing Erskine's poetry, and serving as his companion at social events. Mary recognized how much her own thinking had influenced that of her sister when Sara confided that her affair was not a "selfish thing" but a step in creating a "freer and better" society for her children. Free love would benefit everyone

eventually, Sara contended. Sara's husband, Albert, was not buying any of it and threatened to expose her adultery and take full custody of the children. Mary fretted that public disclosure of adultery and the resultant loss of Sara's children could hurt Sara and counseled her to be patient and cautious.[1] Mary's tensions were hardly eased by voicing her concerns and led her to exhibit behavior more reminiscent of her childhood outbursts than of the restraint she had practiced since then. In October 1912, Mary went to Indianapolis to cover the trial of her new friends, Johannsen and Tveitmoe, accused of blowing up a building. Upset with the judge over the way he handled the admission of evidence and counsel's comments to the jury, she became audibly disrespectful or—in the language of the judge—"sassy." Calling her an "anarchist," the judge had her removed from the courtroom. Once again, she appeared in very unflattering newspaper stories.[2]

Life moved so quickly for Mary in 1912 that she devoted little energy to the presidential campaign that year, despite its national significance. By that time, she had fully repudiated her earlier Republican Party preferences and had become a devoted Democrat. In truth, the differences between the major parties lessened between 1896 and 1912. While the 1896 election could be characterized as a contest between versions of liberalism, the election of 1912 debated versions of Progressivism. Theodore Roosevelt had served nearly two full terms after succeeding McKinley and had instituted significant Progressive reforms. When he left office early in 1909, he felt secure that his successor, William Howard Taft, a friend and fellow Progressive who had made his name as a liberal reformer, would continue his policies. Roosevelt was disappointed, as stylistically and doctrinally Taft shifted to the right. Roosevelt decided to run against Taft as a third-party candidate. By 1912, Roosevelt's "Bull Moose Party" endorsed women's suffrage and a return to more aggressive trust-busting and business regulation. Against Taft and Roosevelt, the Democrats offered Woodrow Wilson.

Wilson's campaign can legitimately be seen as introducing identity politics to the United States, though that term itself was not used.[3] Wilson endorsed the Progressive idea that experts should design government programs to promote jobs, safe working conditions, business growth, and affordable goods and housing. He also encouraged the growth of the public sector as beneficial to efficiency. But, perhaps most significantly, he appealed to interest groups on the basis of class, ethnicity, and religion, an approach both Taft and Roosevelt derided as divisive and un-American. Leading Progressive Robert La Follette responded by castigating Wilson for ignoring the country's celebration of "strong individuality and . . . elemental personal independence of character." La Follette condemned the attribution of identity to group membership, finding the

discipline that it imposed to be a denial not only of individuality but also of democracy. For La Follette, democracy depended on the voices of individuals, not factions or groups designated as valid mouthpieces solely on the basis of shared ethnicity, class, or religion.[4]

Wilson's assertion that certain interest groups required special government attention appealed strongly to Mary's class consciousness and mirrored Darrow's arguments in the McNamara case, in which Darrow implicitly argued for class-based justice rooted in the legal recognition of one group as so disadvantaged and desperate that it must be afforded greater tolerance. Roosevelt addressed this argument directly, speaking out aggressively against labor violence and anarchistic bombings. Claiming that "murder is murder," he refused to accept the argument that economic privation or political isolation justified recourse to violence. He rejected the idea of a subjective class-conscious justice, arguing instead for greater oversight to ensure the proper functioning of an objective legal system. He also promised to remove some corrupt judges who had bent the law to favor corporate interests, complaining of those who "exert their power in protecting those who least need protection and hardly use their power at all in the interest of those who most need protection."[5] Roosevelt hoped for a return to legal objectivity at a time when growing numbers of legal scholars argued that such a thing was impossible.

The campaign fragmented Progressivism into three or four different schools of thought, confusing the voters and damaging the movement. Ultimately, Taft and Roosevelt split traditionally Republican voters and gave the election to Wilson. Following his victory, the new president pursued the most aggressive increase of federal powers in the nation's history, consolidating unprecedented authority in Washington and utilizing new methods of social engineering in pursuit of his political ideals. By the time he left office, the idea of social democracy, nonexistent only a few years earlier, had taken over the government and gained intellectual prominence in academic and social circles. Historian Charles Postel asserts that Wilson's election and his two years in office before the Great War constitute the "high water mark of socialist politics in the United States."[6] Incontrovertibly, the United States had come to prioritize social community and experience as the bases for forming truths, giving a temporary victory to thinkers such as Cooley, Dewey, and James.[7]

Wilson's election buoyed Mary's spirits, and by early 1913 she felt able to enjoy her time with Lem and her old friends. She hosted a dinner party attended by Steffens, Older, Johannsen, Fay Lewis, and Darrow and featuring, in Mary's words, "red wine, beef stew, and cigarettes." Social and political changes had not changed the topics of conversation so much as they altered the participants' moods. Mary and Lem noted that "here was a group of people

all in tune like some fine violins—all the tuning had been done before we met—
maybe years and years had been taken in just tuning up—and then we met!
And the result was harmony on this theme: humanity."[8]

Prior to that dinner party, Mary and Clarence had seen little of each other for
many months, but on March 13, 1913, the two old friends met once again as they
were honored together by organized labor at a soiree in Los Angeles. Hundreds
of people showed their respect for Darrow, the crusading attorney, and Mary,
who had become arguably the leading labor writer of her day. The evening ener-
gized Darrow, and he spoke enthusiastically of a more aggressive campaign by
labor to secure economic justice.[9] In April, Sara wrote to Erskine of her sister's
continuing infatuation with Darrow: "I have found out beyond a doubt that the
one real supreme passion of Mary's life is Mr. D. She still bows at that shrine of
love and yet contemplates matrimony [to Lem]. If D. was half worthy of Mary
he could make her happy without her being forced to [go to] another man for
companionship and to escape the horror of a lonely old age." One week later, in
another letter to Erskine, she added, "Mary would be content as 'his intellectual
food and his loving mistress' if Darrow was not 'running after those disgustingly
brainless women all the time.'"[10]

In June of that year, Mary married Lem Parton in Napa, California, before
the justice of the peace. Years later, her daughter Margaret could write of her
mother that "she loved Clarence Darrow all her life, yet she enjoyed a supremely
happy marriage to someone else for almost thirty years." Darrow offered sup-
port when he heard the news, telling Mary that she made a good choice but
should be vigilant in making sure that marriage did not create "a life of domes-
ticity." He wrote, "I am so glad that Lem doesn't want marriage like death to end
all, for I know you can do wonderful things, he and all of us will be proud of."[11]

Mary took a new position in San Francisco working for Fremont Older's
Bulletin, writing the same kind of stories that she had for the Delineator. She
used her new forum to assert her defense of individual freedoms, focusing on
civil rights and Prohibition as well as labor and class issues. Darrow encour-
aged her to expand her horizons even further. In June 1913, he praised her writ-
ing and suggested she continue to publish in East Coast magazines. A few
months later, he stated very directly that he wanted her to write a book and
"to begin it now." In January 1914, he wrote to her, "you must write my biog-
raphy," though he seemed more interested in documenting his life than in en-
hancing hers: "You know I don't think anyone ever would have heard of
Johnston except for Boswell."[12]

Though his influence in Mary's life had declined, Darrow continued to ad-
vise her not only on career choices but also on her reading materials. He

wrote encouraging her to read *Beyond Good and Evil*, stating that Friedrich Nietzsche "is influencing me greatly, influencing me against the rabbel [sic] with its cruelty, its littleness, its prejudices, its hatred, its stupidity."[13] Both Nietzsche and Voltaire, another author Darrow recommended to Mary, espoused individualistic rather than communitarian doctrines but showed disdain for the thinking of common people, especially regarding their docile acceptance of religion and culturally imposed values. Nietzsche encouraged exceptional people to aspire to greatness by developing their own moral judgments. Accepting, somewhat like the pragmatists, that social truths are subjective creations, he hoped that the strongest and brightest of people would cease to be governed by the rules appropriate for the masses and find their true identities and purposes in asserting new values and truths.[14] Voltaire endorsed the Enlightenment era's rejection of religion in preference for humanity's natural reason and freedoms but stopped short of a full embrace of democracy, believing that enlightened rulers such as Frederick and Catherine were better able both to protect rights and secure a well-governed state.[15] Mary, never one to respect the thinking of the masses, though always ready to defend both their rights and interests, appreciated these contributions to her developing political worldview. Her own Christianity, ever-present in her speaking and writing, tempered her enthusiasm for the atheistic elitism espoused by Nietzsche and Voltaire. She believed that any force that could legitimately overcome popular democratic expression would have to be rooted in Christian morality.

Still, Mary loved Darrow. When he visited San Francisco on a speaking tour to reburnish his image, he traveled up to Portland, Oregon, to see her, and they dined at the Oregon Grill, where Sara watched her sister "as one might watch a scene on the stage, Mary's wonderful love at work for the man she has given her soul to." By now herself a very well-respected figure in labor circles, Mary promoted Darrow's speech in Portland among journalists, union leaders, and liberal activists. As a result, he spoke to a large audience and felt a new sense of optimism. Later, during his speaking tour, he reported to Mary, "I'm glad the labor people are my friends again. I think they are beginning to understand. Of course, I don't care about all this clapping for me. That can change overnight. But, I do care that people clap for what I say, for it shows that Labor is waking up, and once labor wakes up, even I don't know where it will stop."[16]

So much of Darrow's thought was based on emotion more than reason, rendering the man frustratingly inconsistent, even mercurial. Reinhold Niebuhr, a progenitor of neoorthodox Christianity with strong leanings toward Christian socialism, heard Darrow's "Industrial Conspiracy" oration in Detroit. Niebuhr commented that Darrow made those in attendance "writhe as he pictured the injustices and immoralities of our present industrial system. [However], the tre-

mendous effect of his powerful address was partially offset by the bitterness. . . . I suppose it is difficult to escape bitterness when you have the eyes to see and the heart to feel what others are too blind or callous to notice."[17]

By the end of 1914, Darrow's practice and public profile had to a great extent returned. Mary was happy for him, but growing tired of his need for attention and the inconsistency between what he professed and how he lived. Still upset with Darrow's willingness to cater to Ruby's wishes, Mary wrote in her journal after hearing him speak one night, "tonight Darrow speaks of that of which he has no knowledge: personal freedom."[18] Mary could not help but be troubled by the changes in Darrow's attitudes, particularly regarding women. Once a champion of women in the law, he shocked some of his old friends by his address to the Women's Law League in 1913. After telling the women in attendance that they lacked the intelligence of men, he said they could "never expect the fees that men get." Instead of pursuing lucrative practices in large or prestigious firms, they should devote their energies to helping the poor. "You won't make a living at it," he continued, "but it's worthwhile and you'll have no competition."[19] He expressed similarly condescending sentiments in his defense of Emma Simpson, a jealous woman who killed her husband in the courtroom during divorce proceedings. Acknowledging her guilt but hoping to save her from hanging, he told the all-male jury: "You've been asked to treat a man and woman the same—but you can't. No manly man can."[20] During this same time, Darrow joined the Biology Club, an association of forty Chicago-area professors, lawyers, doctors, and businessmen, who met to hear and discuss lectures on science, history, and politics. The club excluded women from attending any meeting, for their presence "would only distract from the seriousness of the evening."[21]

Perhaps sensing Mary pulling away from him, Darrow overtly referenced their similarities in his letters to her, often pitting the two of them against the world. Darrow consistently maintained a contempt for people lacking his degree of erudition and social judgment. He increasingly, in fact, seems to have divided the world between people like himself and all others. His letters to Mary while on his speaking tour evince a new use of the pronoun "us" to distinguish educated and thoughtful liberals from the poor unfortunates who lacked those qualities. From New York, he shared with Mary that he had "found a fine crowd. There are more of us there than anywhere else." In the same letter, he encouraged Mary to read more of H. L. Mencken and Havelock Ellis, fellow liberals with academic and literary sensibilities.[22] From Kansas he wrote: "How stupid they all are. And yet always come some enquiring young men and women looking for light . . . and what is the use of it all."[23] He acknowledged that his current readings only exacerbated his elitist tendencies,

writing that "Nietzsche is . . . influencing me against the rabble, with its cru-
elty, its littleness, its prejudices, its hatred, its stupidity."[24] Darrow's pessimism
could be overwhelming, as when he wrote to Mary that he found himself "al-
ternately laughing and crying about the world and knew it will never be any
different."[25]

Darrow's increasing cynicism and rationalization unnerved Mary. He knew
of her religious beliefs but pilloried religion; he knew of her commitment to
social change but dismissed proposed answers as delusional. In one letter to
her he contrasted himself with more committed socialists or anarchists, not-
ing that their ideologies could blind them to realities. When facts did not sup-
port their theories, they disregarded the facts; Darrow, conversely, modified
his theories. In the same letter, he noted the various means by which people try
to escape from the truth: "Human nature has not changed since man came
upon the earth," he wrote. People try to ignore this basic fact as well as other
inconvenient truths. Some use religion to do so, others drugs or whiskey, but "it
is all dope."[26] In an address before President Wilson's Commission on Industrial
Relations in 1914, Darrow argued, "The righteous man suffers the same as the
unrighteous. The good is crucified as often as the evil, and evil triumphs as of-
ten as good." Later that same year, in a lecture before the Society of Rational-
ism in Chicago, he extended the breadth of his disillusion beyond law to
philosophy, asserting that "all the theories have fallen down—religion, social-
ism, trade-unionism, capitalism, education—every thing has been swept away."
He confided to Mary, "I wonder what I really do believe, anyhow."[27] She had
been wondering the same thing, and the gap between them grew.

Apart from her fervent desire to help the unfortunate, Mary's aversion to
war constituted her greatest political concern in the second decade of the
century. Her cosmopolitan sensibilities, premised upon both a cultural rela-
tivism and a rejection of nationalism, encouraged her to endorse international
cooperation and to promote free human interaction across cultures and bound-
aries. Her support for President Wilson evaporated as he moved Americans
toward war.

Mary was hardly alone in these sentiments. The country's experiences in
the Great War forced a reconsideration of liberal ideals and fragmented Pro-
gressivism. Humanity had never experienced such prolonged horrors on so
great a scale. Most of the world went to war in 1914, but the United States
remained officially neutral until 1917. President Wilson's actions during that
period of official neutrality have proven hard to understand. He discriminated
against Germany by allowing Britain to intercept US shipping to Europe while
simultaneously refusing to respect the German blockade of Britain. He pro-
moted sales of food and domestic products to the Allies at high prices, raising

prices at home by reducing domestic supplies. He granted government contracts to arms makers prior to any declaration of war. He encouraged corporate investments in Allied nations while discouraging them in Germany and Austria-Hungary. He prevented the people from voting in a national referendum on the war. He put munitions on merchant ships, prompting German attack, but lied about it to the people of the United States. All the while, he professed to desire neutrality.

Most Americans did not want to go to war. They held divided sympathies and openly debated on which side the country would enter if it were to do so. Prior to the entry of the United States into the war, most of the nation's people found the war inexplicable and pointless. The *New York Times* wrote, "The nations of Europe have reverted to the condition of savage tribes roaming the forests and falling upon each other in a fury of blood and carnage to achieve [nothing other than] the ambitious designs of chieftains clad in skins and drunk with mead."[28]

For people living at the time, the causes of the war were as difficult to grasp as they have proven to be for historians. The United States had no treaty obligations with either Germany, Italy, and Austria-Hungary, on the one side, or England, France, and Russia, on the other. Culturally, Americans felt very close to Britain, Germany, and France; accordingly, loyalties extended to belligerents on both sides. However, the United States had tremendous economic ties to England and France and less important relations with Germany and Austria-Hungary.[29] Still, in 1914, United States businesses conducted $169 million in trade with Germany and Austria. After the 1916 election, Wilson presented the war as a clear-cut struggle between the forces of freedom and those of totalitarianism. Of course, at the time, Russia, one of the Allies, was ruled by a czar, and Germany and Austria-Hungary each had representative assemblies. Yet the president told Americans that it should prove to be their "glory to shed human blood, if it be necessary so that all the common compacts of liberty may be sealed with the blood of free men." As Wilson went to Congress on April 2, 1917, for a declaration of war, he said that "the world must be made safe for democracy."[30]

Despite Wilson's assertions, many Americans saw the United States' entry into the war as rooted in imperialist desires, conceptions of racial and religious superiority, and the president's own Progressive agenda. The decision to enter the war divided liberals and drove a dagger into the heart of the Progressive movement. Many liberals had tacitly supported Germany, which they saw as a progressive republic, given its modern social welfare system and cultural valuation of intellectual research and dialogue. Great Britain and Russia they conversely viewed as monarchistic, aristocratic, and financially corrupt. It was

not that these liberals wanted to enter the war on the side of Germany; they did not want to enter it at all, but especially not to help Great Britain and Russia. Liberalism had, since the age of Enlightenment, rested on a cosmopolitan sense of human interdependence. Natural rights, free trade, and open discussions of ideas knew no boundaries and respected no loyalties. People might legitimately go to war but only to protect certain ideas, principles, and fundamental rights. The Great War seemed to embody none of these. Eugene Debs and Jane Addams both condemned Wilson's decision. For decades, socialist leaders in Europe and the United States had expressed an "international solidarity" among workers. However, by 1914, German socialists fought French and English socialists for nothing more than national vanity and ethnic pride.

Mary and Sara worked together in opposing the war, with Sara taking the leadership role for the first time in their relationship. Darrow stood nearly alone in endorsing it and appeared to his friends and fellow liberals to have betrayed his liberal ideals.[31] Liberals could more easily disagree on matters of policy than they could on the ideal of human brotherhood. Many of his friends felt more disappointment over his support of the war than when he faced the accusations of bribery. Mary wrote to Sara that his "bathing in the muddy waters of patriotism" shocked and disappointed her. Darrow wrote to her asking her to come to hear him speak so that she could at least understand his reasoning, but she refused. After the war, he told her that "all through the war, . . . [I] felt most keenly our intellectual separation." Carl Sandburg publicly criticized his old friend in an essay in the *Chicago Daily News*, expressing wonder that a lifelong defender of the right to free speech could endorse an administration committed to eviscerating it.[32] Their differences over the war drove another wedge between Darrow and many of his friends, including the new Mrs. Parton.

World War I ultimately gained surprising support from those liberals who hoped to use it to empower the government to tackle long-standing social problems. Arthur Schlesinger Sr. said: "The times call imperiously for the marshaling of the liberals of the country for the purpose of making the war an instrument for the promotion of social justice and public ownership."[33] Randolph Bourne expressed satisfaction that the war accelerated the placement of social experts in positions of power. John Dewey said the war offered "social possibilities," in that it would defeat "the individualistic tradition" in the United States and replace it with a recognition of "the supremacy of public need over private possessions." Dewey proved quite prophetic in these comments, and they may help to explain Wilson's own actions.[34] Many radicals became further excited as the Bolsheviks gained power in Russia and installed a communist regime.

Wilson wasted almost no time in capitalizing on the additional powers granted the president during wartime to centralize power in Washington and initiate his aggressive domestic agenda. His actions prior to the nation's entry into war indicated his direction. In 1913 his administration secured the first progressive income tax, and the next year he created the Federal Reserve Board to regulate banking and the money supply, exempted labor unions from antitrust laws, and created racially segregated lunchrooms and bathrooms in all buildings housing federal employees. As the country went to war, the president successfully moved Congress to pass the Espionage Act of 1917 and the Sedition Act of 1918, providing the federal government with the power to censor magazines and mail and to punish "disloyal, profane, scurrilous, or abusive language" directed at the government, the Constitution, or the flag. Within a matter of months, Wilson's attorney general, A. Mitchell Palmer, and his assistant, J. Edgar Hoover, had arrested sixteen thousand people under these laws, including Emma Goldman and Eugene Debs. The administration utilized the services of over 250,000 men and women in the America Protective League to open mail and bug telephones. In early 1918, Wilson created a propaganda department within the federal government, called the Committee on Public Information, to foster support for the war and a hatred of Germany. The department creatively described the war as "a crusade not merely to re-win the tomb of Christ, but to bring back to earth the role of right, the peace, goodwill to men and gentleness he taught."[35]

Throughout the Midwest, nearly every major newspaper had supported Germany prior to the United States' entry into the war. After 1918, the editorials ceased, as government censorship had done its job. Darrow noted that "almost every German in America was regarded with suspicion, even when members of their families were fighting with the allies."[36] By the end of the year, Darrow had turned on Wilson. After the "Palmer Raids" in which the government entered private homes in fifteen cities looking for communists, dissenters to the war, and anarchists, Darrow came to believe that the president had "brought an era of tyranny, brutality, and despotism that . . . undermined the foundations upon which our republic was laid." In a speech in Chicago, Darrow quoted Thomas Jefferson: "Eternal vigilance is the price of liberty." Darrow added that "a strong element of society, under the cry of a sort of super-patriotism, is today doing all that can be done to crush the liberties of the American people."[37] In voicing this opinion, once again he and Mary found common ground, as they both perceived free speech and freedom of conscience to be defining agents of their liberalism. Some individual rights and freedoms, even these liberals, still valued.

Mary and Clarence felt the loneliness of separation during the years after the war. Darrow wrote to Mary, "I am lonely—loneliness all the time." He lacked someone with whom he could share his innermost dreams, thoughts, fears and desires. Certainly, Mary missed her friend, and she continued to worry about Sara's attachment to Erskine Wood.[38] But Mary now had a loving husband and a young daughter who satisfied her emotional needs. She had moved on.

The country appeared ready to embrace change after the war. Progressives, many of whom belonged to the Republican Party, had sought to use government power to secure greater individual rights and opportunities by curtailing business excesses and limiting the concentration of power. They generally had no interest in concentrating greater power in an alliance of business and government to limit freedoms while imposing socialist conceptions of the public good on the people. Progressives shifted to the right during and after the war. Americans repudiated Wilson's policies in the midterm elections of 1918, turning both houses of Congress over to Republicans and foreshadowing a decade of Republican Party dominance in the 1920s.

Many of the country's foremost liberals also became more conservative after the war, expressing a broad-based disillusion with politics. Darrow confided to his longtime friend Fremont Older the belief that "you and I have both overplayed the labor question, placed it clear out of its proportion to all the rest of life. I am for the poor and always shall be but there are other things in life."[39] Herbert Croly noted that, by 1920, liberalism and Progressivism had been pushed aside "as an effective force in American politics." Croly eschewed politics for religion. Likewise, Walter Lippman turned to "naturalistic ethics," and Lincoln Steffens rejected not only politics but even his democratic sensibilities, embracing totalitarianism and Mussolini. Only the most persistent of the social engineers continued to endorse the liberal doctrines of the early 1900s. Men such as John Dewey, Charles Beard, and Thorstein Veblen formed a coterie of liberal-minded intellectuals who would contribute to the refashioning of Progressivism into the New Deal under Franklin Delano Roosevelt.[40]

The country's turn to the right after the war cannot be blamed for Prohibition, which manifested communitarian goals much more than individual rights. Moral reformists pursued Prohibition as a means of limiting family violence, reducing irresponsible spending by the working poor, and returning to an imagined time of Christian community. As a political initiative, Prohibition may well stand as the last gasp of reformist energy. Yet it too destroyed what it sought to preserve—respect for family, law, and traditional values. Prohibition ushered in an era of unprecedented disrespect for law and communal values; fostered an attitude defensive of individual rights and freedoms; and, in

combination with the economic prosperity of the 1920s, encouraged indulgence. Chicago alderman John Coughlin echoed many popular sentiments but broadened the scope of his disgust beyond Prohibition. "Five years ago," he said, "we were a peaceable city. Reformers spoiled it. Those were happy days. Now we're discontented and everybody knows it."[41] Prohibition had seemingly turned control of the city over to bootleggers and organized criminals.

Mary felt "victimized by [the] hysteria" that resulted in Prohibition. She resented all blue laws, noting with disgust that in some states she could not even buy a candy bar on a Sunday. But she seemed blind to the inconsistency in her support for labor legislation to correct what she perceived as moral wrongs in the workplace and her rejection of morality as a basis for Prohibition and sabbath protection laws.[42]

If Wilson's excesses during the Great War constituted the first strike against liberal Progressivism in its turn at bat, Prohibition served as strike two. The third strike came with the communist takeover in Russia and the resultant loss of freedom and property rights in that country. The rise of communism abroad combined with a popular disillusion with foreign affairs after the war to focus US interests on domestic issues. Americans became increasingly fearful of threats to their lifestyles and values and tolerated both an increase in government persecution of radicals and also vigilante actions deemed necessary to protect communities from harm. The Red Scare of 1918–1919 turned many liberals, including Jane Addams and Emma Goldman, into public enemies, damaging their causes and quieting their friends.

The brutality the Soviets used against their own people frightened most Americans. During the early days of communist rule in Russia, Darrow told Mary, "I am getting afraid of everyone who has conviction. I presume when the Soviets get to boss the world, they will snuff out what little freedom is left." He joined the International Committee for Political Prisoners, dedicated to protecting human rights from totalitarian regimes, including those constructed from workers and peasants. Darrow fell out with long-term friend John Reed when the latter started the Communist Labor Party of America; yet Darrow raised First Amendment defenses for communists prosecuted by the government.[43]

The Bolshevik revolution produced a conundrum for liberals and radicals in the United States. The revolution seemed to empower workers but did so at the cost of individual rights and personal opportunities. The revolution clarified long-standing tensions within the new liberal doctrines of the early twentieth century and in doing so prompted many to reject the contemporary versions of liberalism for the old Jeffersonian model. In the inevitable contest between social justice and individual freedom, many liberals, Darrow included, now found freedom too dear to relinquish.

At the same time, the events in Russia seemed to energize more fervid radicals and socialists who saw these events as the start of a worldwide revolution. In April 1919, the New York City post office discovered thirty-six mail bombs addressed to industrial leaders.[44] But the Socialist Party of America lost more support than it gained. Formed in 1901 from the merger of the Social Democratic Party and the Socialist Labor Party, the party had garnered almost a million votes for Eugene Debs, its candidate for president in 1912, and won control of the city government in Milwaukee.[45] By 1920, the party was in shambles, a victim of the country's right turn during the war as much as fear and resentment of Bolshevik violence. In 1925, Debs himself "said that the Socialist Party was 'as near a corpse as a thing can be.'"[46]

Mary, during the war, spoke openly to friends of her distaste for the military effort and confided to her journal her concerns over Wilson's dangerous limitations on Americans' freedoms. Yet, as always, her chief concerns lay in workers' interests. The war provided little help to her and organized labor. The Clayton Act, passed prior to US entry into the war, limited judicial power to intervene in labor disputes, thereby restricting employers' opportunities to seek assistance from the courts in combating organizing activities. More significantly, the Wilson administration created the modern corporate state as a partnership between business and government while it instituted a planned economy managed by experts.[47] Rights and freedoms were subordinated to national concerns for efficiency, productivity, jobs, and national power and prestige. Slowly but surely, Americans reformed their perceptions of their roles in this new society. Viewing society as a great machine, individuals served as cogs within it. Farmers, steelworkers, lawyers, teachers, and myriad others all functioned for the betterment of society under the control of public sector managers. People became identified with the functional economic unit in which they participated. Progressivism had reached a new stage of development that frightened even many ardent Progressives.

Workers had no difficulty in raising their voices and their fists in protest after the war. The unions had acceded to Wilson's demands for labor peace during the war but immediately afterward erupted in angrily asserting new demands. Twenty-one percent of the nation's workers struck in 1919. At the same time, returning veterans faced unemployment, and employers asked why, with a surplus of available labor, they should have to increase wages and improve accoutrements. The economic argument made little headway against workers who saw themselves in the midst of class warfare.

The new administration only fueled their anger. Republican president Calvin Coolidge famously said, "The man who builds a factory builds a temple; the man who works there, worships there." During the 1920s, Republicans

overturned much Progressive legislation and stripped the vigor from what was left. Prioritizing efficiency, government worked with businesses to avoid anti-trust actions and mergers, and consolidations increased once again.[48]

Surprisingly, Congress, under Republican Party leadership became more aggressive in assisting organized labor in the 1920s and early 1930s. The Railway Labor Act of 1926 protected railroad industry employees' rights to choose bargaining representatives and created a duty on each side in any labor dispute to submit to federal arbitration. In 1932, the Norris–La Guardia Act protected unions' abilities to strike and protest against employers by imposing further limits on courts' powers to enjoin organized labor activities.[49]

The reliance on efficiency and expertise may be the most long-lasting of Progressive reforms, as even the conservatives in power in the 1920s endorsed regulation developed by policy experts to serve public interests. The Commerce Department, the Interstate Commerce Commission, and the Bureau of Standards centralized business oversight in Washington and encouraged efficiency in production and distribution. Progressive legislation that relied on identity markers did not fare as well. The Supreme Court nullified laws prohibiting child labor, setting minimum wages for women, and granting antitrust exemptions for unions and farm cooperatives.[50] These laws violated the contract clause of the Constitution prohibiting government interference with private contract rights or expressed a government favoritism of certain groups that violated the equal protection clause.

Darrow and Mrs. Parton lived separate lives during and after the war, as they were busy with their own concerns. Their opposing views of the country's entry into the conflict created some distance—much as Darrow's trial and his near repudiation of female equality had—but nothing of a long-standing nature. By 1916, Mary's daughter Margaret required a great deal of her attention. At times, Mary seems to have resented the time commitment the child required. A letter to Mary's youngest sister, Marion, complains of the duties and demands of motherhood but concludes, ". . . hell, I made the kid so I guess it's up to me to raise it."[51] Still, Margaret hardly impaired her mother's ability to socialize, and Mary pretty much lived a lifestyle comporting with membership in twentieth-century salon society. During these years she enjoyed dinners with Charlie Chaplin and Carl Sandburg; discussions with university professors and writers on the meaning of justice; and social events at the finest hotels, clubs, and restaurants. Still flirtatious, she took great pride in being asked to dance by a handsome gentleman at one of these functions. He "pick[ed] me out—unerringly the prettiest girl," she writes, "who was, I am glad to note, the most intelligent looking too."[52]

Family matters generally assumed only a secondary importance to Mary. When her father died on January 4, 1916, Mary failed to mention the event in any of her journals, letter, or diaries. Her only truly significant family relationship was with Sara.

Mary helped Sara through a difficult divorce in 1914 and then through a family tragedy that prompted Mary to reconsider, at least momentarily, her values and influence on those she loved. In the fall of 1918, while Sara was driving to visit Erskine, her car went off a cliff road in California. The accident killed her son. Sara survived but suffered severe injuries. Reverend Ehrgott, now her former husband, wrote a letter to her in which he blamed Clarence Darrow, and by implication Mary, for the death:

> That which is overtaking you is retribution, . . . a vindication of those fundamental truths you so ruthlessly cast aside. You remember that day when two happy children were digging together in our garden back of our splendid new home, suddenly a shadow fell over us—it was Clarence Darrow. That fatefull night he introduced us to CES Wood. But for your infatuation for CES Wood and his scandalous conduct toward you . . . Albert [Jr.] would be with us still, abounding with life to his very finger tips. He is sacrificed on the altar of Anarchy, Atheism, and Free Love.[53]

Mary had to reconcile conflicting beliefs and emotions in dealing with the tragedy. A Christian who quoted regularly from the Bible even in the company of atheists and freethinkers, she knew that her introduction of Sara to free love had ended her marriage and caused pain to her children—even if it did not cause young Albert's death. Mary loved her sister and her nephew and felt great sorrow over the accident. She wondered whether anyone, even a sister, should try to counsel another regarding values and major decisions. Yet Mary ultimately realized that the accident was not her fault. She firmly believed in each individual's freedom to make life choices and pursue happiness and had only offered opportunities for her sister to do so. Sara was happier with Erskine than she ever could have been with her former husband. Mary had to find comfort in that fact and move on.[54]

The tensions Mary felt over her role in Sara's life express the ironies and inconsistencies of a progressive, even revolutionary, young woman raised in a devoutly Christian home in the United States of the Victorian era, who came of age in an era of great social upheaval and cultural transition. Mary's life embodied contradiction. She advocated free love, became devoted to Margaret Sanger's causes, swore and smoked cigarettes, and served bathtub gin during Prohibition; but she found the suffrage movement to be silly and once

married became a devoted wife and mother. She was called an anarchist by newspaper writers and a judge and was thrown out of a courtroom; yet she loved white lace, floral decorations, and dressing in stylish and expensive clothes. Her daughter writes of Mary that she "spent a large part of her life taking pot-shots at pretense,"[55] and still she reveled in sharing the company of famous movie stars, writers, and thought leaders. She was a socially prominent nonconformist who really did have the best of two worlds—enjoying a privileged life featuring luxurious homes, clothing, and parties while encouraging workers to reject law, cultural values, and capitalism, through the use of violence and intimidation if necessary, to achieve her idea of social justice.

She found that the United States, seemingly as conservative as ever, had changed little in twenty years. In many ways, the 1920s mirrored the trauma Americans experienced at the turn of the century. By the dawn of the decade, the focus of economic, moral, and political culture in the country had shifted from a local orientation to a national one. The homogenization of the culture produced tremendous strains on people who saw their traditional lives being replaced in a national embrace of predictability and functionalism. Expanded immigration, a national move to urbanization, and the move to economic imperialism only added to popular fears. The emergence of a national society was fostered by and expressed through national publications and by catalogues such as those distributed by Sears, Roebuck and Montgomery Ward, which shaped national tastes, values, and aspirations; the coast-to-coast availability of certain products; the rise of baseball as a national pastime with star players as recognizable in Chicago as in New York; and the creation of professional societies establishing nationwide norms and standards in law, medicine, architecture, and business. The national culture supplanted people's traditional dependence on local communities as the basis for tastes and aspirations, consumer goods, celebrity status, and business norms, not to mention cultural values and morals. The new culture substituted anonymity for personal relationships, formality for informality, and a respect for privacy for communalism.[56] Millions of rural people, especially in the South and the West, resented this change, feared its effects, and marshaled their political energies to resist it. The rapid social change of the 1920s brought with it a common reaction: a conservative defense of tradition and perceived "American values." Simultaneously, the Great Migration of African Americans to northern urban cities and an influx of darker-skinned immigrants provoked a reassertion of White supremacy through the Ku Klux Klan and the National Origins Act. And in response to challenges to traditional sex roles, scientific professionalism, and the loss of communal norms, many Americans adopted more conservative expressions of religion.

Hoping to enjoy life after some tumultuous years, Mary turned to the company of her friends and family to find meaning and enjoyment. Erskine and Sara joined Mary and Lem in celebrating Lem's birthday on October 3, 1924; but Mary resented Erskine's domination of the event. He spent the "entire evening" reading aloud from "a booklet against the Catholic Church. Thus do the strong impose their wills upon the unprotesting." The next morning, apparently feeling no sympathy for Christianity, much less Catholicism, Mary noted the beautiful and "rare golden haze envelop[ing] the earth. . . . Pomona and Ceres are our Gods—rich, fruitful Gods crowned with fruits and grains and grape leaves. No pale ascetic Christ, with thorns for a crown."[57] Romantic metaphors came easily to Mary during these years. She continued to feel loved by and loving toward Lem, and their marriage flourished in New York. In August 1924, feeling like Penelope awaiting the return of Odysseus, she wrote: "It is dark when Lem comes in. The lamps are lighted and the coffee ready. Hence is the sailor home from the sea and the hunter from Murray Hill."[58]

CHAPTER 6

A Rights Revival in the Roaring Twenties, 1924–1929

The political shift to the right during the 1920s expressed widespread dissatisfaction with the subordination of individual rights and liberties to communitarian goals. Many long-standing liberals, always conflicted in their devotion both to libertarian defenses of individual freedoms and to social planning, jettisoned the latter for the former. Mary and Clarence Darrow also keenly felt the tension in their earlier worldviews and shifted, somewhat uncomfortably, toward a greater embrace of individual rights. Darrow's advocacy of libertarian causes in prominent court cases encouraged him to take greater steps away from social planning than Mary was comfortable taking, but both experienced some disillusion with old causes and friends.

Not surprisingly, it took a new direction in Mary's career to reconnect her with Darrow. By the mid-1920s, Mary had undertaken to write a book, something her mentor had long encouraged her to do. Darrow had introduced Mary to Mary Harris "Mother" Jones in Chicago before the start of the Great War. At that time, Jones was a well-known labor leader, appreciated both for her tender care of strikers' families and her advocacy of uncompromising positions on labor's behalf. Mary decided to write Mother Jones's biography.

On a particularly cold winter day in Chicago, still relatively early in their relationship, Darrow told Mary that he had "kind of noticed that [Mother Jones's] coat looked horrid. [And] of course, she's kind of old." Adding that she lacked the kind of looks necessary to attract a man who might buy a coat

for her, he reached into his pocket and peeled some money off of a "big wad of bills" and told Mary to buy a coat for Mother Jones. With the money Darrow had given Mary, she purchased an entire winter wardrobe, down to the woolen underwear, for the labor leader.[1] From that day of shopping, Mary and Mother Jones developed a mutual respect and affection that continued until the latter's death (see figure 6.1).

In 1914, Mary traveled to the Pennsylvania coal fields to write about the lives of the miners and their families. Mother Jones was there at the same time and shared with Mary stories describing the conditions of the mines and her work with the miners. Mary kept extensive notes from these conversations and developed a real friendship with Mother Jones.[2] When, in 1915, the labor leader heard of Mary's marriage to Lem, Jones wrote an emotional letter of support.[3]

Mary's biography of Mother Jones had Darrow's full attention. Showing both his love for Mary and his arrogance, he expressed support and condescension simultaneously. In September 1922, he wrote: "I am anxious to see your book. I know you can write. If you don't get a publisher, let me try. . . . No one can write better and I do hope you will keep at it. I feel sure you will make a great hit."[4] Publishing turned out to be the least of Mary's concerns. In January 1925, she felt herself nearly finished with the manuscript, even indulging in a discussion of the work over lunches with other women. But, in March of that year, her maid, thinking the papers to be garbage, threw the manuscript into the fire. Mary expressed her anger toward her employee in a broad condemnation of poor, ignorant laborers:

> Discover the poor woman who works for me has burned my manuscript. That is the Mother Jones original. It may be that "children are from the kingdom of Heaven," but "morons are from the kingdom of Earth." She is typical. She is humanity. Humanity burning up the precious work of the great martyrs. Stupid "didn't thinkers." They can't think. They have nothing to think with. Lucky for them when they get a job, a government, a dictatorship for the proletariat like Russia! Dictatorship they need, but not the dictatorship of capital. "For" and not "of" is their need.[5]

Mary was understandably upset when she penned that diary entry. Nonetheless, she expresses a relatively clear political view in this passage that mirrors the thought of many other of her liberal intellectual contemporaries. She believes that the poor uneducated masses need the guidance and aid of more capable people, such as herself, whom she considers martyrs, not only in their

dedication to expanding human knowledge but also to the cause of caring for the less able. This social prescription carries with it a political component. As the less able are incapable of governing themselves in a democracy, a benign dictatorship of dedicated kind-hearted individuals must provide for them.

Amazingly, working from notes and her memory of the earlier formulation, Mary reconstructed the book within a month. She shared the draft with Darrow in asking him to write the introduction. He expressed delight in both the text and the invitation and requested once again that she make his biography her next project.

However, the fissures in the worldviews of the author and the writer of the introduction could not be hidden. Darrow's shift toward libertarianism and away from communitarianism is evident in his introduction. His writing clearly endorses the United States' long-standing devotion to individualism, while only hinting at the tensions this devotion precipitated among liberals working for a more benevolent communitarian state. He praises Mother Jones as an "individualist," which is not quite the same as an endorsement of individualism but recognizes many of the same qualities in Darrow's use of the term. His words seem capable of applying to himself as well as they do to his subject. He writes that "the real leaders of any cause are necessarily individualists and are often impatient of others who likewise must go in their own way." He adds, in an amazing disregard of her lifelong devotion to organized labor, that "Mother Jones was always doubtful of the good of organized institutions. These require compromises and she could not compromise."[6]

Mary wrote the book as an autobiography of her subject, utilizing the first-person pronoun throughout the text. Mary's goal, consistent with that embodied in her earlier magazine and journal articles, was to bring the reader closer to her subject, building an emotional connection unimpaired by the interjection of a third party. Relying on emotionally compelling stories of the suffering of workers, the cruelty of industrialists, and government's corrupt complicity in the latter's cause, Mary hoped to engender compassion, moral outrage, and a hunger for societal change. She depended more on feelings than on reason—on a devotion to humanity over any to law. She utilized the pragmatists' formula for constructing truth. In doing so, she left out the uncomfortable conclusions she expressed just a month before completing her manuscript, that the "moronic" members of the working class are utterly dependent upon the benevolent care and leadership of a well-intentioned elite.

The book develops a Marxist class-driven model of the United States from 1880 to 1925. At the outset, Mother Jones describes her early days working in Chicago and what it taught her about the attitudes of the rich:

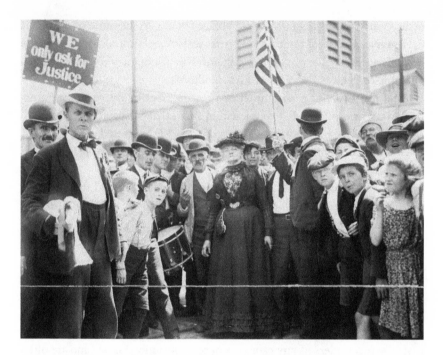

FIGURE 6.1. Mother Jones leads her "army" of striking textile workers out of Philadelphia on a march to gain public support for their cause in 1903. Courtesy of the Library of Congress. Peirce & Jones, photographers, 906 Walnut Street, Philadelphia. Pennsylvania Philadelphia, 1903. [New York: New York World-Telegram & Sun] Photograph. https://www.loc.gov/item /2015649893/.

I returned to Chicago and went again into the dressmaking business with a partner. We located on Washington Street near the lake. We worked for the aristocrats of Chicago, and I had ample opportunity to observe the luxury and extravagance of their lives. Often while sewing for the lords and barons who lived in magnificent houses on the Lake Shore Drive, I would look out of the plate glass windows and see the poor, shivering wretches, jobless and hungry, walking along the frozen lake front. The contrast of their condition with that of the tropical comfort of the people for whom I sewed was painful to me. My employers seemed neither to notice nor to care.[7]

Mary relies on social statistics and accounts of labor history in the United States to support the anecdotal stories that constitute the bulk of the text. She explains that the cotton and silk mills in 1900, in the states of the old Confederacy, employed girls, mostly Black, 25 percent of whom were under fourteen years old, working ten-hour days for small wages. She laments the arduous

conditions of their labor, their lack of education, and the perpetuation of a lower-class existence that the mills fostered. She extrapolates from that example to conclude that organized labor was necessary to redress the workplace injustices that were creating social problems. But law served the interests of the employers, rebutting the attempts by union organizers to bring justice to factory laborers. Speaking as Mother Jones, Mary writes, "I . . . know that there are no limits to which the powers of privilege will not go to keep the workers in slavery."[8] To combat the use of the law to protect the property interests of owners, Mother Jones turned to violence and intimidation, directed both at employees who rejected organization and at the industrialists themselves. Mary recounts how Mother Jones organized strikers' wives and daughters to beat, with whips, brooms, or tree branches—anything at their disposal—the workers who crossed picket lines, knowing that the men would not likely retaliate against the women and, if they did, the press attention would only benefit their cause. Mary proudly describes the workers who succeeded in crossing the line to enter the factory as looking "as if they had been sleeping in the tiger cats' cage at the zoo," so lacerated, bruised, and scratched were they. Mary expresses resentment at the use of police troops to protect the workers she derisively refers to as scabs.[9]

It is difficult, if not impossible, to reconcile the class-based communitarianism espoused in Mary's text with Darrow's celebration of individualists committed to pursuing their own course and refusing to compromise with others. Was not the "scab" acting on his own judgment, determining his own course, and refusing to compromise with the majority of his peers that attempted to dictate when and on what terms he was to labor? Mother Jones, Mary Field Parton, and Clarence Darrow showed no respect for the rights, judgments, or interests of such a man—they preferred that he be beaten by women against whom no "real man" would strike back. The three were willing to compel his conformity; demand his submission; and teach him, at the end of a stick if necessary, to value communitarian duties over individual rights. None of them, apparently, had any difficulty in coming to these conclusions.

Mary's scathing attacks on the maid who burned her manuscript were not unusual. Her relationships with her servants, her condescension toward the masses, and her attitude toward saleswomen all portray a woman who, while working to gain political support for the underprivileged, had absolutely no respect for them. Apparently lacking even Darrow's theoretical affection, or love, for them, she acted toward them as if they were pawns to be manipulated in a great political chess game to reallocate power in society. While Mary wrote extensively of the hardships, loves, and personal aspirations of striking

laborers, her attitudes toward her own household laborers express little if any affection for or personal support of them, neither while she wrote the book nor immediately afterward. She went through maids quite quickly and developed no personal relationships with any of them. In 1923, she writes of one maid, a Japanese immigrant: "English is so lacking [that it is] unspeakable. A Japanese moron is so much worse than an American moron—so it seems. There's the racial barrier; there's the mental—one understands sadism with its emotions swinging between pity and brutality. Shall I choke her when she does her damnedest, stupidest thing in the world, like blowing her nose in the dish towel[?]"[10] Three years later Mary hires another nameless houseworker: "New maid comes. Like the rising and setting stars . . . such is the twinkling and disappearing of maids." Three days after this journal entry, Mary writes in support of the cause of strikers in Paterson, New Jersey, which she proudly notes was "led by a Harvard graduate."[11]

Mary hardly restricted her snobbery to domestic servants or higher educational institutions. In 1927, she wrote of consecutive meals outside of the home, one in the Lafayette, a very nice restaurant, and the other in the automat with her children. She noted that the little ones were able to enjoy the latter experience, "because they do not see all the . . . cheap, commonplace folks that give me the willys." They presented "such a contrast to the . . . elegant groomed folks we saw at dinner at the Lafayette where Mr. Wood took us."[12] At the same time, she ironically noted the egregiously presumptuous actions of a moral elite to control what people read in books or watched in theaters, commenting that behind "all censorship is 'superiority,' conceit, unwillingness to concede to the other fellow the same degree of purity and sophistication" that one believes oneself to possess.[13]

Some of the inconsistencies and contradictions of Mary's worldview may well derive from her attitudes on gender. While supporting women's rights to equality in the workplace and the bedroom, she retained a hierarchical view of women in which the pretty ranked higher than the plain, the well-dressed higher than the shabbily attired, and the wealthy higher than the poor. She could seem downright traditional at times and no less judgmental than her father. She loved to go shopping, yet she resented how merchants targeted women as if they were prey to be hunted and felt guilty in falling victim to their enticements. After shopping at Wannamaker Department Store, Mary noted the "lures of all kinds set like traps to catch women" and listed silk blouses and dresses, stockings, and household furnishings that were all reduced in price. As a middle-aged woman, she felt a certain anxiety in maintaining appearances, both physically and in terms of fashion. She noted that women

confront middle age differently from men and was quick to compare her own looks to those of the saleswomen she encountered when shopping, evincing a strong competitive tendency. So strong were her feelings that she developed a dislike of other women whom she found much prettier than she:

> Bought hat. Inferiority feeling mounts high when seated before the mirror, a handsome determined woman standing above one, dealing hats. You know your doom is sealed and you'll go out with the hat she wills on your head. One always looks a fright before the milliner's mirror, hair straggly from putting on and off hats—on and off—the handsome saleswoman so Damn handsome!! You slink out with your hat feeling the combined gaze of all the handsome milliners focused on your hindside. Blessed relief of the crowd, the impersonal, self-centered crowd . . . what can a person do but celebrate with a hat—men drink—women plunge into an extravagance for themselves!

However, when a store failed to employ attractive saleswomen, Mary became equally critical:

> Hearns specializes in ugly past-middle aged women as clerks. Must get them cheap: bare barrel ankles, granulated eyes, waddling gaits, creased and folded skins like squeezed turnips.

Still, Mary acknowledged the silliness of her competitive drive to look good even at an advancing age. She poked fun at herself and women generally in combining these preoccupations with women's housekeeping concerns. "What a battle life is with accumulations—excelsior hydro-colonic acid in the stomach, fat on the hips, superstitions and prejudices on the mind, dust in the corners, and germs lurking everywhere. Battle on every day for cleanliness, elimination, slenderness, and freedom." After chastising herself for the unimportance of her diary entries on shopping and her preoccupation with her own attractiveness, she writes, "Well who the hell's the diary for anyway?"[14]

Approximately twenty years after her commitment to early feminism, Mary retained not only a surprisingly traditional attitude toward women but also a disillusionment with women's social progress. Parenting raised gender considerations that prompted Mary's particular criticism of societal norms. Women in the 1920s generally shouldered the primary responsibility for housekeeping and child-rearing, and Mary, despite her career, was no exception. Certainly, the dual pursuits created tension, but Mary both accepted and saw humor in it, noting at one point: "Did huge washing today. Queer how literary ambitions dissolve in the hot suds of Lux. A. Hardy would see in this

a real tragedy—the romanticism of youth facing the reality of a wash tub."[15] But the humor she found in her personal experiences dissipated as she considered the larger social context.

As a mother of a young daughter, Mary considered the effects of education on a child's self-image and thought about sending Margaret to alternative schools. Education that appealed to a child's emotional development as much as his or her intellectual development interested Mary. In 1924, she wrote, "The new 'play schools' like Walden, etc. do this important thing for a child: they give him the confidence of his own emotions. Thus, in later life he is trained *to respect* his impulses. He does not suffer inhibitions and suppressions." Subsequent diary entries indicate that Mary's concern over respecting one's own emotions and impulses arose primarily in her thinking about girls and young women. Attending high school graduations in two successive years, she lamented the limitations young women encountered, especially those without attractiveness or money.

In June 1926, she acknowledged the grand gifts and flowers received by the "rich men's daughters" as they graduate, while the daughters of striking workers had only their dreams. Those dreams were likely to be worthless, she noted in reaction to the minister's address entitled "Dream on Pretty Girls." Mary wrote that in the graduation class on that day, there were "not many pretty girls" and that dreams come true more easily for rich and pretty women than for poor, ugly ones. For Mary, economic opportunities for women were never really distinct from sexual freedom—the former would come only with the latter. The following year she commented on the limitations society imposed on young women by teaching them to be fearful and restrained. She criticized the minister once again, for his "sing-song . . . admonition" to preserve girls' innocence. She saw his message as an attempt to prevent "young buds" from "flowering." Religion interacted with cultural myths to lock "wide-eyed living girls" into "coffins." A few weeks later Mary expounded on the same theme. Celebrating the values of the "flappers," she resented the comments of many mothers she knew who encouraged their college-age daughters to remain virgins until "marriageable men come along." This attitude, she asserted, denied young women, even if only temporarily, the pleasures of sex and taught them to be adjuncts to men—to find their identity and self-worth through marriage. This approach turned women into "parasites" living off the work of men and taught them that sex was a commodity to be traded for a big home and beautiful clothes. In this way, this attitude hurt men and women and distorted the essential human needs of both as well as the ideal of marriage as a loving partnership of equals.[16]

Mary's support of the flappers is hardly surprising, for as one historian has noted, "the Gibson Girl . . . was the generational predecessor of the flapper."

Yet the flappers also signified just how little society had progressed since the early years of the century. Women had the vote but were still fighting for economic and social equality with men. Contemporary descriptions of the flappers, while touting them as harbingers of change, could well have been written about the new women of twenty years earlier. Dorothy Dunbar Bromley wrote in 1927 that the flappers expressed a new form of feminism through which they sought to claim their "twentieth-century birthright to emerge from a creature of instinct into . . . full-fledged individual[s]." F. Scott Fitzgerald rhapsodized about them: "They are just girls, all sorts of girls, their one common trait being that they are young things with a splendid talent for living." A latter-day historian states that they always had "pleasure as the goal: pleasure in activity, pleasure in drinking and smoking, and pleasure in sex."[17] No wonder Mary felt somewhat disillusioned in the 1920s; she had the same goals and fought the same battles twenty years earlier. She could enjoy the flapper movement as a continuation of her own feminist expressions, but its pursuit of "full-fledged individualism" and the societal acceptability of women's pursuit of pleasure promised no greater chance of success than her's.

After seeing a movie in 1926, Mary touched again on the idea that marriages often fail to fulfill women's dreams. However, a passage in her diary addressing the movie seems to put the blame for the deficiency on women's unrealistic expectations rather than on societal limitations:

Movie tiresome—and yet better than usual for the poor little heroine does not marry a prince but a policeman whom her fancy makes a prince in her fevered dreams. That's what women do. They can't land the princes of their hearts' longing, and so they set about making the husband[s] they get as near the dream as possible. Who would marry reality? Love truth? There would be no babies at all, at all without glamour of romance. One has only to look at oneself and stare at the flood of human faces and shapes to know the necessity for illusion.[18]

One cannot read this passage without wondering about the extent to which Mary not only felt disillusion with the feminist movement, but also may have settled in marrying Lem rather than Darrow. Despite their physical and political separation, Darrow was always present in her thoughts. Mary's pessimism at this time evokes Darrow's, finding nothing in human nature to offer hope and promise. She saw women as destined by their gender to form unrealistic dreams and assuage their sorrow in romance—another form of "dope."

Most troubling for Mary during the late 1920s, and possibly at the root of much of her anxiety over aging, her looks, marriage, and women's place in society, was Darrow's attention to other younger female companions, his

relationship with Ruby, and his growing tendency to denigrate women. His deprecation of women corresponded to his generally more conservative attitudes in politics and social values. Publicly, Darrow remained true to his support for a more honest and open social engagement with sex. In 1929, he spoke in support of Margaret Sanger, who faced continued ostracism and persecution for her stands on sex education and birth control, and he defended Theodore Dreiser on an obscenity charge.[19] Yet privately Darrow became increasingly disparaging of women. His diminution of women's abilities outside of the bedroom astonished his latest romantic partner, Josephine "Jo" Gomon, the pretty daughter of a college professor, whom he met in 1925 at the Penguin Club, a Detroit hot spot for affluent liberals. She recounted that he told her that "I like pretty women and women with brains, but I rarely meet the latter." He added that he met all too many who were "impossible"— those who thought they were smart but were not.[20] Following a discussion with him concerning the 1928 election, Mary wrote: "D speaks with his usual bitterness against women, referring to their part in the defeat of Smith for president. Here is one unthoughtful part of Darrow—women. Yet, to any woman he is the best, the most helpful, the most understanding friend. But the collective women! Here he lets emotion color his views. Against the collective women he rages as he would like against the little piss ant wife whose pettiness and jealousies have galled him for years."[21]

While noting Darrow's vituperative attacks on women in law, business, and politics, which can read as almost misogynistic, Mary, although upset, defended him by considering his new attitudes a reaction to Ruby's controlling behavior. Not content to share her disappointments in her journal, Mary spoke again with their mutual friend Helen Todd about Darrow's "curious fear" of his wife and her capacity to "humiliate and betray him."[22] The women were far from alone in seeing Ruby this way. An opposing counsel, Robert Toms, said of Darrow's marriage, "Ruby was a hair shirt to him. He used to complain, volubly and occasionally profanely." Yet, as Darrow neared seventy years of age, he chose to spend more time with her, traveling with her on pleasure trips and pursuing less business travel himself. Meanwhile, Mary clearly missed Darrow's company, even amid the lively intellectuals constituting her social circle, her loving husband, and her children. She bemoaned the boredom she found in most friendships. Noting that "life is only relationships" and that she "is not alone," she seldom felt able to be herself in the company she kept. The feeling unnerved her. "I am 1000 ["I"s]—who knows me—and what do they know?"[23] For all of his faults, Darrow knew her, and she could be herself with him.

Two prominent trials compelled Mary to reach out to Clarence even as they transformed him from the greatest attorney of his generation into the most famous litigator in US history. In each instance, Darrow became a part of the case; his ideology as much as his public image was on trial not only in the courtrooms but also before the people of the United States. In summer 1924, he challenged the country's use of the death penalty in the murder trial of Nathan Leopold and Richard Loeb. The following summer Darrow became the lead player in the Scopes "monkey trial," defending Darwinian evolution, the teaching of state-of-the-art science in the public schools, and the principle of church-state separation from fundamentalist Christians' attempts to limit children's classroom learning to matters consistent with these Christians' reading of the Bible.

Darrow, hoping to save his clients in the Leopold and Loeb trial from execution, faced a daunting task. In May 1924, Jacob Franks, father of a fourteen-year-old boy named Bobby, learned that his son had been kidnapped. The kidnappers demanded a $10,000 ransom; but as Mr. Franks prepared to deliver the sum, he learned that Bobby had already been killed and sodomized, most likely after his death. Two teenagers, Richard Loeb, age seventeen, and Nathan Leopold, Jr., age eighteen, confessed to the crimes. Both were highly intelligent young men from wealthy families. Graduate students at the University of Chicago (U of C) in 1924, Leopold was the youngest person ever to have graduated from U of C and Loeb held the same distinction at the University of Michigan.[24] Leopold planned to attend Harvard Law School in the fall. The two young men considered themselves devotees of Nietzsche and drew encouragement from his assertion that "superior individuals [are] exempt from the rules constraining the average man."[25] In fact, they shared with their counsel more than an interest in the nineteenth-century philosopher. The two were atheists who rejected society's moralistic proscriptions, sought pleasure consistent with their own values, and believed their intelligence should accord them special status in society. Darrow recognized that it was not the boys' philosophies that made them murderers. Many people read Nietzsche and many were atheists, yet they did not become murderers. His clients were sick youths who happened to justify their actions through a perverse reading of thought-provoking texts. Still, the similarity in worldviews between the lawyer and his clients was striking.

Mary traveled extensively during spring and summer 1924 and came to Chicago in June to gain insights into the Leopold and Loeb case. Lem had used his contacts in journalism to secure for her an assignment covering the case, knowing, of course, that she would be spending considerable time with Darrow. She and her young daughter left Grand Central Station in New York on the

luxurious Twentieth Century Limited, in Mary's words, "full of hope!" She had already conceived of her story line and planned to "get a story from Darrow on this strange murder . . . Leopold and Loeb, rich boys, precocious, everything to live for—kill a little boy of 14 'for the thrill' they say. Whole country, foreign countries, avid for news—for explanation . . . Darling Lem put this one [together] for me."

Darrow met Mary and nine-year-old Margaret at Union Station on June 17, 1924. Mary soon realized that, once again, he had no plans to give her an "exclusive" story, hoping instead to mobilize large numbers of reporters to work to eliminate the death penalty. She met him at the Congress Hotel on June 20 and afterward recorded her disappointment in her diary. Mary clearly resented what she perceived as a personal snub but could not muster much anger toward her former lover. "Terribly disappointed. Darrow will not give me anything. Nor will he 'see' my position. I too am employed. . . . Oh hell—he is like all business men. Business first and a ballet show, but a great personality and a great charm." They went to dinner a few nights later with a sociology professor from the University of Chicago, Ellsworth Faris, whom Darrow hoped could offer some insight on Darrow's clients. Darrow also brought, in Mary's words, "some dame friend," probably Jo Gomon, clearly annoying Mary even more than he did by rejecting her entreaties for an exclusive story. The facts of the case and her disappointments in Darrow contributed to Mary's never feeling comfortable covering the trial. The shocking perversity of the crime upset her more than most cases she covered, and she found it difficult to reintegrate into the Chicago community she had left years ago. After having dinner with some other friends in Chicago she noted that "everything, everybody bores me." The trial started on July 21, and Mary chose not to stay through its conclusion.[26]

The trial, at times, seemed to be as much concerned with the defense counsel as the crime. Newspaper accounts reported mobs of people fighting "like animals [to gain entry into the courtroom] . . . to hear Darrow speak." Even the prosecutor focused attention on the famous litigator. Robert Crowe told the court that the trial created a means of purging evil from a society in decline. Clearly, the attorney argued, US culture—with its tolerance of flappers, jazz, anarchy, and irreligion—spawned corruption. Organized crime, and now these two youths who looked for fun in the gruesome killing of a boy, were the products of a society gone crazy. The prosecutor claimed that Darrow "endorsed" societal corruption and that judicial leniency would put an "official seal of approval upon the doctrines of anarchy preached by Clarence Darrow."[27] It seemed as if Darrow himself were on trial.

At times, Mary seems to have wished that she had remained in Chicago—her mind was still on the trial and the man defending Leopold and Loeb. After

an afternoon with six female friends, she noted that their interests were not hers. They might be doing some funny or even interesting things—church work or community projects—but they did not "think, ponder, query." The discussions were all about what and never why, how, or what it meant. She would rather have discussed the use of psychological experts in criminal cases or the discrepancy in justice accorded the rich and the poor. On the day Darrow began his summation, she recorded in her diary: "Today Darrow begins his plea to save the life [sic] of two boys, Leopold and Loeb. If saved, will mean saving hundreds of others. Precedent. Also—beginning of scientific method in dealing with crime. Things start with [the] rich. Then [the] poor get the benefit." Unable to find the full text of Darrow's argument in the local papers or on the radio, she read the *Chicago Tribune*'s accounts in the library. Even she, who knew Darrow so well, was moved by his address: "Beautiful, tender, noble plea," she wrote. "At last people are saying 'a philosopher.' They compared him to Socrates and his alpaca coat to a Greek robe." When the court ruled in the case in early September, Mary reported that the "verdict came in today." Thrilled that the "boys" would not hang, she also recognized the ruling as a victory for psychological defenses mitigating the death penalty. Yet she acknowledged that public sentiment still favored "blood . . . no wonder tho' . . . mob knows no other way to deal with its abnormal [people] whether they be saints or criminals they just die."[28]

Mary reconnected with Darrow in New York a few weeks later when he capitalized on the sensational case to speak against the death penalty and Prohibition, combining two of his favorite libertarian causes, in front of more than ten thousand people in Madison Square Garden. She found "the Great One . . . enveloped with admirers." When basking in the love of hundreds, he had little time or energy for her. In spite of her better judgment, she "reluctantly" returned with Darrow to the Belmont Hotel after the lecture. There she found herself in the company of a few old friends. They took turns lauding Darrow and her love for him reintensified. He seemed to her "a great character of wonderful sweetness."[29]

The Leopold and Loeb trial could well have served as the capstone on Darrow's fabulous career, but a year later he took what promised to offer even a broader audience for another of his favorite causes, the irrationality of religion and its pernicious influences on societies that use it as a basis for law or morality. The Scopes trial brought national attention to what had been, up to that time, a largely southern variant of Protestantism known as fundamentalism. Fundamentalism offered a moralistic critique of contemporary values and lifestyles. It asserted a heretofore unknown theory of premillennialism, promising Jesus's return to save true believers prior to a period of tremendous

suffering caused by the Antichrist. The evils of the day, apparent in the fashions, fast cars, and sexual attitudes of the Jazz Age, served as indications that the millennium drew near. As humanity's unremitting sinfulness pointed to its extermination, no greater evil appeared than that of teaching Darwinism, the new atheistic science spawned by the work of Charles Darwin, which implicitly raised doubts about the literal truth of the Bible and God's active providence in the world.[30]

In 1925, acting on the broad popular acceptance of fundamentalism within the state, Tennessee enacted a law prohibiting the teaching of, in the words of Governor Austin Peay, the "so-called science" of evolution in contravention of the Bible. People outside of the "old South" expressed, often with derisive laughter, complete shock at this statute, and the American Civil Liberties Union (ACLU) undertook to rescind it through litigation. The Supreme Court had yet to apply the establishment clause of the First Amendment to the states, so challenges to the law had to be made through the protections of free speech and religious conscience in the constitution of Tennessee.[31]

Darrow could not wait to participate in the case, framed as a defense of John Scopes, a well-respected biology teacher in Dayton, Tennessee, who violated the law by teaching evolution. Darrow later remembered, "at once I wanted to go. My object, and my only object, was to focus the attention of the country on the programme of Mr. Bryan and the other fundamentalists in America." Darrow volunteered to handle the defense.

As Darrow noted, William Jennings Bryan would be a part of the prosecutorial team, despite the fact that he had not handled a case in forty years. Darrow knew that Bryan's inexperience meant nothing; he had other attorneys to handle the legal matters while "he represented religion, and in this he was the idol of all morondom."[32] Bryan had shifted his populist appeals in recent years to the cause of fundamentalism and had attracted a solid following in the old South. The Scopes case offered a second chance for Bryan to take down the champions of modernism on the national stage. Mary, once again, would be there for support as much as for her reporting.[33]

Darrow never expressed his libertarian tendencies more than when speaking or writing against laws that restricted people's own moral judgments, lifestyle choices, or freedom of conscience. In these cases, Darrow turned to a conception of rights as basic protections of individual freedoms in societies governed by law, not as malleable social constructions intended to serve particular interests or conceptions of a social good. In other words, Darrow's understanding of the nature of rights depended on the context in which they arose. In his opening statement at the Scopes trial, Darrow appeared also to turn away from his pragmatic tendencies to construct truth inductively; to ac-

cept moralistic conclusions that serve the public good; and to see law, even constitutions, as fungible expressions of lawmakers rather than absolute guarantees of undeniable and invariable natural rights. In making the argument for the separation of church and state in order to protect each person's freedom of conscience, Darrow seemingly became deductive in his reasoning, accepting of certain undeniable absolutes dictated by reason, and willing to submit to the rule of law but not to men and their superstitions and prejudices. Law was no longer a tool but an essential bulwark of freedom.[34]

Darrow used the proceedings to make an argument to the people of the United States. More than one hundred newspapers sent reporters to cover the trial; Western Union installed twenty-two telegraph wires; and radio broadcasts beamed across the country every word spoken in little Dayton, Tennessee. The jurors actually heard less of the trial than many Americans in New York, Chicago, or Los Angeles, because the judge excused the jury for all arguments of law. Composed almost entirely of evangelical Baptists and Methodists, the jury might not have liked some of Darrow's pronouncements, but the national audience loved them.

Darrow prepared his listeners for the critique of Christianity that the trial would offer: "I think this case will be remembered because it is the first case of this sort since we stopped trying people in America for witchcraft, because here we have done our best to turn back the tide that has sought to force itself upon this modern world, of testing every fact in science by a religious dictum."[35] The jury missed Darrow's questioning of Bryan, seated as an expert on the Bible, who in an extraordinary move took the witness chair to defend a literal reading of the Bible as a basis for law. The examination lasted all day and provoked howls of laughter within the courtroom and caused listeners at home to laugh until they cried. Bryan defended, as literally true, the stories of Jonah living in a fish for three days; Joshua, with God's intervention, making the sun "stand still"; woman being created from Adam's rib; and Noah saving the animals from a flood by building an ark. Amazingly, this man had almost become president of the United States; more amazing perhaps was that Darrow had voted for Bryan in that election.

Ironically, Bryan's testimony raised an issue that Darrow and Parton struggled with for most of their lives; it also expressed the major intellectual inconsistency in contemporary liberalism. Bryan ultimately contended that the laws of humanity must comply with the laws of God as expressed in the Bible. If they do not, people have a right to disobey them. Democratic theory, however, vests sovereignty in the people to make the laws and imposes a correlative duty to obey them. Darrow scoffed at the idea that fundamentalists could ignore a constitution because God's law superseded human law; yet Darrow had earlier

justified union supporters destroying property, assaulting and battering those who crossed picket lines, and even killing antiunion obstructionists in accordance with a great moral crusade for social justice. Darrow had accepted a higher law, but it was of his own making, not God's. By 1925, Darrow had grown disenchanted with the labor movement, which he saw at that time as "jungle creatures fighting for a bone more, a breathing spell more—but not the least bit more intelligent about their bondage, as addicted to their religions and fetishes, their political and social myths, as ever."[36] Yet the glaring inconsistency of his ridicule of Bryan while he endorsed illegal union activity remains obvious.

The jury in the Scopes trial ultimately returned a guilty verdict attended by a de minimis fine. Fundamentalists celebrated a victory but soon afterward retrenched into their conservative southern redoubts, finding their beliefs, values, and lifestyles not only unacceptable to the majority of Americans but the butt of ridicule.[37] William Jennings Bryan died on July 26, just days after the trial ended.[38] The trial had raised Americans' consciousness. Nationwide, people spoke openly of the threat fundamentalists posed to freedom. At a dinner party in New York with various friends, Darrow and the Partons heard a young judge from Detroit comment that the most difficult people he dealt with in his courtroom were Christians, usually Methodists. They wanted "punishment" for moral wrongs and had no conceptions of rights or law. To them, the Constitution was not the final arbiter; the Bible was. The group wondered how "they" (ardent Christians) could ever be acclimated into the country's political culture.

Meanwhile, Darrow reached new heights as a national celebrity and parlayed his fame into speaking opportunities on Prohibition and religiously inspired laws that provided outlets for his reinvigorated libertarian positions. While in New York in December, he hosted a small cocktail party for friends, including Carl Sandburg and the Partons, before lecturing on evolution in front of a crowd of almost two thousand people. After the lecture, a man in the audience asked Darrow how he could leave people without a crutch. Mary recorded, "Darrow answered so tenderly. He realized, he said, the need for 'dope,' . . . But [that] for some the 'dope' didn't work. These people must face the darkness because they require truth rather than illusion. His voice was gentle, unargumentative. Tears came to one's throat. I knew again he was a man of sorrow and acquainted with grief." Mary recognized Darrow's refusal to take the dope, be it alcohol, religion, or drugs, as symptomatic of the man's strength, and she again felt closer to him than she had in several years. Together, they wished humanity could be equally strong but had little hope of it ever being so. Even Mary seemed willing to try going "cold turkey" declar-

ing, in 1925, her "eternal enmity to formulated religion. It mildews a good brain."

Social acclaim can be another form of dope. Darrow never previously experienced the degree of fame that came to him after the two trials in 1924 and 1925. Yet he refused to be compromised by it as well. On the way back to his hotel after the lecture in New York, Darrow told Mary, "I am terribly famous and goddamn unimportant."[39]

Mary also realized that Darrow was growing old. Following yet another dinner party, she describes her close friend as a "sad old lion" and quotes *Passage to India*: "C.D. has 'come to the state where the horror of the universe and its smallness are both visible at the same time.'"[40] His latest young lover came to a similar conclusion but expressed it with far less tenderness. Jo Gomon discussed with her friends her doubts over dating "an old man with dirty ears; reflected glory is not so gratifying without the vigor of sustained interest in personality and sex." She also recounted a dream in which "Mrs. Darrow [was] too drunk to properly supervise his bath the night before, and [I] pitied her marriage to an old man."[41]

Clarence and Mary vacillated between hopefulness and despair. They celebrated the scientific community's progress in understanding human nature and optimistically envisioned a day in the not too distant future when all intelligent people would reject prescriptive morality. Yet Mary and Clarence lamented that the masses did not comprehend recent scientific thought. The two continued to see people as divided between smart and stupid, pretty and ugly, rich and poor. The intelligent people gave Clarence and Mary hope; the less so, only despair.[42] They surrounded themselves with successful people—economically, artistically, socially—but felt a commitment to the less successful. Mary and Clarence became even more ensconced in their bastions of sophistication while devoting their energies to the "morons" and the poor, whom they simultaneously ridiculed and failed to understand. By the mid-1920s, however, their fascination with both these groups had started to wane.

The booming economy of the 1920s added to the intellectual and emotional distance between Mary's more radically liberal friends and herself. She contended that radicals saw only "the monstrous effects of capitalism and conclude that it must be failing. But is it?" She increasingly turned to romance as a means of appreciating the world around her. Contemplating the stars one evening, she determined that "romance is the will-to-live, is self-preservation dressed in fancy costume for the masked ball of life."[43] In 1923, she took a trip to Europe, and her romantic inclinations came to full bloom while reveling in history and architecture.[44] Yet she missed Lem. "Traveling alone," she thought, was "horrid. You are shut out from all night life." She tried to strike

up conversations with young men and became upset when doing so proved difficult. She described some students she encountered as "sexless strangers— no companionship. No conversation." Her own unsatisfied desires contrasted with the parochial judgments of other travelers from the United States. She encountered some women she knew who were also traveling in Paris, at Café Rotunde, in the fashionable fifth arrondissement. They sat for hours watching various passersby and customers pairing off for afternoon trysts. The women seemed to love the style of European life—its promise of "affairs," "scandal," and "intrigue." Yet none of them did anything themselves. To Mary, these women seemed "bored from long contacts with life" and its impositions of moral judgments. The women had "no purpose" and seemed hypocritical. "Mrs. Austin," she noted, "wouldn't bring her daughters in this café, but enjoyed it exceedingly although expressing constant disapproval."[45] Mary, of course, had lived much of her life as a devotee of free love and seemingly longed for at least one more night of sexual abandon. Why did other women find it so hard to admit their own lust?

Mary proved more interested in observing the political and cultural tensions in Europe than the mating practices of the French. The 1920s would prove to be a crucial period between the two world wars, as countries redefined their national purposes and places in the world. The tensions of the last war simmered before the hatreds that would spawn the next war had taken root. On the French-German border, she watched "good natured lads on either side of the blue river—boys who might be friends but for the invisible masters who give one side a 'tri-color'—the other a German flag. It is utterly ridiculous." Mary reasserted her despair over the artificial barriers people use to divide themselves from others. National identity and patriotism, sex, race, religion, all seemed like silly labels to her, justifying bigotry and hatred and impeding a natural inclination to know other people.[46]

One of the risks of spending much of one's life with people older than oneself is that one may grow old before one's time. Mary turned forty-seven on January 1, 1925, yet her attitudes indicate a degree of bitterness and disillusion stereotypically found in much older people. Her political detachment and cynicism may well reflect Darrow's continued influence; but if so, Mary seemed unaware. She rejected, in vivid language evincing real fear, some of the new ideas and perspectives of contemporary society. After dinner with Grace Potter, a Freudian psychologist, Mary wrote: "I get scared [sic] and creepy when I talk [about] these . . . things."[47] Mary, neither the first nor the last reasonable person to express exasperation after an evening with a Freudian, could only long for a return to old-fashioned liberalism modeled on the

worth of the individual. Nothing so quickly turns a liberal into a conservative as the need to integrate new ideas into established ways of thinking.

At times it seems as if everyone and everything bothered Mary. After an evening with friends Nettie Richardson and Mike Chubalo, Mary commented: "Mike is a radical because he loves humanity; Nettie because she hates the rich." It was admittedly difficult to be a liberal in the 1920s. The Republican Party dominated the White House and Congress, and the Supreme Court articulated a conservative jurisprudence. Liberalism lacked new leadership and seemed mired in the old ideas of the pragmatists and the Progressives, already offered to the public and rejected. As a result, liberals turned to one another, in the process finding cause to disagree or to consider ever more radical ways to redesign society. At one dinner party Mary and Darrow attended together, the diners discussed eugenics and birth control as means of curbing the alarming number of "morons" in society. Mary heard Lincoln Steffens speak on "the bankruptcy of liberalism," in which he asserted democracy had been subsumed by capitalism. Completely rejecting the founders' premise that political and economic liberty went hand in glove, he argued that Americans had to choose between one or the other—and had seemingly made the wrong choice. Meanwhile, Mary could not escape hearing voices rejecting her worldview for another and seeming to her to gloat in her defeat. She argued with a "tall, blond, Nordic" woman "whose idea of liberty [was] . . . narrower than a pencil stroke" and rooted in traditional understandings of "justice, morality, [and] uprightness." Mary called this woman's religion "superstition" and considered her success to be the result of "luck" or "magic." "A sense of reality," Mary thought, "would make [her] . . . more credulous." Mostly, though, she just was angry that this woman's vote could be as valuable as anyone else's. Democracy![48]

Mary's religion, always rooted more in a morality of compassion than in doctrine or mysticism, offered no respite from the social forces challenging her worldview. At times, in fact, religion itself was an affront. After listening to a bishop speak of the need for people to return to church, she noted that religion no longer appealed to her. She quoted Ardo Hering, described as a "fascinating" "Harvard man," who said, "God's a gentleman without a job" in the United States in the 1920s. A few weeks later she dismissed as equally vacuous the secular faiths of her friends: "Wretched radical dinner . . . Felt out of line with the whole lot. The old radicals playing the old times, the doxologies and toxologies of their religions. Poor dears."[49] She found it hard to identify with any group or affiliation.

The radio served as an incessant reminder of how society had gone mad. On the day it arrived, she wrote:

I resent its coming. Another Babbit to live with. All the Babbits into one. Hate the suggestion of interference behind the bland, wooden face of the Radio box—the little turn of the screw brings preachers, politicians, thimble riggers, mummers, and maskers into one's home—the last stand against mediocrity, uniformity. I hate it. Can't put into words all the instrument means to me. No longer these walls are barricade against the screaming blatancy of our civilization, the bawling and hawking of virtue, of patriotism, of cold creams, of safety pins, and groceries. And I have no refuge from it in our little flat . . . no where I can escape.[50]

Lem and Mary prospered in the 1920s, in large part because of Lem's professional success. In 1924, the couple moved to New York, where Lem worked for the *New York Sun* and taught journalism at Columbia University. In 1931, he began work on a syndicated column, "Who's News Today," for the *Sun*, describing the actions and ideas of prominent people shaping national culture. The column made Lem a national figure himself and produced significant income during its run through 1942. The Partons were able to buy a beautiful home in Sneden's Landing (now known as the Palisades) in New York overlooking the Hudson River. Their new home introduced them to several prominent people. Their next-door neighbor was Robert W. Bruère, a longtime liberal whose brother, Henry, served as a member of President Roosevelt's "brain trust." His wife, Martha Bensley Bruère, worked as a magazine writer and editor.[51] The Partons' lives were once again enriched by an active network of friends who shared their interests in political, literary, and philosophical discussion.

Yet judging by Mary's diary entries, none of her new friends compared to Darrow. As always, she most enjoyed her time alone with him. Hearing Darrow speak in public created mixed sentiments. After seeing him deliver an oration in front of "a roaring crowd," she commented less on his words than on the self-delusion of the attendees who believed themselves empowered simply by attending a lecture. She contrasted their ready ability to identify with a larger group with her own feelings of political isolation. "People of the inferior class feeling the superiority of belonging to a mob . . . mob power . . . herd strength," she wrote. She concluded that nobody wanted objectivity or fairness anymore. She noted, "The word 'fair' obscures the entire situation. Law emanates from human minds and emotions control the law and emotions are never fair."[52]

These are strange sentiments coming from a pragmatist who supported union organizing. Mary had herself learned to use emotions to motivate people, making them feel injustices in order to redress them. Yet she strug-

gled to integrate her own feelings and her ideas. Darrow had hopefully expressed that "some time perhaps we will reach a plane above the commercial age. Some time in the realm of ideas, in the realm of good emotions, in the realm of kindness and brotherly feeling, we may find truth."[53] With Darrow's influence, Mary had come to feel for wrongfully incarcerated prisoners, those suffering from economic exploitation, and those fighting political oppression. But her emotional sensitivity had limits his did not. The objects of her sentiment seldom had a face or a name. Despite her manipulative personalization of the poor in her writings, Mary found it easier to love those she had never met. She felt estranged from those who wept for people they knew but turned away from the plights of millions unknown. They were selfish, too engaged in their personal lives, and unaware. The "trouble with people," she wrote, "is that they are under-emotionalized . . . [they] can't imagine feeling compassion for prisoners, for political exiles, for slaves. So one can't [move] them to Sacco [and] Vanzetti in the death house for a murder they did not do. For the struggle in China—life in any of its tragic moods."[54] Mary was a counterpoint; she perceived a remote injustice more readily than one near to her.

Mary's strongest emotions expressed themselves in the 1920s in protective defenses of Darrow. She conveyed a vibrant cynicism, seeing those who engaged in public arguments with her former lover as only hoping to improve their stature and those who walked away from causes when success seemed unlikely as rationalizing their failures. After a day with Darrow at the Belmont Park race track, she discussed a preacher who approached them and challenged Darrow to a debate: "Anything for publicity and then he can turn his defeat into advertising and his ignorance into 'defense of the true religion.'" Following a "wonderful dinner" with Darrow, Dreiser, and Ed Nockles—"a grand old labor man"—she commented that Ed typified the labor movement, "once robust, dominant, lusty, vociferous: now sickly, distrustful, delicate and still." Ed claimed that the labor movement had died, killed not only by the "courts, soldiers, [and] injunctions" but also by a "lack of faith and idealism" on the part of Americans.[55] Committed to their cause, Mary and the others struggled to accept that the majority of the people held a different ideology and value system.

Mary, the one-time stoic, turned ever more to romance. She took great pleasure in writers who could capture the essence of contemporary society and make readers feel shame in how they lived. At yet another dinner party she engaged in a discussion of Sinclair Lewis's *Elmer Gantry* with Charles and Mary Beard, Sara, and Erskine Wood. They found it a "magnificent" exposé of the "Billy Sunday type" of preacher and the hold such men had over rural Americans. A few weeks later Mary again praised Lewis for creating Babbitt as an

iconic American: a "super patriot; super salesman; super Methodist." She also enjoyed her friend Carl Sandburg's Lincoln: "The work of a poet seeing with a poet's vision the life of a great, wise man."[56] Unlike many of her peers, Mary seemed to pull away from elitist answers involving social engineering in supporting democracy. Invited to the home of famous historian Charles Beard, she argued with several other professors over the continued viability of the jury system. Recognizing that most jurors do not understand the applicable law and also may struggle to understand sophisticated fact patterns, the professors argued for the creation of professional full-time juries. Mary defended the traditional composition of juries and their importance to democracy. She liked jurors who "spat in the cuspidor" and dismissed professional jurors as likely to seek career advancement by pleasing property interests and the powerful. Her dining partners thought her "sentimental." She ultimately acknowledged that perhaps she was.

Truthfully, given the decline in radical thought after the Great War, many liberal intellectuals came to doubt that Americans, or perhaps any people, could handle the task of self-government. Darrow himself, while on the speaking circuit in 1925, argued that "everything the human race has touched it has ruined."[57] He encouraged Mary to join a number of liberals who again sought to redefine democracy, this time from meaning a commitment to self-government to instead entailing a sentimental moral sensitivity to the needs of others. The redefinition allowed these liberals to remain democrats in word only, while becoming ever more celebratory of paternalistic governance by an educated elite. Mary seemed to embrace the new understanding, explaining democracy to her daughter Margaret as "a feeling of friendliness for people irrespective [of differences in] clothes, . . . houses, . . . education—just human friendliness." Later that day, she and Margaret passed a sad, lonely stray dog. Margaret wanted to help it, but Mary called it a "common dog" with "bad points." Margaret responded, "Oh, can't you be democratic about dogs?"[58]

Mary's role as a mother in the 1920s not only forced her to rethink her own values and political views so as to explain them to a child but also increasingly prompted Mary's consideration of appropriate methods of child-rearing. She was far from alone in deviating from the earlier generation's attitudes and approaches. After meeting a woman and her twelve-year old son, whom Mary described as being raised "in perfect freedom," though more as understood in the twentieth-century urban United States than as envisioned by Rousseau in *Emile*, she recounted: "He smoked, drank, sat up past midnight, never went to school (until he wanted to) kept the company he liked—and is today a dear lovely child. I'd be afraid to try it. Wonder if her method arose from a faith in freedom or a desire for her own perfect freedom unhampered by the [need to

provide the] discipline of a child."[59] Mary tried to strike a balance between freedom and control, introducing her child to travel, different people, and urban culture to a degree unimaginable in her own youth. She did resort to corporal punishment, though it seemed to have pained her more than her child. After administering a spanking to Margaret, she scolded herself: "Poor child. She is so defenseless against us. They are so little, so pitifully dependent, such sufferers from our anger, nerves, tempers. I wonder children love their parents at all." On another occasion, she further lamented her resort to violence and expressed more self-doubt: "Gee I was hateful to Margaret today. For a little inch of skin I sinned a mile: Lost temper, slapped her, grounded her, made her cry. . . . I am hideous horrible. She ought to punish me. I am unfit to guide the darling."[60] Though Mary never wrote of it, the contrast between her father's ritualistic and dispassionate use of violence and her own must have been apparent to her. She thought it wrong to hit her child but did so on rare occasions when moved to violence by short-term anger. Mary's father, conversely, thought the use of his belt an appropriate, perhaps even necessary, aspect of child-rearing and could wield it even when calm and sober and in a spirit of detachment.

Mary's valuation of compassion and friendliness shaped the way she raised Margaret, but so too did her cosmopolitan sensibilities and cultural interests. To her, liberalism encompassed all of these attributes. She exposed her child to different religions, cultures at home and abroad, and entertainments. However, remembering her own difficulties being respectful in church, she avoided taking Margaret. She also grew aware of the fact that sometimes young children were not ready for the adult themes that dominated their parents' lives. After taking Margaret to a film, Mary found it amusing that her daughter hated the love scenes, responding that "some day you'll not say that. Now you are my little, little girl."[61] In 1926, Mary let eleven-year-old Margaret travel without her mother on the *Acquitania* to Europe, arranging for friends to be the girl's guides. Mary hoped the trip would fill her daughter with an appreciation of the cultural differences between the two civilizations and cultivate an awareness of taste, sophistication, and political differences. She said to Margaret on her embarkation: "Oh Margaret, the lovely old world before you! You are going to your Fatherland. We don't belong to this strong, heady new country. Our citizenship is 'over there' with ruins and hard-crumbled soil, and old lace and wines and ways."[62] At eleven, Mary could not leave the confines of the white picket fence unless going to school or church; her daughter boarded a ship bound for Europe.

Shortly after their move to New York, Lem and Mary took in the daughter of a woman sentenced to prison. Young Dorothy, known as Dot or Dotty, had

experienced almost none of the cultural advantages and tenderness with which Margaret was raised. In caring for the girl, Mary evinced a liberal kindness but also a judgmental dismissal of Dotty's abilities and prospects. The generous and compassionate inclusion of Dotty in Mary's home and family contrasted with her harsh appraisal of Dotty's differences from Margaret. The boys all preferred Dotty to Mary's own daughter, prompting Mary to write that Dotty "never has an idea, never a thought of her own, never a choice, never a suggestion . . . a loveable bore. [Yet, she is] a big hit with the males. She needs no brains with her pretty curls."[63]

As Mary dealt with a new generation growing in her home, she also confronted the passing of an earlier one. Her mother, when her health began to deteriorate, moved in with Lem and Mary. The older woman's presence disrupted Mary's lifestyle and child-rearing. Mary hated the radio, resenting the endless talking that intruded on her domain. Her mother loved it, so Mary tolerated the noise until religious programming came on the air. At that point, her mother would bow her head in prayer and Mary would turn off the machine. "It's such fun to punch the radio off when the preachers begin talking," the still rebellious Mary noted. She explained her actions to her mother by telling her that Jesus served as a "poor role model" for children—"incompetent" at any remunerative task, "weak," "soft," and ultimately a "failure." Margaret, too, resented religious interferences in her life, especially school holidays. She thought her teachers lazy and referred to "Holy Week" as "wholly miserable." One has to wonder at Darrow's possible influence as well. Throughout his adult life he called the Christmas and Easter holidays the "hollow days." Margaret seems to have picked up not only his gift for wordplay but also the tenor of his convictions.[64]

Annie Field died on November 7, 1926. Mary, with some anger, commented on the near torture and false hope that her mother endured in the last months: all the "pills, doctors, poultices, experts, enemas . . . did no good."[65] Having watched one loved one die, Mary devoted herself to spending as much time as possible with another in his last years.

By the late 1920s, Darrow took very few cases, traveled a bit with Ruby, and overcame his penurious tendencies to bestow legal counsel and funds on new and old friends alike. Mary attended a celebratory lunch with her longtime mentor after he earned an acquittal of two men charged with the murder of two Italian fascists in New York aligned with Mussolini. He took only $1,000 in fees for the case but, in her words, "received their love," if not their money. Without telling Ruby, he had lent $8,000 to Lem and Mary, free of interest, to buy their new home; paid for the medical care of friends suffering from cancer;

and rewrote his will, leaving money to the National Association for the Advancement of Colored People (NAACP).[66] However, while Darrow remained close to the NAACP and received support from significant African American leaders, such as W. E. B. DuBois, the lawyer angered many Black ministers when he complained that he resented "some damn preacher start[ing] . . . off with a prayer" whenever Darrow spoke in their churches.[67]

Mary met Darrow wherever and whenever she could—at speakeasies or elegant restaurants; at lectures or at trials; at parties or one-on-one occasions. She repeatedly remarked on his constant emotional sensitivity to others and how he had helped her to become more sympathetic and "friendlier." A few months after her mother passed away, she had dinner with Darrow and others in a private room at a hotel in New York and commented on his decline:

> Darrow looks very old and even more tired. Sags like an old bag out of which almost everything is taken. Jokes as usual, simple rustic jokes. Criticizes none. Asks nothing. People come to strut before him and ruffle their feathers. He sits humbly, with head bowed, silent—he who knows, who feels, so much more than they. Reporters, photographers, tuft hunters and all come. They all want something. A lonely great man of such imagination, Sympathy . . . —all—all he understands. He is the law of suffering made flesh, dwelling among us a while.

The next day she saw him board the train back to Chicago and noted her sorrow: "always the sense of great loss."[68]

Mary could not attend Darrow's birthday party in April 1927 but sent a telegram message to him. She expressed joy that "people are honoring him before he dies." Later that year, she saw him twice in New York. On one occasion, she resented the sycophants who surrounded him; she so much preferred time alone with him. Yet she thought that he liked the attention, especially as she was once again present to witness it: "Lions are hard to entertain," she confided to her diary, "they get used to homage." That fall she reveled in sharing a ride with him "in some rich Jewish lawyer's automobile, holding the hand that has so often been raised in protest against injustice and inhumanity."[69]

Darrow never stopped encouraging Mary. He believed she could become a great novelist. In 1928, he reminded her, "You said you were going to give up your job and write. You should have done that long ago and you should do it *now*. Nobody can write like you. No one feels as much and knows so well and can do it. So do it. I want to see it." He signed the letter more emotionally than most, "Ever With Love, Clarence," in a rare instance when he used his first name. Of course, he had awakened in Mary both those feelings and

that writing ability to which he referred. He retired that same year, noting "I was weary and timorous of the crowd. It was hard to longer brace myself for the fray. I wanted to rest and play."[70]

As the roaring twenties reached an end, both Darrow and Mary took stock of their lives and their society and turned inward. Neither had given up on the causes that had energized the two of them for so many years, but society had seemingly turned its back on the things they valued. Feeling a bit older, somewhat chastened, and very much desirous of enjoying friends, family, and cultural excitements, Mary and Darrow looked to themselves and to each other.

CHAPTER 7

A New Deal for Liberalism and the United States, 1929–1969

In the first three decades of the twentieth century, prosperity seemed to be the key to the future. Economic growth could eliminate poverty; spread knowledge, sophistication, and culture; promote discoveries and inventions; and keep the United States free from alliances and trade agreements that might threaten national independence or security. The cultural commitment to prosperity, however, also "made money the measure of the man," and by 1929, the lure of easy money had brought the nation to its knees.[1] On October 24, 1929, known ever since as Black Thursday, the world changed.

Americans today, when hearing or thinking about the Great Depression, may form the impression that everyone suffered greatly in the economic collapse. This simply is not true. Lem and Mary lived very well during the Depression. Mary made no diary entries and left no correspondence from October 24 or 25. Ironically, on October 26, she recorded that she took Margaret shopping for high heels and cosmetics, hoping to encourage her to develop a more mature and sophisticated sense of style. Mary told the reticent Margaret that there is "no difference between . . . [cosmetics] and jewelry, between lace and silks and spangles and embroidery. The female adorns herself in our species. Adornment has an important job to do." Five days after Black Thursday, Mary and Lem attended a dinner party. Mary described the cocktails, the "delicious dinner," "the magic of music," and her beautiful hostess

in a black dress and a long string of pearls. Other dinner parties followed on November 3 and 5.[2] The first mention of the stock market crash in Mary's diary appears on November 25, 1929. She responds to a conversation she heard in which the speakers blamed the collapse on Jews and bankers. She also heard many people calling for a revolution "that destroys capital." Mary worried about the anti-Semitism she heard but acknowledged that perhaps some fiendish plot had precipitated the crisis. The crash "destroyed thousands of little people," she wrote, "and made a few richer than ever." Perhaps there had been a "planned campaign: impersonal as an earthquake, a fire; cruel and relentless." A few weeks later, after a discussion with one of her liberal friends, Mary noted, "Nettie wants to live through a Revolution. I don't!"[3]

Lem and Mary had purchased an apartment house in Greenwich Village about a year before the crash. They, like so many other Americans, believed the economic growth of the 1920s would continue. The Partons refurbished the building with the assumption that their tenants would appreciate what Mary referred to as "an environment of elegance and respectability." The building itself had been originally designed for gracious living. Once a grand mansion, it still contained high ceilings, crystal chandeliers, carved marble mantles, mahogany doors, silver fittings, and an extensive wine cellar. Much like the founders of settlement houses, the couple believed that the gracious beauty of the apartments would uplift the tastes, lifestyles, and behaviors of the tenants who lived there. Instead, Mary found her tenants undeserving of their fine surroundings and began referring to the building as a "human zoo." Mary kept notes on her tenants, seemingly fascinated even as she was repulsed by them. One tenant decided to slide down a mahogany railing, shattering the balustrades that supported it. A young woman, "a student of numerology sensitive to harmonics," burst into tears upon realizing that her apartment was on the third, not the fourth, floor. Another renter stole electricity by removing the hallway light and running a cord from the socket into her apartment, thereby bypassing charges to her meter. The same woman took the hallway rug to use in her apartment. A self-proclaimed fan of art hung "a hundred soap wrappers" arranged in a collage, a photograph that had been filled in with crayons, and a deer head on his walls. He told Mary that he had "shot that deer myself and no matter where my castle, my mother's picture and that souvenir go with me. My home's my castle!" Two women whom Mary found particularly beautiful and referred to as the "budoir [sic] buds," stayed only twelve months. Upon their departure, Mary remarked that their apartment looked as if the two of them had "never held a broom nor a mop, nor a likeness thereof." "Rugs of dust, city grime and soot, the slow deposit of months" lay everywhere. Of course, she also dealt with bounced checks and one family

that ate oatmeal for breakfast and dinner and left their furniture in lieu of back rent.[4]

As her tenants seemed always to disappoint her, Mary continued to refer to them using not their names, but various descriptions. She called one "the Marquis" for his extravagance in decorating. "The Nurses" were a couple of "gay young things with lots of men friends, parties, and pink underwear on the line." In addition, she rented to a "pornographic grunt," a "drunk," a "Jewish couple," "two widows," and a "honeymoon couple." At times her comments regarding her tenants were so judgmental as to challenge any assertion of her cosmopolitan sensibilities. In 1933, she wrote: "No Jews in the house except Rosita Joseph who lives up to the '*traditional*' reputation of the Jews and only pays her rent when she just can't help but to pay for it. I wish Hitler would collect for me, the horrible brute that he is."[5]

Mary thought that cultural leadership from a benevolent elite combined with socialist redistributive policies could make everyone middle-class. She seemed moved by the sufferings of millions at home and continued to profess allegiance to socialism and the Russian Revolution throughout the 1930s. Yet, when face-to-face with the more unfortunate, she stiffened. She defended her own lifestyle, rooted in rents generated by property ownership as much as in white-collar labor. Reading the Sunday paper, she found a growing litany of crime, poverty, cruelty, "and the terrible fear of horrible pain." Though very much a beneficiary of the capitalist system, she attributed all of it to capitalism. "I see men pawing through the garbage pails for food," she wrote, "men and women shivering in their cotton coats, mad lives, despairing figures on park benches, beggars—and fear in every eye one looks into." She wondered whether communism would be deemed a success if it brought champagne and polo to the Russian people or provided radios, silk stockings, and layer cakes. Her idealization of Russia, in the context of the kidnapping and murder of the Lindbergh baby, led her to conclude that "in Russia, where money is not the standard of success, such a deed would be impossible."[6]

Mary continued to attend parties, concerts, and theater events. She enjoyed regular lunches and shopping trips at Marshall Field's department store. She sent Margaret on a weekend getaway to Barbados in June of 1933, and in October, Mary noted that Lem "left early for a trip to the Chesapeake Bay on the Darlingtons' yacht." In September 1933, Margaret started college at Swarthmore. Mary wrote that she left with many pretty clothes and that her dormitory room had casement windows that opened to provide lovely views of the campus. She contrasted the support Margaret had from her parents in going to college with Mary's own escape in running away from home. Despite their continued economic support of Margaret (Mary expressed pride in Lem for

"sending his girl to college in the Depression"), she now considered her daughter to be fully "grown."[7]

Lem and Mary benefited from the capitalist system that she denigrated. They were landowners who derived income from rents. They made good salaries or commissions from media companies that profited from subscriptions and advertising. They were not merely surviving in the capitalist United States but thriving in it during a time when many were not. Mary frequently expressed the attitude that her lifestyle was deserved; Lem and she were smart, worked hard, and were good at what they did. But the value of their work, like that of all Americans, was determined by the market. She did not earn the same income as the lady garment workers, and Lem was not paid as a miner. Yet Mary continued to champion collectivist theories, even socialism, over capitalism.

By the 1930s, Mary's condemnation of capitalism arose as much from her perception of its deleterious effects on culture as from her perception of its economic unfairness. After one particularly banal social interaction, Mary described what she heard. As people sipped cocktails and stole glances over her shoulder, they repeatedly asked, "What do you do?"; "How much do you get for it?"; "Do you like our hostess?"; "Isn't eating on one's lap horrid?" Mary concluded that society had turned even more vulgar as people guarded their "precious little egos" more than their abilities to think and communicate. She found most conversations polite but shallow and utterly without value. She much preferred political activities. After attending a town meeting at which debates were resolved quickly "by a showing of hands," Mary praised "simple pure democracy" as "always thrilling."[8]

In her musings about her tenants and her friends, Mary expressed a disenchantment with the values, behaviors, and cultural limits of her fellow Americans. Mary had tasted the best society could offer, discussed and debated with its greatest minds, and traveled domestically and abroad in the finest company. Yet she deprecated the people she knew and the society in which she lived. She remained judgmental, disillusioned, and dejected. Even in the end of Prohibition, she found reason to despair. After drinking all afternoon, evening, and night, she noted that she would miss the romance that Prohibition provided; sneaking into speakeasies on dark streets would be no more.[9]

Mary acknowledged that she had everything—a loving and supportive husband, a healthy daughter, a beautiful home, financial security, a luxurious and cosmopolitan lifestyle, and acclaim and respect in her chosen profession. Yet she felt unsatisfied. She wondered whether she had strayed too far from the religious precepts with which she had been raised, yet expressed more confidence in the state than in any church. She wrote that the human soul "reaches

out for . . . the explanation of pain, the meaning of death," turning inevitably to God. Still, millions of people and animals suffered painfully every day, had done so for eons, and would do so for eons more. God had not, did not, and would not help them. She concluded that society should try to alleviate suffering; yet when it tried to do so, its good efforts were stymied. "Up in Albany," she wrote, "men gather to defeat the child labor bill, Governor Smith among them. And the Catholic Church!" Too often, she concluded, organized religion was a reactionary force perpetuating itself as part of the status quo at the expense of those to whom religion should be responsible.[10]

Americans nationwide shared some of her same feelings, even if they harbored no dreams or conceptions of the life she lived. Certainly, the Depression created pain, sorrow, and disappointment for millions. But it only partly accounts for the despair Americans felt in the 1930s. Many felt as if they had lost something more valuable to them than money. The turn of the century had promised social, intellectual, and technological advances—human progress. By 1930, that promise appeared chimeral. In 1890, Americans felt connected to their communities, knew their neighbors, and felt as if they shared with them certain values and beliefs—or so they romanticized. Life in small towns reaffirmed these convictions. Ice cream socials, spelling bees, church activities, sleigh rides, circus trains and parades, gatherings at general stores, and summer band concerts in gazebos—a Norman Rockwell portrait of the United States—seemed more real than fictional in people's minds and memories. By 1930, that life seemed to have vanished long ago. The town and its community no longer mattered. Progressivism, social sciences, and the growth of a national media had created national standards. Local values, customs, and community support had been supplanted by national norms. Authority had passed to experts, who appeared simultaneously across the land in magazines, schoolhouses, radios, and movies. These experts told people what to believe, how to dress, and how to live. The Progressives' search for a "single-standard society" had been achieved, but it had destroyed local cultures. Morality was no longer set by local ministers and no longer learned at Grandma's knee. Responsibility for the local poor and downtrodden no longer resided with the wealthy families in town; professional social workers cared for the needy, from town drunks to mistreated kids. Lawyers, doctors, and schoolteachers no longer studied with local professionals but instead went away to colleges and universities—choosing to return only sometimes. Sherwood Anderson noted that "now the players do not come to the towns. . . . They are in Los Angeles. We see but the shadows of players. We listen to the shadows of voices. Even the politicians do not come to us now. They stay in the city and talk on the radio."[11] In some important ways, then, class mattered less than it had. It no

longer bought authority; it no longer created prestige. Mary had developed a cosmopolitan attitude during her years in Chicago, San Francisco, and New York and felt no longings for an imagined Rockwellian past. Yet even she was not immune from the malaise that enveloped the nation in the early years of the Depression. Mary had attained tremendous economic, professional, and social achievements but remained frustrated and disillusioned. She, like so many Americans of less means and smaller horizons, felt an overwhelming disappointment—a haunting fear that there should be something more, and there was not.

In 1932, Franklin Delano Roosevelt tapped into these sentiments as much or more than he offered solutions to the nation's economic crisis. In doing so, he both reinvigorated and redefined the nation's unique brand of liberalism. Mary supported FDR in 1932, perceiving him to promise a new form, albeit undefined, of economic system. The calamitous economic conditions of the 1930s prompted unprecedented governmental responses from the new admin- istration. The New Deal redefined liberalism by legitimatizing the active par- ticipation of government in the economy in order to stimulate demand, direct production, and compensate those otherwise unable to share in the nation's economic success. New Deal liberalism recognized a need for the government to give shape and direction to the economy. Earlier expressions of liberalism, most notably the Progressivism of the preceding forty years, had focused pri- marily on rights and in doing so retained some connection to classical liberal- ism. Progressives justified regulation by the need to preserve individual autonomy amid the growth of powerful trusts and corporations—perceived as enemies of rights that did not exist in earlier years. Conversely, the New Deal diminished talk of rights in preference for social planning and the rise of a communitarian ethic. New Deal liberalism changed liberalism and the United States but formed only a tenuous hold on the country's people.

Shortly after taking office, FDR gained passage of the National Industrial Recovery Act (NIRA) and the Agricultural Adjustment Act, creating one last chasm between Mary, who favored the laws, and Clarence, who opposed them. The NIRA created the Public Works Administration to distribute a $3.3 bil- lion appropriation for public sector jobs intended to reinvigorate the economy. The NIRA also created the National Recovery Administration (NRA) to su- pervise businesses as they undertook to establish codes for "self-governance" pursuant to government directives intended to encourage businesses to use their economic power to serve the public good. The codes established appro- priate wages, prices, and forms of competition within an industry. Large com- panies and trade associations dominated the drafting of the codes. Companies that complied with the code established for their industry were able to display

a blue eagle on their products and in their marketing. The government ran a public service campaign that, in effect, not only endorsed companies that displayed the blue eagle but also encouraged a boycott of those that did not. In addition, section 7(A) of the NIRA established some protections for labor organizers and collective bargaining. When Roosevelt introduced the NIRA, Mary "felt strangely happy to be in accord with my government." She perceived it as a necessary correction to the free market and worried only that, "the capitalists [might not] . . . allow the new economics to function."[12]

Darrow, however, criticized not only the NRA but also the NIRA's labor provision, refusing to endorse any law mandating unionization or collective bargaining. He stated that "I think labor has got to depend on itself, just the same as anybody else has."[13] The lifelong champion of labor made many of his long-term friends in its cause, Mary among them, shake their heads in dismay that day. However, H. G. Wells came to Darrow's defense. Wells argued that Darrow was a classic American "insurrectionist," committed to the "individual unorganized free common man." More sentimental than analytical, more of an anarchist than someone devoted to social order, Darrow fought "against rule, against law" and for the quixotic personal pursuit of autonomy, freedom, and self-fulfillment.[14]

Darrow's testimony before the Senate Committee on Finance did little to thwart passage of a new labor law. Section 7(A) of the NIRA encouraged employers to recognize their employees' rights to collective bargaining, but failed to create any authority for enforcing those rights. Most employers either shunned organizing efforts or created company unions, dominated by the employer. In 1935, Senator Robert Wagner successfully introduced a bill that would not only limit disruptions to business caused by labor disputes but also provide an "affirmative vehicle" for social change. Senator Wagner perceived cooperative efforts among laborers to be essential to securing employees' dignity. His bill created three new legal rights and provided a mechanism for their enforcement. The Wagner Act protected the right to unionize, the right to bargain collectively, and the right to use concerted economic activities, such as strikes and picketing, in the course of exercising the first two rights. The Wagner Act mandated that employers recognize and bargain with unions chosen by their employees and created the National Labor Relations Board as an administrative agency designated with the authority to enforce the law.

The law provided tremendous protections to unions as businesses operating as third parties in the employer-employee relationship. The law provided no protection from union actions to either management or individual employees. The Wagner Act permitted unions to establish closed shops and required management to discharge any employees who failed to join the union. The

law made no provision for other forms of union coercion aimed at forcing employees to unionize and allowed unions to engage in secondary boycotts and extensive picketing without legal limitations.[15] Mary celebrated the new law as a harbinger of restructuring the country's economic order. Roosevelt had fulfilled her greatest dreams for reform.

Darrow's rejection of the New Deal was not unusual for an old liberal whose politics took shape in the early days of the Progressive movement. Many of these liberals had become disillusioned; others moved toward a more rights-oriented liberal platform; still others, hoping for more radical change, saw the New Deal as nothing more than a corrupt compromise with capitalism. Their rejection of Roosevelt's programs frequently evinced less disappointment in the president than in the people of the United States. Like Darrow, the people generally were unwilling to give government the power it needed to make radical changes in the society of the United States. As historian Barry Karl has written, "Americans do not want an effectively managed government [or economy] if it limits their individual control over access to opportunities for personal achievement." FDR left the ownership and control of capital in the hands of private individuals and sought to manipulate corporations through political pressure. He succeeded only to a minimal degree, and the US economy returned to strength only with the need to mobilize for war. Radicals, both then and later, argued that the New Deal's only "success" was in muting calls for more aggressive reforms during the time of the nation's greatest economic despair, removing the most serious threats to the free-enterprise capitalism system.[16]

The US Supreme Court, as far back as the John Marshall era, recognized the commerce clause as giving primary responsibility for regulating interstate commerce to the federal government. But this responsibility, like all federal powers, had been tempered by the superior claims of individual rights, including the right to contract. The founders understood no hierarchy of rights. In fact, the founders included the protection of economic rights in the contract clause, while they reserved protecting the rights of free speech, conscience, and other civil rights until ratification of the amendments. Most important, they conceived of the Constitution as a social contract establishing law as a bulwark against the potential, in any democracy, of tyranny by a majority.

For much of the first four decades of the twentieth century, the Court used the contract clause, in combination with a substantive due process argument, to protect individual rights from government overreaching and as a check on majoritarian impulses to pursue political extremism in response to contemporary crises. The substantive due process argument, in reliance on the Fourteenth Amendment, allowed the Court to censor state actions that interfered with individual rights. For instance, in 1905, in its *Lochner* decision, the

Court struck down a New York statute prohibiting employers of bakery employees from permitting or requiring their employees to work more than sixty hours in a week. It found no reason to allow a state's police powers to violate the employers' and employees' rights to contract.[17] In the 1930s, the same reasoning had been used to nullify much of the early New Deal legislation. However, after FDR's reelection in 1936 and his threat to pack the Court, the contract clause began to fade into memory. In April 1937, the Court upheld the Wagner Act under the commerce clause of the Constitution, and a new era of jurisprudence was born.[18]

Of significant importance to the new liberals was a footnote to the decision in *United States v. Carolene Products*, in which the Court introduced its policy of deferring to state legislatures in passing laws reflecting cultural value judgments. The justices reserved the power to more scrupulously review legislation that may be "directed at particular religious, national, or ethnic minorities," than at broadly defined economic rights. The Court further noted that such "prejudice against discreet and insular minorities . . . tends seriously to curtail the operation of those political processes ordinarily to be relied upon to protect minorities."[19] In distinguishing civil from economic rights, the Court assumed the authority to find some rights more important than others and minimized the role of the contract clause in the jurisprudence of the United States. And in defining rights as belonging to groups of people as well as to individuals, and in particularly identifying minorities as deserving of extra protection, the Court announced a jurisprudence in which certain rights pertaining only to certain groups may serve as the basis of legitimate legislative or judicial policies.

The bifurcation of rights asserted by the Court had no basis in earlier constitutional understandings and arose instead purely from political considerations. The Court created the preferred position of civil rights relative to economic rights in recognition of civil rights having social value. As the idea of natural rights lost favor, rights that did not have social utility lost significance relative to those that did. The legal positivist positions expressed by Zecharia Chaffee Jr., Louis Brandeis, and Oliver Wendell Holmes in arguments for the social utility of civil rights created a new rights jurisprudence. The Court devalued economic rights in order to place economic interests on an equal legal footing with civil rights.

The *Carolene Products* decision provided a legal basis for the new liberals to argue that social justice, understood as an expression of civil rights, held greater significance than economic rights. The Supreme Court had paved the way for legislation rooted in sympathy and humanitarian concern. But Mary, already nearing sixty years of age, seemed uninterested. She reveled in the promises offered by the Wagner Act but otherwise felt weighted down by a disenchantment

with revolutionary causes. She wondered whether "liberalism is but a brake on the wheel of progress?" Perhaps, she mused, capitalism was the system of the future—born, as was the United States, in revolution, and still very far from perfected or fully realized. In such a case, liberals provided a necessary contribution as critics who might shape the course of history but could not hope for success on their own terms.[20] She still felt the pain of injustice, but had come to accept it as inevitable—the product of human self-interest, or as others put it, the human condition. She wrote, "I do not think this is a moral universe to begin with and our morality is the outcome of our economics. To think with Nietzsche it is neither moral [n]or immoral—just is." Upset over a report of a lynching and a governor's praise for the racist vigilantes, she lamented the seemingly inherent sadism among people and the inadequacy of the legal system to address it. She let herself consider whether some people, those "rotten to the core," are "better off dead. . . . better for the human race."[21]

Mary saw her old friend Darrow at a party held in his honor in 1934. She expressed shock at how small he looked, as he remained somewhat bent over while standing or sitting. As Lem and she left, she told him that "her heart ach[ed] horribly at the sign of death upon [her] . . . friend." The next day she picked Darrow up at his hotel to take him to lunch and felt that he was but a "shadow" of himself—uninterested in her and in the world, his "face . . . shrunken, cheeks hollow, eyes cavernous."[22] In winter 1938, Mary learned of Darrow's continuing decline. She shared the news with Sara:

> I have tragic word from Chicago, namely that Mr. Darrow has lost his mind, just walks up and down, up and down, mumbling and muttering. Paul, his son, writes that they have no hope of his recapturing his memory. Intimate friends are strangers. I personally think he has retreated from a world that was too inhuman and cruel for him to bear. Unlike you, he had not . . . refuge into which to escape: a world of beauty. He knew nothing of the solace of music. Science only confirmed his beliefs in the fixed pattern of homo-sapiens, his fundamental brutality, cruelty. Art was an unknown door. Nature alone comforted him. Of all the people I have met in my lifetime of meeting people, I never knew a soul who shrank so before cruelty.[23]

Darrow died, at age eighty, on March 13, 1938. Mary marked the day and time (12:30 p.m.) with this journal entry:

> Darrow died today at this hour. That is, his body died following the earlier death of his brilliant mind. It will not be long before a generation will say, "Who was Darrow—never heard of him."

So quickly the waters of oblivion close over even the great of a generation. Goodbye dear friend. We spoke the same language—the inarticulate language of the heart. You who never knew a moment free from heartache over man's travail, now are free . . . yet death ending consciousness, you do not know you are free. Oh grave, where is thy sting? I know. It is in life itself, for such as Darrow. Farewell, Good night.[24]

Mary began working on different types of writing projects as early as the 1920s. With Lem's constant encouragement and through his contacts at various publishing houses, she successfully placed numerous fictional stories in magazines and, by the late 1930s, turned her attention to writing travel books that emphasized local cultures and politics. The two genres, in Mary's capable hands, merged to some degree, as each offered a window into cultural understanding and provided a surprising outlet for her romantic sensibilities. Whether writing fictional stories of young immigrants, or telling readers about New York or Washington, DC, Mary encouraged an empathetic sensitivity to different social values and lifestyles and, in an implicit apology for her time in the settlement house movement, denigrated the need of some to impose on others middle-class standards for timeliness, cleanliness, or competitiveness.

Mary's short stories generally address people's conceptions and pursuit of the American dream. To do so, she repeatedly turned to stories of immigrants, young couples in love, and of the cultural meaning of Christmas. In several instances, she creates fantasy tales involving witches and fairies to convey the values she hoped to impart to her readers. These stories present the bourgeois temptation to assert the universality of moral values while lampooning the presumptuousness of those who would try to impose them. One wonders how much Mary, aware of the parallels to her own life, wrote in order to expel the tension in these positions. In one story of a father fighting to retain custody of his daughter after his wife died, Mary pillories self-righteous and well-intentioned people who try to impose their values on others. The father is forced to rebut the argument, prevalent among neighbors and relatives, that his home is inappropriate for raising children because it lacks a "woman to do your cooking and sewing." Another story describes two young people, told they lack sufficient funds to marry after the man's wages are cut during the Depression, who forgo a fancy wedding and strike out on their own to California. Both stories castigate patronizing busybodies for their intrusive judgments. Happiness comes to the heroes in the stories only when they ignore public opinion to follow their own wishes.[25]

Several of Mary's stories are vulnerable to the criticism that her text seems too preachy and moralistic. In "The Durable Angel," a burglar breaks into a

home on Christmas Eve and is discovered by a five-year-old boy. The burglar pretends to be Santa, trimming the tree and talking to the boy before sending him to bed. Then he steals the gifts. The boy's parents later attend the criminal trial of the man and learn he is really a nice person fallen on hard times who grew up poor and never had a Christmas tree. After the man is released from jail, the boy's father hires him at his business. The one-time criminal, once given a chance, proves to be an excellent employee and every year thereafter distributes Christmas trees to poor families. In "The Miracle in Apartment Five—Rear," a six-year-old girl supplements the family income by making artificial flowers at home, hoping to buy a goose for Christmas. The girl's teacher learns of her efforts and has her successful boyfriend provide a job for the girl's father.[26] In these stories, Mary appeals to wealthy or middle-class people as potential redeemers of criminals or poor people. She asserts a duty, arising from the human condition, for the able to take care of the needy.

Perhaps Mary's best stories concern women who hope to develop and express themselves professionally and sexually and encounter societal limitations and condemnations in doing so—women who openly share their attitudes on love, desire, conformity, and societal repression. In "The Sails of Destiny," Mary depicts marriage as analogous to the white picket fence of her youth, defining a realm of appropriate play and preventing new adventures. The wife at one point says to her husband: "I'll tell you a secret. A woman may be ever so much in love with her husband, can despise the disloyalty, the ill-breeding of flirtation; but she always cherishes the thought that she could attract men; that she could, if she would encourage a romance, promote an adventure." In another story, Mary depicts young modern women, one a president of a brassiere company, who engage in sex with multiple partners, have careers, smoke, drink, and generally flout conventional norms. While they remain unperturbed by the censure of the moralists, they are troubled by the realization that this fun will end when their looks decline.[27] The moral is not that women should pursue more permanent forms of love and satisfaction but rather that they should enjoy the transient forms while they can, for the enjoyment they bring is fleeting.

Mary addressed her stories to successful, or at least middle-class, readers. She implored them to adopt a greater social awareness and to press for greater sexual freedoms. But while she criticized those who attempt to impose their social values on others, she readily filled her stories with values and judgments she hoped her readers would share. In writing her travel books, she had to be more restrained, but she still made her point.

Mary published her book on Washington, DC, in 1938. The title, *Your Washington*, indicates her thesis: that a traveler to the nation's capital should come

to the city "as a friendly employer visiting a great cooperative undertaking: the maintenance and management of Democracy." The book conveys to tax-payers how they can access government to gain assistance on agricultural, transportation, or legal issues and discusses the various communities within the city and their issues, concerns, and contributions. One reviewer wrote that the book was of at least as much value to "high school students of civics and government" as it was to travelers. A review in the *Los Angeles Times* noted that "while there are guidebooks to lead them about the streets, . . . [this] is the first to show them that city as their servant, their instrument, their laboratory, and reference room."[28]

By the time Mary's next book, *Metropolis*, on New York City, came out, *Your Washington* had become, in the words of one reviewer, "the favorite guide for older young people on a pilgrimage to the nation's capital." *Metropolis* dealt even more with the people in New York, their cultural communities and var-ied ways of life. A reviewer refused to consider it a travel book: "If this is a school book, let's have more like it, but I'd call it a home adjunct to the educa-tion one now gets in school." The reviewer loved the book's focus on how people lived rather than on tourist information.[29]

By the late 1930s, the world seemed to encroach upon the life Mary had built for herself. Events in Europe and in Asia promised yet another war, pos-sibly even worse than the last, and a rapidly changing culture challenged her vaunted liberalism. The New Deal had done little to alleviate the sufferings of people during the Depression. In June 1935, Mary calibrated the tolls of people's despair: "60,000 suicides in 1934; 45,000 murders; 65,000 automobile deaths; untold thousands of sex crimes." She concluded that "man is a killer. . . . Our society is so insecure, so hopeless, so hungry."[30] Sometimes the despair seemed to overwhelm her, as she confessed to being too numb to cry or feel ill at the "terrible injustices" and "cruelty" all around her. After lunch with her friend Lydia, she noted that communists always talked about economic injus-tice when they came together, reciting the timeworn maxim "the workers will soon rise." However, her coterie of radical friends increasingly believed that the workers would not do so. Having lost their belief in revolution, Lydia and Mary confided to each other that among their friends, they found themselves not truly communists any longer but almost conservatives.

The world was changing, and Mary had to change with it. At age fifty-seven, she decided to learn how to drive a car; society now required mobility, and driving became necessary. The labor movement, once such a great passion of hers, had been restructured as well. Finding that the laws granting collective bargaining rights and creating closed shops had failed to reallocate power and wealth, she found herself parroting Darrow in asserting that the essence of

the labor movement must be love—"the brotherhood of the workers"—and that commitment to brotherhood seemed nonexistent.[31]

In 1935, Japan invaded China and Italy invaded Ethiopia. Adolph Hitler, elected chancellor of Germany in 1933, formed an alliance with Benito Mussolini of Italy, and together they made plans to support General Francisco Franco in Spain. Mary lamented that despite all their wars, people had learned nothing: "guns still thundering, the bayonettes [sic] yet plunging into young hearts and bellies."[32] Within a few short years, guns and bayonets would seem like children's toys in comparison with the new weapons unleashed on the world.

But what most disturbed Mary was a perceived decline in culture. "When I was young," she wrote, "we had tremendous discussions about socialism, *sex*, Bernard Shaw plays, our jobs." Everything then seemed so important to her, and she anxiously partook of vibrant discussions on a variety of topics. Now it is all just "talk, talk, talk," she bemoaned. In March 1935, she expressed utter exhaustion after a conversation with her more liberal friends. She found their repetitive reliance on well-worn phrases, "humble the proud," "exalt the lonely," both vapid and irritating. "I want to escape," she noted. After a friend's birthday party, at which "pleasant people" engaged in "pleasant talk" while eating lobster and pastries, she said: "I am *starved* for intellectual conversation. . . . [I must] talk to poets, philosophers, thoughtful people." Of course, many of her longtime companions, who shared her taste in literature, politics, and theater, had died, only adding to her despair.[33]

Mary longed for the cosmopolitan society of her Bohemian young adulthood. Not even the Depression, it seemed to her, could erode the growing parochialism of her society; in fact, it seemed to encourage it. The Depression prompted many to seek security and comfort in traditional values even as the era encouraged others to see hope in the dawn of a new political culture. Mary felt alienated from both the patriots and the revolutionaries, believing the former to be shallow-thinking reactionaries and the latter to be sophomoric idealists. She found that Americans expressed a type of religiosity in their "love for America." Much as the Bible teaches people to devote themselves to the one true God, worship him, and preach his message to others, she understood patriots to devote themselves to the United States; worship the flag; and work to spread its message of Christianity, democracy, and capitalism throughout the world. Like Christians fearful of the devil's influences, patriots sought to keep their enemies at bay. "By hating Jews, communists, socialists, trade unionists, liberals, dissenters of the palest pink—and prosecuting them," Mary saw patriots as defensively protecting their small little world from different

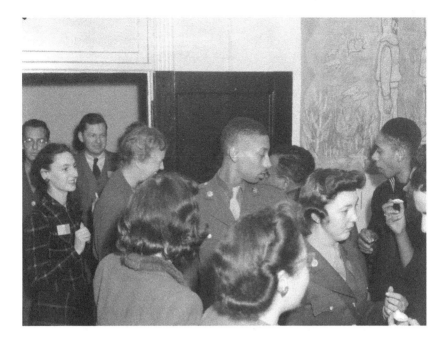

FIGURE 7.1. Mary had no female role models and very few powerful women whom she could idolize. Eleanor Roosevelt, shown here opening a federal labor canteen in 1944, was an exception. Courtesy of the Library of Congress. Horne, Joseph A., photographer. Washington, DC, United States. Washington, DC, 1944, February. Photograph. https://www.loc.gov/item /2017864316/.

ideas, religions, cultures, and values. She concluded that the love of country required a lot of hate of everything else. But the revolutionaries were no better. As they spoke of the workers uniting, while they ate lobster and drank martinis, Mary could only chuckle scornfully. "The system is safe," she concluded, "so long as we sit beneath the grape arbor and curse and drink beer. And that's all I want to do."[34]

Mary did put down her beer and move from under the arbor long enough to campaign for FDR in 1936. Despite protestations to the contrary, politics still interested her. Mary capitalized on her well-known name in liberal and literary communities to undertake a speaking tour on behalf of the president. Yet her motivation derived more from her respect for the first lady than for the president (see figure 7.1). "Mrs. Roosevelt is to me the embodiment of the American Constitution," Mary wrote. "She is the word made flesh. She is the Constitution in its guarantees of free speech, assemblage. She is Christianity in its brotherhood and fellowship." FDR's reelection even prompted a flirtation with patriotism:

This election restores one's faith in the masses. I felt very patriotic and devoted to democracy. Perhaps I am wrong, but today it seems to me that only through this form of government can the human spirit grow, only in this freedom (limited though it may be) is there room for development. Communism may assure bread, shelter, clothing, but at the price of freedom of thought, movement. I'd rather be a beggar here than a machinist under communism.[35]

When Mary met Darrow, she had an intellectual curiosity about the world, a desire to utilize her very capable mind, and a sense of justice that compelled her to pursue social change. She lacked the cultural exposure and intellectual openness to embrace cosmopolitanism, and she lacked the emotional capacity to love others and empathize with their suffering. Darrow, over the course of nearly thirty years, cultivated these characteristics in Mary. By 1940, she viewed events at home and abroad through the dual lenses of a sophisticated cosmopolitan thinker and a tenderhearted woman caring for humanity.

As Mary heard of the Nazi invasions of Poland, Denmark, Holland, Norway, and France, she focused almost exclusively on the suffering of the people in these lands. "Oh you hideous crazy cruel creature-man," she wrote. She remembered when she studied German in school, and later when she visited Europe and "sang at the German Athletic Club. Grey hairs and brown sat around the singing tables. Why must we kill Germans and Germans kill us? Why can't we all drink beer, sing, and march down the road [together as] . . . comrades?" Once again, Mary expressed disgust with nationalism and hoped to see people united rather than divided by religion and patriotism.[36]

She had to laugh at humanity as she despaired over its cruelty. Within just a few minutes, the radio told her "of the terror over England and the efficiency of Crisco in baking and the rape of France and [it played] a cute jingle about a new toothpaste." Capitalism necessarily promoted consumer purchasing even as the world crumbled around it. But Mary found domestic politics just as unsettling as world affairs. After seeing the film *Mr. Smith Goes to Washington*, starring Jimmy Stewart, Mary asked, "What does this picture to do the millions who see it?" The movie, "says this is a government for, by, and of the people." How, she wondered, can the followers of Father Charles Coughlin reconcile the ideals of the film with the expressions of their political leader? Democracy had to tolerate men like Coughlin, but one hoped it could also overcome them. Certainly, in 1940, democracy appeared threatened by extremists at home and abroad. Always thoughtful, Mary lamented that totalitarian states could form and execute strategies far more quickly than democracies. "Democracy moves like a huge snail," she observed. "Dictatorships move like

panthers."[37] Surprising even herself, Mary supported the entry of the United States into the war, even as she hated war. The Japanese attack on Pearl Harbor served merely as a confirmation of what she knew—Americans once again had to fight and die; but this time they did so in self-defense and the need to defeat an evil enemy.[38]

Mary continued to write as the war started. However, professional and world events took a back seat to personal tragedy in 1943 when Lem died. She now felt truly alone. Her pen was silenced as Mary become disconsolate for a while and turned inward. Nothing seemed to interest or mobilize her; not even the end of the war enthused her. But a couple of years later, a new age of labor relations was born, and it again slowly but surely energized the workers' ally.

Mary wrote, "Children do not play. They work; but their work is [in pursuit of] joy, pleasure, creation. Some day man may work that way too." She retained an ideal of labor, business, and society that had no counterpart in the world in which she lived. Still, it colored her perceptions of the national labor law. The Wagner Act constituted the nation's first broad-based labor legislation. It championed a collectivist approach to labor and gave huge support to unions. By 1947, union membership had grown from three million to fifteen million since the passage of the Wagner Act in 1935. However, a more conservative Congress than that of 1935 began considering the voluminous complaints from management and individualistic-minded employees over union corruption, intimidation, and economic bullying. In June 1947, Congress passed new legislation, which President Truman promptly vetoed. Congress overrode the veto less than two months later, and the Taft-Hartley Act became law as the new National Labor Relations Act.

The law returned to a legal construction of labor-management relations as an economic matter, not a class-based social concern. The Taft-Hartley Act recognized employee rights apart from unions, including the choice to join strikes, picketing, boycotts, and other concerted activities. The Taft-Hartley Act also recognized seven activities engaged in by unions that would now constitute unfair labor practices, severely limiting picketing, intimidation, coercion, and some forms of union corruption. Perhaps most important, the new law revised the procedures under which employees chose a union, allowing management a right to participate in union election campaigns and establishing a more democratic process involving private ballots. The law also, for the first time, compelled collective bargaining to be cognizant of the law of supply and demand. Management was permitted to employ replacement workers during an economic strike at the same rates of pay and on the same terms as those rejected by the union prior to its walkout. In other words, the company could test the market "fairness" of its offer by its appeal to replacement

workers. If it could hire enough workers to keep the plant open, the last best offer was competitive; if not, the offer was not competitive.[39]

The new legal construct appalled the long-term union supporter who perceived "workers' issues" as class-based concerns for social equality. Mary responded to the new law as if Congress had just denied labor's right to organize. She claimed, "Labor today was sold into slavery. . . . What wicked men these legislators are, destroying what men have struggled to attain—freedom. May terrible revenge for the national consequences [come] to Senators Taft and Hartley, who forged the chains."[40] Mary, for all of her experience in the world and her growing disillusion with liberal dreams, still saw the world as divided and defined by class. In fact, the labor movement achieved its greatest successes after the passage of the Taft-Hartley Act.

During the 1950s, the United States experienced what has been termed a time of consensus. Tensions percolated under a placid surface as concerns over race discrimination, women's rights, juvenile delinquency, and the threat of nuclear annihilation brewed without demanding the public's full attention. Fresh from victory in World War II, Americans, for the first time, truly felt they lived in the most powerful country in the world, enjoyed the best lifestyle, and could expect the best future. As if in confirmation of these beliefs, Americans turned out babies at an unprecedented rate, forming the baby boom that would eventually transform the culture of the United States once again. Differences in politics, religion, and lifestyle continued, but they seemed to matter less to a people committed to putting the Depression and two world wars behind them and simply enjoying their lives.

Even Mary felt a form of contentment during the 1950s. In fact, she took some credit for having influenced the changes that resulted in social improvement. Remembering her years in reform movements in Chicago and New York, she wrote:

> But what we didn't realize was that society's thinking would parallel our own, that society would change without revolution and without inaugurating a new social system and that we would achieve almost everything we had fought for. Our social concerns became the social concerns of the cities and of the nation because of the constantly expanding conscience of society. As society becomes aware of social wrongs it corrects them— slowly but eventually. The function of young radicals, as I see it now, is to call attention to the evils which need correction and to function as a stimulant to the conscience of society.[41]

In her conclusions, Mary emphasized an understanding of social change consistent with that asserted by the pragmatic thinkers she studied in her youth. Change came from the "bottom up," as people reacted first morally, then politically, to social wrongs and injustice. Mary had lived to see society embrace not only many of her values but also her approach to social change. The political culture of the country moved incrementally, especially relative to the developments in business and technology during the same period, but it did move.

Mary remained thoughtful and quick-minded but increasingly relied on old biases and an almost blind devotion to the Democratic Party. She also turned, once again, to Christianity for confirmation of her values and life choices. Perhaps none of these tendencies are surprising for a woman who turned seventy-two in 1950. She clung to the ideals, values, and social goals of her past regardless of their currency in the world in which she now lived. Though the Supreme Court, in its *Carolene Products* decision, had paved the way for legislation addressing special interests of the very groups she had long championed, she rejected some of the means by which social justice was being addressed by younger liberals. Mary showed little patience with identity-based legislation and with those who offered psychological interpretations rooted in sex or race to explain social inequities. At dinner parties she challenged the position that "group identification" was largely determinative of "social attitudes." She saw the world as simply divided by class distinctions and quests for power. The rich and powerful always had increased the misery of the poor and powerless, she believed, and always would.

Mary had a similar reaction to events developing on the international stage. She had seen the same pattern play out so many times that she had become numb, noting her inability to generate much sympathy for the people in the Middle East and Hungary who suffered greatly in political struggles. She even lacked an interest in reading about the events, deeming newspapers "a waste of time," merely "retelling over and over the agony of mankind," though she claimed that her "conscience bothered [her]" over her lack of interest.[42]

As Mary castigated herself for her lack of concern over other people's sufferings, she continued to be troubled by the seemingly incessant wars in which the United States found itself. She could not help but believe that wars appeared inevitable because war proved beneficial to some—each generation of military officers seeking glory and promotion, the arms manufacturers who profited from war, and the fearmongers who gained political power by finding new threats and enemies that needed to be vanquished. "There would be no organized war if not for profits," she contended, while grieving for the "mothers

who have lost their sons in the senseless, [yet] profitable Korean War." She argued astutely and presciently that the Cold War was not really about capitalism versus communism; it was about control of colonial lands as colonial people began to exercise their own autonomy. Despite differences, policy makers in both the United States and the Soviet Union believed that the rise of the "third world" had to be controlled for "White people" to continue to appropriate the wealth from lands held by darker-skinned people.[43]

The lifelong inconsistency Mary harbored between her denigration of materialistic drives born of capitalistic morals and her own desires for fine things and a genteel existence continued to express itself into her seventies. She had been a property owner profiting from rents for decades yet seemed unable to view herself as a capitalist, even when complaining that the tenants' demands for a new furnace in one of her apartment buildings would depreciate her savings and profits. Alone in her beautiful home on the Hudson, she frequently rode into the city with her neighbors, including Mr. Vanderbilt. Mary commented, "What a nice family the Vanderbilts are."[44] The rich people she knew offered a counterpoint to the poor whom she knew. She found it easier to love poor people she had never met than the various "morons" who crossed her path as maids or salespeople. Conversely, Mary found it so much easier to pillory bankers and industrialists whom she had not met than those who were friends or neighbors. She could assume that the ones she had not met were not "nice," that they intentionally caused pain to the less fortunate, and that they deserved whatever suffering they might receive as a result of the redistributive policies she championed. Her neighbors, the Vanderbilts, were different.

Mary, during the 1940s and 1950s, seemed always to be losing loved ones. In April 1953, Erskine Wood, whom Mary described as "poet and thinker, Sara's fond companion-husband," died. Mary noted that his funeral was attended by "scores of friends [who] ate and drank under the shade of the grape vines that roofed the tiled patio." Mary admitted to not feeling particularly close to Wood, but to "feel[ing] a distinct loss; one by one then passes [sic] the landmarks of other days." Fortunately, Mary had introduced her precocious daughter to many of her friends, and Margaret could now share a sense of her mother's losses. The two of them reminisced about the great men of "personality and character" who had enriched their lives: Fremont Older, Carl Sandburg, Erskine Wood, Lincoln Steffens, and—of course—Clarence Darrow.

Mary, looking backward, appreciated what she referred to as the Bohemian style that characterized her looks and tastes and found it so very different from that of the 1950s. She contrasted herself with the actress Grace Kelly, whom Mary acknowledged to be a lovely woman but so much more elegant in style and appearance. Simultaneously, a new Bohemian lifestyle, of which Mary

seemed quite unaware, focusing on jazz, the Beat poets, and an individual quest for meaning in the homogenized world of the 1950s United States, percolated in Greenwich Village once again, just across the river from Mary's home.[45] Of this Bohemian resurgence she remained completely unaware.

To be fair, many more Americans perceived the more tranquil aspects of American life than had a great awareness of Thelonious Monk and Jack Kerouac. Cultural rebels seem always to be generational icons with limited abilities to transcend age differences. Mary lived in a realm defined more by custom and habit than new experiences. As a result, she came to reject new cultural values and attitudes. Admittedly, much of American culture in the 1950s would not appeal to anyone with a rebellious temperament. Television, through both programming and advertisements, brought images of a prescribed way of dressing, speaking, eating, acting, and even thinking to millions coast-to-coast. Levittown, a large real estate development of identical "tract homes" near New York City epitomized, for many Americans, not only this prescribed homogeneity but also a tremendous rejection of cultural taste as expressed in architecture and home furnishings. Mary detested this new culture of the 1950s United States, noting after a visit to a friend's home in the suburbs, "Frances Adams comes and draws me to see her little stone house which [now] faces a hideous development. Why called a '*development*' when trees are cut down, the forest floor leveled, and hideous little chicken coops built like rows of privies, all alike, naked under the scornful sun."[46]

Yet even when new attitudes endorsed self-assertiveness, Mary seemed to prefer "sameness" to change. In the 1950s, young adults embraced a new conception of the nuclear family as an entity apart from parents, uncles and aunts, and cousins. These young people, asserting their autonomy as a means of gaining independence, took advantage of interstate highways, suburban developments, and greater disposable incomes to leave the cities, and extended family living there, for new homes of their own. Mary resented Margaret's decision to live miles from her and openly expressed her disappointment to her daughter. Mary had taken her widowed mother into her home; Margaret refused to behave the same way. Mary contrasted her exclusion from Margaret's happy home with her treatment of her mother: "I think of my little mother and how eagerly we begged her to stay with us." She had apparently forgotten not only her moves to Chicago and the West Coast but also the more recent arguments over the radio. Significantly, Mary failed to realize the degree to which her life was out of step with that of her daughter.

Mary's reactions to cultural changes at this time indicate how difficult living with an older woman intent on imposing her own values on her daughter would have been. Mary urged irreligious Margaret to adopt Christianity and

showed little appreciation of Margaret's priorities, positions, and attitudes, thinking she had the answers to her daughter's stresses. During a visit to Margaret's home for a dinner party with professors from Swarthmore, she was "shocked" by their discussion of the prevalence of nervous breakdowns among both students and young adults. Why and how could these people be so frail or weak?, she wondered. What had society come to that successful and intelligent young people felt so overwhelmed? The writings of Dr. Spock, encouraging parents to befriend their children, encourage them with positive reinforcement, and abstain from using corporal punishment, shaped an entire generation of young people, especially in the North, during the 1950s. Mary, however, seethed at Margaret's adoption of Spock's methodology and encouraged her daughter to use "the rod" more frequently.[47] Mary wrote in her diary: "Margaret upset. She works hard and comes home to a poorly cooked dinner and a disobedient, demanding, violent, assertive little boy. And she is *so* devoted. He needs a good spanking—unsparing of 'the rod' . . . He is [a] smarty this little 5 ½ year old. I love him but he aggravates."[48]

As a girl, Mary fought mightily to establish her independence in a home in which her father sought to mold her thoughts, beliefs, and behaviors. She accepted brutal punishments rather than submit to his will. As a young woman in Chicago, she rejected the proposal of a wealthy young man who also tried to mold her by censoring her smoking and drinking. She was later criticized by judges and newspapers for her outspokenness and yet never regretted, for even a moment, her fiercely independent nature. But, late in life, she had trouble giving the same degree of autonomy to her daughter. She knew best how Margaret should live and how she should raise her children.

Despite a diminished interest in popular culture and politics, Mary continued to pursue intellectual stimulation. She found the work of Royce Brier particularly interesting, supporting the Pulitzer Prize–winning author for his argument that totalitarian leaders, like Adolf Hitler and Joseph Stalin, are products of sick societies rather than the creators of them. The library became her favorite place in the city. In October 1952, she wrote:

> Today I smelled again that strange nameless combination of marble and books. Felt the thrill of knowing of hundreds of books back in the stacks of locked away wisdom, entertainment, information—to be released by presenting a little slip of paper properly designating the book wanted. I envied the people purposefully entering—they had a job to do—research. The pregnant quiet of the library excites me. The sound of feet softly treading hushed marble. And I wanted to tread as one walks in the cathedral—reverently. I felt a sensation of—almost love for

the kind woman who helped me find the references—the servant of my lord library.[49]

Mary, who had resented the intrusion of the radio, believed, in 1955, that she "needed" a television set. Yet at every turn, it seemed, her values and perspectives were challenged by contemporary society. She exclaimed that pork chops that once sold for sixty-eight cents a pound now cost $1.66 a pound— "and they will go higher . . . imagine!" For a woman who had lived through the Depression, albeit in fine style, inflation proved to be a hard pill to swallow. She turned more frequently to the Bible and the more doctrinaire beliefs of her childhood. Her diary during the 1950s became dotted with references to Christian holidays and aphorisms, and she increasingly sought God's intervention in helping her through life's struggles.

Mary devoted less time to political engagement while she relied on party identification for her preferences. She saw the 1952 campaign between Eisenhower and Stevenson as a "military man" contesting with a "scholar" who had run a "nice administration as Governor of Illinois." She liked Stevenson's concern for the environment and his promise to address poverty, but she was drawn to him mostly because he put "transcendental spiritual values above materialism." He was also a Democrat. When Eisenhower, generally perceived as a moderate, won, Mary lamented the "landslide for the reactionary candidate backed by all the money interests, the fascist minded, the power hungry." In January 1953, she acknowledged that his inaugural address was "full of noble sentiments with which no one . . . would quarrel." Upon Eisenhower's reelection she expressed hope that the Democratic Congress would "offset the reactionary." Again, she watched the inauguration on television, commenting that it celebrated the people acting on their will to choose its leaders and deeming it "profoundly significant."[50]

By 1960, her interest in politics had waned even further. Now eighty-two years old, she watched the Republican National Convention on television but remained silent regarding Richard Nixon and the party platform. By election day, she was much more concerned with her health and her loved ones than with Kennedy's victory. Meanwhile, Mary found it increasingly difficult to attend worship services and not only missed them but also expressed a "dreadful need" for them. Without worship in a beautiful church, she lacked the "radiance from celestial imagery" that might "lighten the dark places of the mind."[51]

Had Mary paid more attention to politics during the 1960s, despite her antagonism to some of the new doctrines, she most likely would have identified with the calls for social change and the tensions in liberalism that came to the fore. Not only did the country erupt in protests over still another undeclared

war, persistent racism, and changing ideas of gender roles and the meaning of sex, but liberalism fragmented once again. Ultimately recognizing the untenability of the form of liberalism Mary had espoused, liberals briefly divided between those who advanced a rights-oriented protection of individual freedoms and those encouraging a greater commitment to the social good emphasizing collective responsibilities. Some of the motivation for the reassertion of individual freedoms came from an antipathy to an increase in identity politics and resulting legislation, legitimized by the *Carolene Products* decision, that created new rights for distinct groups of Americans. The laws fulfilled some of the promises of pragmatism and the desires of Brandeis and the legal positivists.[52] Yet, equally important, young people, longing to express their own individuality in ways that challenged traditional norms, asserted an individual rights-orientation that at times brought them more into alignment with contemporary conservatives than with the liberals of Parton's time.

Libertarianism, having its roots in the guiding principles of the nation's founding, had broad appeal among Americans in the 1960s. Liberal Supreme Court justice William O. Douglas and conservative senator Barry Goldwater from Arizona expressed largely indistinguishable ideas. In his 1960 publication *The Conscience of a Conservative*, Goldwater described his political goal as "achieving the maximum amount of freedom for individuals that is consistent with social order." Noting that the government posed the biggest threat to individual rights, Goldwater advocated "the utmost vigilance and care . . . to keep political power within its proper bounds" and understood the Constitution as "an instrument, above all, for limiting the functions of government" so as to protect individual rights. Douglas made the same point in asserting that "the purpose of the Bill of Rights is to keep the government off the backs of the people." His consistent defense of the rights listed in the first eight amendments as providing absolute protections lends credence to his libertarian beliefs. Douglas is perhaps best known for his articulation of penumbral rights, specifically regarding privacy and association. Goldwater endorsed freedom of association a few years before the justice articulated it, writing: "What could be more fundamental than the freedom to associate with other men, or not to associate, as each man's conscience and reason dictate?" In accepting his party's nomination at the Republican National Convention in 1964, Goldwater famously asserted: "Extremism in the defense of freedom is no vice. Moderation in the defense of liberty is no virtue."[53]

More collectivist liberals criticized their rights-oriented brethren for their legal protection of individualism, which many of them perceived to be a lost ideal, "irretrievably gone," and properly laid to rest to allow the construction of a new communitarian society. These collectivist liberals contended that a

commitment to law and democratic political traditions frustrated economic reforms. Of course, anarchists and socialists had made the same argument around 1900, and just thirty years earlier New Dealers castigated the Supreme Court for the same reasons, contending that "we talk . . . in this country too much about freedom in a political sense and too little about freedom in an economic and social sense."[54]

Some of the fragmentation among liberals, and ultimately within society as a whole, during the 1960s can be attributed to a new generation of Americans trying to make sense of their world. The United States, after World War II, was unquestionably the most powerful nation on the globe. It was also the richest. The gross national product of the country increased by an incredible 250 percent from 1946 to 1960; the median family income doubled during that same period, and the stock markets regularly reached new highs. In 1956, for the first time in the history of any nation, the United States had more people employed in white-collar than in blue-collar jobs or on farms. The American dream seemed truly accessible to all. Home ownership, a college education, dinners out at fine restaurants, nice clothing, and modern appliances seemed within reach of all but the very poor and created "a feeling of limitless hopes and opportunities." Relieved of the stresses of having to labor for their existences, young people considered broader, more philosophically oriented goals and looked on the imperialism, racism, and the limited social opportunities for women in the United States with shame.[55]

Yet the protest movements on college campuses began in order to address none of these concerns. Rather, they followed a course mirroring Mary's own, starting in pursuit of greater sexual and academic freedom.[56] The libertarian leanings of young people expressed in these movements eventually gave way to those demanding social justice. The drastic change in the focus of young people in just a few years paralleled the changes in the broader liberal movement and appeared overwhelming to many Americans hoping just to revel in the postwar successes of their society.

Liberalism in the 1960s faced, as it has ever since, the same intellectual crisis that confronted Mary Field Parton. Liberalism's simultaneous embrace of both individual rights and prescriptive solutions to serve the social good limited its political ability to address either. The "revolution" of the 1960s was largely stillborn and succeeded mostly in creating a conservative backlash that lasted more than forty years.

Mary Field Parton could well have identified with the liberal crisis of the 1960s, but by then she cared little. The old lions of American liberalism had fought their battles in their own time, and would most likely have been disappointed but not really surprised to see the same battles being fought once

again. At Mary's age, personal concerns mattered more. Margaret found it increasingly difficult to tend to her mother's needs and demands and moved Mary into a nursing home in 1963. Mary, still thoughtful, resented the decision: "The executioner decides that today is the day for my execution. I, a sane and capable person, is [sic] shoveled onto another 'home' without any consulting of my wishes."[57] Mary lived the last few years of her life largely alone in the nursing home. Finding some comfort in her memories and in her Bible, she eventually succumbed to the inevitable in 1969.

AFTERWORD

Mary Parton lived a full and, by most people's standards, wonderful life. Yet, as an intellectual, she must be assessed on bases other than just success in love and career, the accoutrements of life, and the extent of her experiences. We must also ask whether she was true to herself: whether she integrated her attitudes, values, and beliefs into a consistent worldview and lived in accordance with it. Hermann Hesse begins his novel *Demian* with the following thought: "I wanted only to try to live in accord with the prompting which came from my true self. Why was that so difficult?"[1] The life of Mary Field Parton attests to the difficulty of that task. It also indicates the extent to which attempting to adhere to mutually exclusive values and ideas can prove destructive, not only of individuals but also of political ideologies.

For many years, philanthropy was largely understood as "voluntary action for the public good."[2] Such a definition supposes a consensus among Americans regarding the nature of the public good and the steps necessary to pursue it. In actuality, philanthropists have been a heterogeneous lot, most often concerned with imposing their vision of an ideal society upon others. In other words, philanthropy in the United States has always been a form of political activity.[3]

Mary committed her life to improving society—that is, to promoting its conformity to her values, perspectives, and political goals. Whether as a settlement

house worker, a supporter of union organizing, or an author of books endorsing a moralistic way of life, Mary sought to influence individuals so as to redesign an entire society. She was a consummate philanthropist who lost far more battles than she won.

The extent to which people like Mary Field Parton embraced radical politics—the use of violence, an endorsement of socialism, and the consideration of anarchy—demonstrates not only the widespread antipathy to the individualistic orientation of American law expressed at various times in the nation's history but also the strength of the culture wedded to individual rights to withstand such challenges. The people of the United States rejected radical appeals, in part because of people's ideological antipathy to these appeals and in part because the radicals themselves failed to express their positions with intellectual consistency and with a justification that extended beyond emotional sympathy. Freedom is defined in the United States in terms of rights, and liberal reformers, despite help from the Supreme Court, have never been able to reconcile the protection of rights necessary to protect some freedoms with the condemnation of other rights recognizing freedoms these reformers deem extraneous.

Incontrovertibly, Mary Field Parton, through her embodiment of the pragmatic ideal, helped to shape the liberal ideas and values that formed between the end of Reconstruction and the Cold War. She did so more by her actions than by her intellectual contributions. Even her writings emphasize emotion and personal interaction more than adherence to a consistent system of belief. Pragmatism reshaped the intellectual landscape during those eight decades. Simultaneously, liberalism transformed itself from an ideology expressing a rights-oriented individualism to a political doctrine advocating positive government action to improve the collective interests of the people of the United States. In the process, liberalism moved its home from the Republican Party to the Democratic Party and contributed to the building of a new political coalition of laborers, ethnic minorities, and eastern intellectuals. Parton helped to forge this somewhat anomalous political partnership.

But in the third decade of the twenty-first century, pragmatism has adopted a new guise and broadened its appeal. Beginning in the 1960s, pragmatism deviated from its roots in science and positivism, each of which imposed a rational framework upon pragmatist thought, toward a postmodernist humanism. Thomas Kuhn's *The Structure of Scientific Revolutions* (1962) is credited, by David DePew and Robert Hollinger, for asserting that "scientific theories do not organize data in ways that are any more, or any less, rational than political ideologies, religious beliefs, and aesthetic movements, and therefore that those who would strongly demarcate the rationality of science from the alleged irrationality of the other dimensions of life were misguided." These authors further

contend that "postmodern pragmatists are convinced that the full scope of self-creation, self-interpretation, and self-expression will be granted only when liberalism has liberated itself from the earnest appeals to human nature and natural rights that bewitched our founding fathers, and from the religious conception of the human condition that modern philosophy both displaced and at the same time preserved."[4] In fact, leading contemporary scholars find the roots of postmodernism in classical pragmatism.[5] Its recognition of emotional response as a means of knowing, rejection of the value of rational contemplation, embrace of plural and relative truths, call for morality to govern the conceptions and administration of justice, and emphasis on language as a means of shaping perceptions are all indicative of postmodernist thought that eschews reason and rationality.

DePew asserts that Dewey advocated nothing less than a "redescription of experience in which individual life is characterized as social and in which social life is described in interactive and cooperative terms that foster ongoing projects of social reconstruction through experimental inquiry and democratic decision-making." He adds that this "cooperative democratic experience in political, economic and educational, even private spheres, was for Dewey, to replace the comforts of religion."[6] A communitarian ethic would also replace the recognition of individual rights at the root of the US legal system.

Not too long ago, postmodernism seemed solely a product of the political left in the United States. Postmodernism's rejection of the importance of an objective truth in its pursuit of a usable one fostered a societal embrace of political correctness, identity politics, and a subordination of legal rights to political interests in social justice. Few could envision that the nation's first truly postmodern president would arise from the Republican Party in the form of a reality television star. Undermining faith in an objective truth, President Donald Trump spearheaded a populist crusade formed as much in identity politics and nonlegal conceptions of justice as any emanating from the left. In recent years, the far left and the far right have appeared strangely aligned as insurrectionists fighting governmental institutions and the laws undergirding them.

Mary Field Parton was almost certainly correct when she said that the nation remained safe from revolution when the leftist radicals were drinking wine and beer under the arbors. But can the same be said of the radicals on the right? Right-wing postmodernists seemingly join those on the left in rejecting principles central to American democracy: a respect for law, a reverence for truth, and the defense of individual liberties in speech and lawful action. The subordination of law and truth to right-wing political goals may well galvanize some on the left to defend individual rights from politics of any stripe. Yet many progressives seem not to have heard this message.

Mary's life is relevant today both for the insights it offers into the past and into our current political culture. Mary came of age at an exciting time in the history of the United States and the world. Far from being merely an observer of the new ideas, technologies, career options, lifestyles, and values that redefined society in the early 1900s, she assumed a prominent role in their adoption and development. A progressive thinker, she took advantage of the opportunities opening for women to crusade for reform, first in the settlement house movement and then as a writer focused on labor organizing and participatory democracy. Her actions, like those of many of her peers, gave expression to the ideas—pragmatism, Christian socialism, and primary group theory—that defined the intellectual age. Just as important, she became a leading exemplar of the "new woman movement," largely forgotten today, but a crucial antecedent to the flappers and subsequent quests for female autonomy and equal rights.

Mary's life embodied, to an unusual degree, the political tensions and prevailing ideas of her era and gave them meaning. Her life helps us not only understand these ideological, cultural, and political currents but also to appreciate the importance of intellectual consistency and informed reasoning. The ideological tensions and inconsistencies that Mary Field Parton faced are not unique to the early 1900s. These tensions are endemic to populist movements in the United States. Moreover, these inconsistencies dominate progressive thought and continue to perplex, frustrate, and hinder reformers in their pursuit of a more equitable society.

The life and worldview of Mary Field Parton present a cautionary tale to today's progressives who fantasize about a new "democratic socialist" movement in the United States. The very term is oxymoronic, assuming a free society can protect political rights while denying economic freedoms, and captures the very inconsistencies that bedeviled Parton. The difficulties she had in accomplishing radical social change indicate the problems inherent in promoting an agenda corrupted by inconsistencies and tensions. The United States' devotion to the primacy of law, protecting both the right to hold property and the essential freedoms of conscience and speech, even that which may offend, though threatened, has never been overcome. True equality is more likely to come from adhering to the law and respecting individual rights than by jettisoning both as impediments to radical social change. Radical change would require a revolution that topples the institutions and destroys the laws that protect everyone's rights. As Mary came to realize, she did not want a revolution any more than most of her fellow Americans did—then or now.

Notes

Introduction

1. This tension, and the cyclical cultural prioritization of one or the other, has been a central focus of my earlier work, in which I argue that it is a product of our dual intellectual heritage of Puritan communitarianism and Enlightenment individualism. A synopsis of the historiography on this topic appears in *One Nation Under Law: America's Early National Struggles to Separate Church and State* (DeKalb: Northern Illinois University Press, 2004), 190. Most recently, Robert Putnam, *The Upswing: How America Came Together a Century Ago and How We Can Do It Again* (New York: Simon & Schuster, 2020), contends that twentieth-century US history can be understood through fluctuations in its cultural embrace of "selfishness" and the "common good," somewhat more judgmental terms that convey the same dichotomy. Similarly, Heather Cox Richardson finds a "profound tension in America's two fundamental beliefs, equality of opportunity and protection of property." Heather Cox Richardson, *To Make Men Free: A History of the Republican Party* (New York: Basic Books, 2014), vi. Abraham Lincoln confronted this issue, which he expressed as follows: "Must a government," the "leading object" of which he defined as "to elevate the condition of men—to lift artificial weights from all shoulders—to clear paths of laudable pursuit for all—to afford all, an unfettered start, and a fair chance, in the race of life . . . of necessity, be too strong for the liberties of its own people, or too weak to maintain its own existence?" Quoted in Richard Carwardine, *Lincoln: A Life of Purpose and Power* (New York: Alfred A. Knopf, 2003), 169.

2. Eric Foner, *Free Soil, Free Labor, Free Men: The Ideology of the Republican Party before the Civil War* (New York, Oxford University Press, 1970). The best history of the nineteenth-century labor movement and the law's embodiment of Jeffersonian principles in reaction to it remains Christopher Tomlins, *Law, Labor, and Ideology in the Early American Republic* (New York: Cambridge University Press, 1993).

3. These are the words of the American Social Science Association (ASSA), one of the leading liberal organizations of the period. Quoted in Richard White, *The Republic for Which It Stands: The United States during Reconstruction and the Gilded Age, 1865–1896* (New York: Oxford University Press, 2017), 176, 192–193.

4. Edwin G. Burrows and Mike Wallace, *Gotham: A History of New York City to 1898* (New York: Oxford University Press, 1999), 790–791.

5. Richard White, *The Republic for Which It Stands*, 2. White writes: "The 'Gilded Age' exposed rot beneath the gilded surface. Historians once embraced corruption as diagnostic of the age, but for the past half century they have downplayed its importance.

They have been wrong to do so. The Gilded Age was corrupt and corruption in government and business mattered. Corruption suffused government and the economy."

6. Edmund Burke, English author of *Reflections on the Revolution in France* in 1790, was a major figure in the eighteenth-century Enlightenment that toppled monarchies and celebrated individual rights. Despite his role in advancing rights theory, Burke is seen as a conservative for his defense of societal order and civil standards, including those derived from Christianity, as essential to any democratic polity.

7. See Mark Douglas McGarvie, *Law and Religion in American History: Public Values and Private Conscience* (New York: Cambridge University Press, 2016), 48–80; Ronald G. Walters, *American Reformers, 1815–1860* (New York: Hill & Wang, 1997).

8. See generally Kevin White, *Sexual Liberation or Sexual License: The American Revolt Against Victorian Sexuality* (Chicago: Ivan Dee, 2000).

9. David Walker Howe, *What Hath God Wrought: The Transformation of America, 1815–1848* (New York: Oxford University Press, 2007), 342.

10. Christopher Lasch, *The New Radicalism in America: The Intellectual as a Social Type* (New York: W.W. Norton, 1965), xiv, xv.

11. Francis Fukuyama, *The End of History and the Last Man* (New York: Avon Books, 1992).

12. Patrick Deneen, *Why Liberalism Failed* (New Haven, CT: Yale University Press, 2018). To some degree, Deneen's work perpetuates the criticism of liberal individualism that has formed a major argument of social conservatives in the culture wars that have dominated our political society since the late 1970s. Representative of these works are Robert H. Bork, *Slouching toward Gomorrah: Modern Liberalism and American Decline* (New York: Regan Books, 1996); William J. Bennett, *The Broken Hearth: Reversing the Moral Collapse of the American Family* (New York: Doubleday, 2001); Robert Putnam, *Bowling Alone: The Collapse and Revival of American Community* (New York: Simon & Schuster, 2000); Mary Ann Glendon, *Rights Talk: The Impoverishment of Political Discourse* (New York: Free Press, 1991); and more recently Jeffrey Bell, *The Case for Polarized Politics: Why America Needs Social Conservatism* (New York: Encounter Books, 2012). See also David Harvey, *A Brief History of Neoliberalism* (New York: Oxford University Press, 2007); W. Andy Knight, ed., *Adapting the United Nations to a Postmodern Era* (Hampshire, England: Palgrave, 2005). But liberals too have become dismayed by contemporary progressivism. See Michael Blechman, "Liberalism Isn't What It Used to Be," *Wall Street Journal*, June 21, 2019, A15. See also Adam Gopnik, *A Thousand Small Sanities: The Moral Adventure of Liberalism* (New York: Basic Books, 2019). Gopnik hopes that contemporary progressives will learn to harmonize their "woke" causes rooted in emotional sensitivity to others and the prioritization of "identity" with traditional liberal protections of free speech, the rule of law, individual conscience, and reasoned and rational debate. However, he is not hopeful, finding that contemporary progressivism tends to devalue the rational inquiry upon which traditional liberal values have been erected.

1. A Victorian Childhood in Defense of Tradition, 1878–1896

1. Writer John Wilson first expressed a phrase popular in the late 1800s: "the sun never sets on the British empire." So extensive was that empire that some of it was always under daylight. Britain remained the most powerful and influential nation in the world until the United States assumed that role after World War II. Britain's cul-

tural influence is clear from the nearly universal adoption of the name of Britain's Queen Victoria to denominate the era from the late 1830s through the early years of the twentieth century.

2. Both Quakers and Huguenots were religious dissenters—that is, members of Christian sects who held views different from the state-sanctioned religion and were persecuted for those views. English Quakers and French Huguenots (Protestants in a Catholic country) immigrated to America in hopes of finding religious toleration.

3. Margaret Parton, "Mary Field," 4–5, typed manuscript, box 38; "family history," file 10, box 38, Mary Field Parton Papers within Margaret Parton Papers, 1885–1981, Division of Special Collections and University Archives, University of Oregon Libraries ("Parton Papers").

4. Parton, "Mary Field," 6, 8, 7, 16, Parton Papers.

5. Quoted in John A. Farrell, *Clarence Darrow: Attorney for the Damned* (New York: Vintage Books, 2012), 497n10.

6. Parton, "Mary Field," 8, 11, 29, Parton Papers.

7. Notes in file 9, box 38, Parton Papers.

8. Farrell, *Clarence Darrow*, 497n10. Christmas had long been seen by evangelicals as a perverse human-centered holiday without religious merit. Stephen Nissenbaum, *The Battle for Christmas* (New York: Vintage Books, 1996).

9. Michael McGerr, *A Fierce Discontent: The Rise and Fall of the Progressive Movement in America, 1870–1920* (New York: Free Press, 2003), 43.

10. Parton, "Mary Field," 16–17, and typed notes, file 9, box 38, Parton Papers.

11. Parton, "Mary Field," 16–17, and typed notes.

12. Typed manuscript of tape recording of interview with Mary Field Parton, file 9, box 38, Parton Papers.

13. Kate Greenaway, 1846–1901, was an Englishwoman who began as a teacher and artist but ultimately became a well-known author of children's books based on fairy tales and fantasies and featuring colored drawings of elaborately clothed characters.

14. Typed manuscript of taped interview with Mary Field Parton, file 9, box 38, Parton Papers; "Mary Field," 20, 25.

15. Christine L. Heyrman, *Southern Cross: The Beginnings of the Bible Belt* (Chapel Hill: University of North Carolina Press, 1997), 18, 3.

16. Typed manuscript of tape recording of Mary Field Parton, file 9, box 38, Parton Papers.

17. Yet its acceptance was far from universal. See Michael P. Weber and Peter N. Stearns, "Introduction," in Ethel Spencer, *The Spencers of Amberson Avenue: A Turn of the Century Memoir* (Pittsburgh: University of Pittsburgh Press, 1983), xxix.

18. Parton, "Mary Field," 16–17, and typed manuscript of interview with Mary Field Parton, file 9, box 38, Parton Papers.

19. Sydney E. Ahlstrom, *A Religious History of the American People* (New Haven, CT: Yale University Press, 1972), 763–784. Ahlstrom refers to the second half of the nineteenth century as the "golden age of liberal theology in America." It persisted into the first two or three decades of the 1900s; but by the mid-1920s, Protestant Christianity was riven with divisions over theology, mission, and social involvement and entered a long period of decline. See also William R. Hutchison, *Religious Pluralism in America* (New Haven, CT: Yale University Press, 2003), 141; Winthrop S. Hudson, *The Great Tradition of American Churches* (New York: Harper, 1953); Karen Armstrong, *The*

Battle for God: A History of Fundamentalism (New York: Random House, 2000), 95, 140–45, 171–76.

20. Edward J. Larson, *Summer for the Gods: The Scopes Trial and America's Continuing Debate over Science and Religion* (New York: Basic Books, 1997), 14 (quote), 19, 31; James German, "Economy," in *Themes in Religion and American Culture,* ed. Philip Goff and Paul Harvey (Chapel Hill: University of North Carolina Press, 2004), 280; John T. Mc-Greevy, *Catholicism and American Freedom: A History* (New York: W.W. Norton and Co., 2003), 104.

21. Sidney Warren, *American Free Thought, 1860–1914* (Ph.D. diss., Columbia University, 1943), 95; Noah Feldman, *Divided by God: America's Church-State Problem and What We Should Do About It* (New York: Farrar, Straus and Giroux, 2006), 111–134.

22. Bruce J. Dierenfield, *The Battle over School Prayer: How Engel v. Vitale Changed America* (Lawrence: University Press of Kansas, 2007), 27.

23. Quoted in Philip Hamburger, *Separation of Church and State* (Cambridge, MA: Harvard University Press, 2002), 314, 319–20n85, 319.

24. Quoted in German, "Economy," 279, 280.

25. John L. Thomas, *Alternative America: Henry George, Edward Bellamy, Henry Demarest Lloyd and the Adversary Tradition* (Cambridge, MA: Harvard University Press, 1983), 50, 56, 66–67, 107–08; Edward T. O'Donnell, *Henry George and the Crisis of Inequality: Progress and Poverty in the Gilded Age* (New York: Columbia University Press, 2015); Robert H. Wiebe, *The Search for Order, 1877–1920,* The Making of America Series, ed. David Herbert Donald (New York: Hill & Wang, 1967), 159–61.

26. Dean A. Strang, *Worse than the Devil: Anarchists, Clarence Darrow, and Justice in a Time of Terror* (Madison: University of Wisconsin Press, 2016), xi, 23–24. Referring to "socialism, syndicalism, communism [and] anarchism," Strang writes on p. 27: "All of these doctrines shared at least a basic resentment of existing economic and class structure." See also Paul Avrich, *Anarchist Voices: An Oral History of Anarchism in America* (Princeton, NJ: Princeton University Press, 1995).

27. Turner's lecture, "The Significance of the Frontier in American History," is included in Martin Ridge, ed., *Frederick Jackson Turner: Wisconsin's Historian of the Frontier* (Madison: State Historical Society of Wisconsin, 1993).

28. Wiebe, *Search for Order,* 54–59.

29. In 1900, the divorce rate in the United States was the highest in the world. McGerr, *A Fierce Discontent,* 85.

30. Typed manuscript of audio recording, file 9, box 38, Parton Papers.

31. Parton, "Mary Field," 14, 11, Parton Papers.

32. Joseph Kett, *Rites of Passage: Adolescence in America, 1790 to the Present* (New York: Basic Books, 1979), 173–245.

33. Parton, "Mary Field," 14, 11, Parton Papers.

34. Parton, "Mary Field," 14, 11, 28, Parton Papers.

35. Parton, "Mary Field," 30–31, Parton Papers.

36. Kathleen McCarthy, "Women and Political Culture," in *Charity, Philanthropy and Civility in American History,* ed. Lawrence J. Friedman and Mark D. McGarvie (New York: Cambridge University Press, 2003); Lori Ginzberg, *Women and the Work of Benevolence: Morality, Politics, and Class in the 19th Century United States* (New Haven, CT: Yale University Press, 1990); Wendy J. Deichman Edwards and Carolyn De Swarte Gifford, eds., *Gender and the Social Gospel* (Urbana: University of Illinois Press, 2003).

37. Typed manuscript of taped interviews, file 9, box 38, Parton Papers.

38. Parton, "Mary Field," 32, Parton Papers.

39. The only earlier elections of comparable clarity and significance are probably Jefferson's victory in 1800, Jackson's victory in 1828, and Lincoln's victory in 1860. Since 1896, one must consider Franklin Roosevelt's victory in 1932, Reagan's victory in 1980, Obama's victory in 2008, and that of Biden in 2020 as arguably as significant.

40. The play *The Music Man*, made into a film in 1962, is a musical depiction of this cultural change, perceived as a crisis in rural Iowa. See generally Wiebe, *Search for Order*.

41. Jack Beatty, ed., *Colossus: How Corporations Changed America* (New York: Broadway Books, 2001), xx. Most of the large corporations created by mergers were able to control as much as 40 percent of the market in their industry, but fully a third of them controlled more than 70 percent of the industry in which they operated. McGerr, *A Fierce Discontent*, 151.

42. Parton, "Mary Field," 26, Parton Papers.

43. The traditional interpretation of Progressivism expressed here is challenged by a recent publication asserting that the Progressive movement arose largely from concerns raised by agricultural and industrial workers, constituting a more class-based challenge to US capitalism than has generally been recognized. Charles Postel, "T.R., Wilson, and the Origins of the Progressive Tradition," in *Progressivism in America: Past, Present, and Future*, ed. David B. Woolner and John M. Thompson (New York: Oxford University Press, 2016), 3–16. This book suffers, in this author's opinion, from an overriding concern with continuity between various "progressive" political expressions over more than one hundred years, minimizing the unique character of each.

44. Robert Crunden, *Ministers of Reform: The Progressives' Achievement in American Civilization, 1889–1920* (New York: Basic Books, 1982).

45. McGerr, *A Fierce Discontent*, generally at 79–80.

46. Arnaldo Testi, "The Gender of Reform Politics: Theodore Roosevelt and the Culture of Masculinity," *Journal of American History* 81, no. 4 (March 1985): 1509–33; David McCullough, *Mornings on Horseback* (New York: Simon & Schuster, 1981).

47. Wiebe, *Search for Order*, 73–74, 167, 47–52,

48. James T. Kloppenburg, *Uncertain Victory: Social Democracy and Progressivism in European and American Thought*, 1870–1920 (New York: Oxford University Press, 1986), 357, 395.

49. Yet several historians see in Progressivism a conservative attempt to prevent the working class from securing political power—to save capitalism and democracy by making minor corrections rather than overhauling the system. See, for example, Samuel P. Hays, "The Politics of Reform in Municipal Government in the Progressive Era," *Pacific Northwest Quarterly* 55 (Oct. 1964): 157–169.

50. David P. Thelen, *Robert La Follette and the Insurgent Spirit*, The Library of American Biography Series, ed. Oscar Handlin (Boston: Little, Brown & Co., 1976), 23.

51. David P. Thelen, "Social Tensions and the Origins of Progressivism," *Journal of American History* 56, no. 2 (September 1962): 323–341, 335 (quote); Wiebe, *Search for Order*, 169–170; William E. Leuchtenburg, *The Perils of Prosperity 1914–1932*, Chicago History of American Civilization series, ed. Daniel J. Boorstin (Chicago: University of Chicago Press, 1958), 3.

52. Thelen, *Robert La Follette*, 1, 12, vii, 26.

53. McGerr, *A Fierce Discontent*, 153–155.

54. McGerr, *A Fierce Discontent*, 59, 49; Henry F. May, *Protestant Churches and Industrial America* (New York: Harper, 1949), 57.

55. Thelen, "Social Tensions," 336, 339.

56. This traditional understanding of populist actors, perhaps most prominently expressed in Richard Hofstadter, *The Age of Reform* (New York: Vintage Books, 1955), is challenged in Charles Postel, *The Populist Vision* (New York: Oxford University Press, 2007).

57. Steve Fraser, "The Misunderstood Robber Baron," review of *The First Tycoon: The Epic Life of Cornelius Vanderbilt* by T. J. Stiles, *Nation*, November 11, 2009. Even Charles Francis Adams, a member of society's upper crust, found little to like in the robber barons: "nor is one of them associated in my mind with the idea of humor, thought, or refinement. A set of more money-getters and traders, they were essentially unattractive and uninteresting." Charles Francis Adams, *An Autobiography, 1935–1915*, with a memorial address delivered November 17, 1915, by Henry Cabot Lodge (Boston: Houghton-Mifflin, 1916), 190. Historian Paul Johnson conversely lauds the engineers of US social and economic transformation. Paul Johnson, "The Prospering Fathers," in *Colossus: How Corporations Changed America*, ed. Jack Beatty (New York: Broadway Books, 2001), 158–167. See also Ron Chernow, *Titan: The Life of John D. Rockefeller* (New York: Random House, 1998); Allan Nevins, *John D. Rockefeller: The Heroic Age of American Enterprise* (New York: Charles Scribner's Sons, 1940).

58. Wiebe, *Search for Order*, 84. Bryan's calls for adopting a bimetallic (gold and silver) standard for US currency were predicated on an assumption that doing so would put more money into circulation and help the poor.

59. Farrell, *Clarence Darrow*, 78.

60. H. L. Mencken, *On Politics: A Carnival of Buncombe* (Baltimore: Johns Hopkins University Press, 1996), 21.

2. Expanded Opportunities beyond the Home, 1896–1905

1. Parton, "Mary Field," 32, typed manuscript, box 38, Parton Papers.

2. Parton, "Mary Field," 33–34, 35, Parton Papers.

3. The percentages of men and women in college come from the *National Center for Education Statistics: 120 Years of American Education: A Statistical Portrait*, figure 14, "Enrollment by Sex, 1869–70 to 1990–91," p. 65. By 1930, the percentage of Americans in college increased to 7 percent, but the percentage of women declined to 44 percent. The percentage of women continued to decline every year thereafter until the 1970s, except during World War II. Statistics on the number of women in college come from the United States Census Bureau, "A Century of Change: America, 1900–1999," www .census.gov/dataviz/visualizations/055/. In 1900, there were 37.2 million women in the United States and 38.8 million men. The median age for males was 23.3; for females, 22.4. The information on the number of women who started and completed degree programs is in Margaret Nash and Lisa Romero, "Citizenship and the College Girl: Challenges and Opportunities in Higher Education for Women in the United States in the 1930s," *Teachers College Record* 114, no. 2 (2012): 5–6. See also Nancy Cott, *The Grounding of Modern Feminism* (New Haven, CT: Yale University Press, 1987), 22, 40.

4. "Mary Field," 29, Parton Papers.

5. Typed manuscript of interview, file 9, box 38, Parton Papers.

6. Dorothy Ross, "Socialism and American Liberalism: Academic Social Thought in the 1880s," *Perspectives in American History* 11 (1977–1978): 5–79.

7. Parton, "Mary Field," 35–37, Parton Papers.

8. See generally George M. Frederickson, *The Inner Civil War: Northern Intellectuals and the Crisis of the Union* (Urbana: University of Illinois Press, 1965); Dorothy Ross, *The Origins of American Social Science* (New York: Cambridge University Press, 1991).

9. William James, *Pragmatism*, ed. Bruce Kublick (Indianapolis: Hackett, 1981), 115.

10. James, *Pragmatism*, 26.

11. James, *Pragmatism*, 28.

12. James, *Pragmatism*, 34.

13. James, *Pragmatism*, 17.

14. James, *Pragmatism*, 93.

15. John Dewey, *A Common Faith* (New Haven, CT: Yale University Press, 1934), 83.

16. Dewey, *A Common Faith*, 79.

17. Dewey, *A Common Faith*, 80.

18. James, *Pragmatism*, 95, 100–101.

19. David A. Hollinger, "The Problem of Pragmatism in American History: A Look Back and A Look Ahead," in *Pragmatism: From Progressivism to Postmodernism*, ed. Robert Hollinger and David DePew (Westport, CT: Praeger Press, 1995), 24.

20. Hollinger and DePew, *Pragmatism*, 6–7.

21. Charles Cooley, *Social Organization: A Study of the Larger Mind* (New York: Charles Scribner's Sons, 1909), 3. See also Edward Shils, "The Study of the Primary Group," in *The Policy Sciences*, ed. Daniel Lerner and Harold D. Laswell (Palo Alto, CA: Stanford University Press, 1951).

22. Casey Blake, *Beloved Community: The Cultural Criticism of Randolph Bourne, Van Wyck Brooks, Waldo Frank, and Lewis Mumford* (Chapel Hill: University of North Carolina Press, 1990), 2, 4, 120.

23. Edward A. Ross, *Sin and Society: An Analysis of Latter-Day Iniquity* (Boston: Houghton-Mifflin, 1907).

24. Mark Tushnet, *The Rights Revolution in the Twentieth Century* (Washington, DC: American Historical Association, 2009), 14.

25. *Lochner v. New York*, 198 U.S. 45 (1905), Harlan dissent at 67.

26. Quoted in Linda Przybyszewski, *Religion, Morality, and the Constitutional Order* (Washington, DC: American Historical Association, 2011), 30.

27. Zechariah Chafee, *Free Speech* (New York: Harcourt, Brace, and Howe, 1920).

28. Samuel D. Warren and Louis D. Brandeis, "The Right to Privacy," *Harvard Law Review* 4 (December 1890): 193.

29. See generally Thomas L. Haskell, *The Emergence of Professional Social Science* (Urbana: University of Illinois Press, 1977).

30. Frederick Rudolph, *The American College and University: A History* (Athens: University of Georgia Press, 1990), 395–396. See also, for a contemporary work on the college experience, Edwin E. Slosson, *Great American Universities* (New York: Arno Press, 1977), a reprint of the same title published in New York by the Macmillan Company in 1910.

31. Rosalind Rosenberg, *Beyond Separate Spheres: Intellectual Roots of Modern Feminism* (New Haven, CT: Yale University Press, 1982).

32. Parton, "Mary Field," 37–38, Parton Papers.

33. Parton, "Mary Field," 37–38, Parton Papers.

34. Typed manuscript of interview, file 9, box 38, Parton Papers.

35. Parton, "Mary Field," 3, Parton Papers.

36. Parton, "Mary Field," 87, Parton Papers.

37. Quoted in Parton, "Mary Field," 40, Parton Papers. Readers may underappreciate the radicalism expressed in that assertion. Victorian women constructed cultural imperatives rooted in gender, and "independence . . . excluded [women] from the bounds of respectable womanhood." Wendy Gamber, *The Female Economy: The Millinery and Dressmaking Trades, 1860–1930* (Urbana: University of Illinois Press, 1997), 6.

38. Journal entry (undated from early adulthood) in box 58, Parton Papers.

39. Margaret Parton, Mary's daughter, seems to agree. She writes that before meeting Lem Parton, Mary "had been operating on the hard, brilliant, and masculine side of her nature, the part that had been formed by the childhood battles with her father." Parton, "Mary Field," 93, Parton Papers.

40. Gamber, *The Female Economy*.

41. Mary Field journal (undated), box 58, Parton Papers.

42. Parton, "Mary Field," 54, Parton Papers.

43. Parton, "Mary Field," 55, Parton Papers.

44. William E. Forbath, *Law and the Shaping of the American Labor Movement* (Cambridge, MA: Harvard University Press, 1991), 3, 7, 12–18, 27.

45. Arthur Weinberg and Lila Weinberg, *Clarence Darrow: A Sentimental Rebel* (New York: G. P. Putnam's Sons, 1980), 91–104, quoted on 91.

46. Christopher Tomlins, *The State and the Unions: Labor Relations, Law, and the Organized Labor Movement in America, 1880–1960* (New York: Cambridge University Press, 1988), 58, 21, 25–26; George Baer to Mr. Clark, "Divine Right Letter," July 17, 1902, Clarence Darrow Digital Collection, University of Minnesota Law School.

47. Mary Field 1902–1903 journal entries, undated, box 58, Parton Papers.

48. Heather Cox Richardson, *To Make Men Free: A History of the Republican Party* (New York: Basic Books, 2014), quotes at ix, 150–151. Richardson's position is rejected in Bradley C. S. Watson, *Progressivism: The Strange History of a Progressive Idea* (Notre Dame, IN: University of Notre Dame Press, 2020). Watson sees Progressivism as a radical rejection of the rights-based ideologies expressed in the founding documents (the US Constitution) and perpetuated by subsequent defenders of individual private realms immune from government interference.

49. Robert H. Wiebe, *The Search for Order, 1877–1920*, The Making of America Series, ed. David Herbert Donald (New York: Hill & Wang, 1967), 44, 53–54, 208; Michael McGerr, *A Fierce Discontent: The Rise and Fall of the Progressive Movement in America, 1870–1920* (New York: Free Press, 2003), 156–164.

50. Robert Crunden, *Ministers of Reform: The Progressives' Achievement in American Civilization, 1889–1920* (New York: Basic Books, 1982), 15.

51. Quoted in Jill Lepore, "The Fireman: Eugene V. Debs and the Endurance of American Socialism," *New Yorker*, February 18 and 25, 2019: 88–92, at 91.

52. Mark Douglas McGarvie, *Law and Religion in American History: Public Values and Private Conscience*, New History in American Law series, ed. Michael Grossberg and Christopher Tomlins (New York: Cambridge University Press, 2016), 84, 94–107, 125;

Henry F. May, *Protestant Churches and Industrial America* (New York: Harper, 1949), 125, 158, 163, 235; Sydney E. Ahlstrom, *A Religious History of the American People* (New Haven, CT: Yale University Press, 1972), 785–804.

53. McGerr, *A Fierce Discontent*, 66 (quotes), 108–111.

54. Parton, "Mary Field," 55, Parton Papers; John A. Farrell, *Clarence Darrow: Attorney for the Damned* (New York: Vintage Books, 2012), 201.

3. The New Women and Life in the Urban United States, 1905–1908

1. The facts and figures about Gilded Age Chicago can be found in various college textbooks. The one relied on here is Bernard Bailyn, David Brian Davis, David Herbert Donald, John L. Thomas, Robert H. Wiebe, and Gordon S. Wood, *The Great Republic: A History of the American People* (Lexington, MA: D.C. Heath and Company, 1977). The term "Gilded Age" is attributed to Mark Twain, who wrote *The Gilded Age* in 1873. Insights regarding Chicago presented in the text have also been garnered from various monographs including Robert Cromie, *A Short History of Chicago* (San Francisco: Lexikos, 1984); James Green, *Death in Haymarket* (New York: Random House, 2006); Karen Abbott, *Sin in the Second City: Madams, Ministers, Playboys, and the Battle for America's Soul* (New York: Random House, 2007); Gary Krist, *City of Scoundrels: The 12 Days of Disaster That Gave Birth to Modern Chicago* (New York: Random House, 2012); James R. Grossman, Ann Durkin Keating, Janice L. Reiff, eds., *The Encyclopedia of Chicago* (Chicago: University of Chicago Press, 2004). On factory labor versus agrarian labor see Richard White, *The Republic for Which It Stands: The United States during Reconstruction and the Gilded Age, 1865–1896* (New York: Oxford University Press, 2017), 217. Quotes on isolation within the cities are from Michael McGerr, *A Fierce Discontent: The Rise and Fall of the Progressive Movement in America, 1870–1920* (New York: Free Press, 2003), 209.

2. White, *The Republic for Which It Stands*, 17.

3. Jane Addams, *Twenty Years at Hull House* (New York: Macmillan, 1916), 116.

4. See Louise Carroll Wade, "Settlement Houses," in Grossman et al., *The Encyclopedia of Chicago*, 747–748; Judith Sealander, "Curing Evils at their Source: The Arrival of Scientific Giving," in *Charity, Philanthropy and Civility in American History*, ed. Lawrence J. Friedman and Mark D. McGarvie (New York: Cambridge University Press, 2003); Barry D. Karl, *The Uneasy State: The United States from 1915 to 1945* (Chicago: University of Chicago Press, 1983), 27–28; McGerr, *A Fierce Discontent*, 100–104.

5. Addams, *Twenty Years at Hull House*, 41–42, 116–20, 124.

6. "Thirty Years and After," a pamphlet history of Chicago Commons (1924), Chicago Commons Association Collection, Chicago History Museum, Box 7.

7. Steven Adams, *The Arts and Crafts Movement* (London: New Burlington Books, 1987), 9. See also Wendy Kaplan, *The Arts and Crafts Movement in Europe and America: Design for the Modern World* (Los Angeles: Thomas and Hudson for the Los Angeles County Museum of Art, 2004); Samuel G. White, *The Houses of MicKim, Mead, and White* (New York: Rizzoli for the Museums at Stony Brook, 1998); Paul Duchscherer and Linda Svendsen, *Beyond the Bungalow: Grand Homes in the Arts and Crafts Tradition* (Salt Lake City: Gibbs, 2005); Patrick F. Cannon, *Prairie Metropolis: Chicago and the Birth of the New American Home* (Petaluma, CA: Pomegranate Communications, 2008).

8. Gustav Stickley, *Craftsmen Homes and Bungalows* (New York: Skyhorse, 2009), 4.

9. Robert H. Wiebe, *The Search for Order, 1877–1920*, The Making of America Series, ed. David Herbert Donald (New York: Hill & Wang, 1967), 168.

10. Geoffrey Cowan, *The People v. Clarence Darrow: The Bribery Trial of America's Greatest Lawyer* (New York: Random House, 1993), 48, 32.

11. On January 8, 1896, Clarence wrote to Jessie: "We have not been happy and I suppose neither of us are [sic] to blame. I presume that we never in any way were fitted for each other. . . . Of course we were too young to know it then and it is always terribly hard to correct such mistakes." Jessie Ohl Darrow-Clarence Darrow Papers, Newberry Library.

12. John A. Farrell, *Clarence Darrow: Attorney for the Damned* (New York: Vintage Books, 2012), 90.

13. Parton, "Mary Field," 92, Parton Papers.

14. Parton, "Mary Field," unnumbered pages on Chicago years before Darrow, Parton Papers.

15. Farrell, *Clarence Darrow*, 201.

16. Undated 1906 journal entries, box 58, Parton Papers.

17. Parton, "Mary Field," unnumbered pages in draft of chap. 4, Parton Papers.

18. Quoted in Farrell, *Clarence Darrow*, 201.

19. Parton, "Mary Field," 56, Parton Papers.

20. Farrell, *Clarence Darrow*, 201.

21. Parton, "Mary Field," unnumbered pages in draft of chap. 4, Parton Papers; Farrell, *Clarence Darrow*, 201.

22. Parton, "Mary Field," unnumbered pages in draft of chap. 4, Parton Papers. Mary always claimed not to remember where and when she met Darrow, and he left no record of their meeting; in fact, she is totally absent from his autobiography, most likely in respect of his wife, Ruby. However, Geoffrey Cowan makes the plausible argument that the two met at a rally supporting Christian Rudovitz, a Russian revolutionary facing extradition from the United States and certain death in Russia. Darrow served as Rudovitz's attorney. Cowan, *People v. Clarence Darrow*, 63. Arthur and Lila Weinberg argue that Todd introduced the two in 1908 and that teasing and humor paved the way to a deeper relationship. Arthur Weinberg and Lila Weinberg, *Clarence Darrow: A Sentimental Rebel* (New York: G. P. Putnam's Sons, 1980), 154.

23. Quotes from Farrell, *Clarence Darrow*, 202–203, 4, 202, 203, 204.

24. Farrell, *Clarence Darrow*, 121–124; Cowan, *The People v. Clarence Darrow*, xx; Weinberg and Weinberg, *A Sentimental Rebel*, 115, 117–118, 287 (quote).

25. Parton, "Mary Field," unnumbered draft pages of chap. 4 and p. 1, Parton Papers; Farrell, *Clarence Darrow*, 200–205, 91 (quote); Weinberg and Weinberg, *A Sentimental Rebel*, 154.

26. Parton, "Mary Field," unnumbered draft pages of chap. 4, Parton Papers. Most writers, including Mary's daughter Margaret, who have looked at their relationship have assumed that Mary and Clarence had a romantic sexual affair that probably lasted at least until Mary's marriage to Lemuel Parton.

27. Perhaps the greatest advocates for free love were Victoria Woodhull and her sister, Tennessee Claflin. They largely endorsed cyclical monogamy and premised that endorsement on the reasonableness of pursuing natural desires and a recognition of marriage as a contract between equal individuals, void of moral or religious dictates, and subject to dissolution when one's sentiments changed. See Myra MacPherson, *The*

Scarlet Sisters: Sex, Suffrage, and Scandal in the Gilded Age (New York: Hatchette Book Group, 2014).

28. The novel can also be read as a rebuke of Cooley's primary group theory.

29. Clarence Darrow, *Farmington* (New York: Charles Scribner's Sons, 1932; originally published 1904); see also Weinberg and Weinberg, *A Sentimental Rebel*, 116–117.

30. Quotes from Farrell, *Clarence Darrow*, 92–93, 89. Richard White argues that the free love movement "proved so shocking to Victorians not because of its embrace of sexuality but because it put personal satisfaction and emotional conditions above the home." White, *The Republic for Which It Stands*, 163.

31. Farrell, *Clarence Darrow*, 89, 200–201 (quote).

32. McGerr, *A Fierce Discontent*, 64. Two wonderful compilations of Gibson Girl cartoons, published with explanatory text, are Henry C. Pitz, ed., *The Gibson Girl and Her America: The Best Drawings of Charles Dana Gibson* (New York: Dover, 1969); and Woody Gelman, ed., *The Best of Charles Dana Gibson* (New York: Crown, 1969).

33. Quoted in Weinberg and Weinberg, *A Sentimental Rebel*, 72.

34. Peggy Pascoe, *Relations of Rescue: The Search for Female Moral Authority in the American West, 1874–1939* (New York: Oxford University Press, 1990), xvii–xx.

35. Nancy Cott, *The Grounding of Modern Feminism* (New Haven, CT: Yale University Press, 1987), 13, 14 (quote), 16, 37 (quote), 41–42, 44 (quote).

36. McGerr, *A Fierce Discontent*, 260–263. Bill Greer, *A Dirty Year: Sex, Suffrage, and Scandal in Gilded Age New York* (Chicago: Chicago Review Press, 2020), 11–12 (quotes).

37. Greer, *A Dirty Year*, 9–11; McGerr, *A Fierce Discontent*, 262.

38. Margaret Sanger, "Suppression," *Woman Rebel* 1, no. 4 (June 1914): 25.

39. Mary's undated notes on birth control, file 10, box 28, Parton Papers.

40. Margaret Sanger, "The Eugenic Value of Birth Control Propaganda," *Birth Control Review* (October 1921): 5.

41. Parton, "Mary Field," notes for draft of ch. 4, Parton Papers.

42. Parton, "Mary Field," notes for draft of ch. 4, Parton Papers. Though she expressed it fervently and frequently, Darrow always doubted Mary's lack of support for women's suffrage, which he playfully referred to as "Lady's suffrage." Letter of Darrow to Mary Field, Mary 15, 1913, folder 19, Parton-Darrow Papers. See also Cott, *Feminism*, 102–104.

43. Parton, "Mary Field," 83, Parton Papers. See also George M. Frederickson, *The Inner Civil War: Northern Intellectuals and the Crisis of the Union* (Urbana: University of Illinois Press, 1965), 11, 33–35, 217. For discussions of benevolence and the work deemed attributable to a general feminization of society in the antebellum United States, see Ronald G. Walters, *American Reformers, 1815–1860* (New York: Hill & Wang, 1997); Lori Ginzberg, *Women and the Work of Benevolence: Morality, Politics, and Class in the 19th Century United States* (New Haven, CT: Yale University Press, 1990); Wendy J. Deichman Edwards and Carolyn De Swarte Gifford, eds., *Gender and the Social Gospel* (Urbana: University of Illinois Press, 2003); Mark Douglas McGarvie, *Law and Religion in American History: Public Values and Private Conscience*, New History in American Law series, ed. Michael Grossberg and Christopher Tomlins (New York: Cambridge University Press, 2016), 48–80.

44. Journal notes, undated, from 1908, Parton Papers.

45. Quoted in Farrell, *Clarence Darrow*, 203.

4. The Trials of Progressivism, 1909–1914

1. Dean A. Strang, *Worse than the Devil: Anarchists, Clarence Darrow, and Justice in a Time of Terror* (Madison: University of Wisconsin Press, 2016), 142.

2. Clarence Darrow, *The Story of My Life* (New York: Charles Scribner's Sons, 1932; Da Capo Press, 1996), 52.

3. John A. Farrell, *Clarence Darrow: Attorney for the Damned* (New York: Vintage Books, 2012), 198. On the Progressive movement's campaign for direct primaries, see Geoffrey Cowan, *Let the People Rule: Theodore Roosevelt and the Birth of the Presidential Primary* (New York: W.W. Norton, 2016).

4. Letter from Mary Field Parton to Sara Ehrgott, June 4, 1925, folder 21, Parton Papers.

5. John C. Livingston, "The Mind of a Sentimental Rebel," in *Modern American History, A Garland Series*, ed. Robert E. Burke and Frank Freidel (New York: Garland, 1988), 63.

6. Michael McGerr, *A Fierce Discontent: The Rise and Fall of the Progressive Movement in America, 1870–1920* (New York: Free Press, 2003), 21 (quote), 32–33.

7. Nancy Cott, *The Grounding of Modern Feminism* (New Haven, CT: Yale University Press, 1987), 15 (quote), 35 (quote), 24. See also Philip S. Foner, *Women and the American Labor Movement* (New York: Free Press, 1979).

8. Cott, *Feminism*, 24. See Christine Seifert, *The Factory Girls: A Kaleidoscope Account of the Triangle Shirtwaist Factory Fire* (Minneapolis: Lerner, 2017); Albert Marrin, *Flesh and Blood So Cheap: The Triangle Fire and Its Legacy* (New York: A.A. Knopf, 2011); David Von Drehle, *Triangle: The Fire That Changed America* (New York: Atlantic Monthly Press, 2003).

9. Cott, *Feminism*, 39–40.

10. Darrow, *Story of My Life*, 112.

11. John L. Thomas, *Alternative America: Henry George, Edward Bellamy and Henry Demarest Lloyd and the Adversary Tradition* (Cambridge, MA: Harvard University Press, 1983), 35.

12. Quoted in McGerr, *A Fierce Discontent*, 178.

13. James T. Kloppenberg, *Uncertain Victory: Social Democracy and Progressivism in European and American Thought, 1870–1920* (New York: Oxford University Press, 1986), 377.

14. Casey Nelson Blake, *Beloved Community: The Cultural Criticism of Randolph Bourne, Van Wyck Brooks, Waldo Frank, and Lewis Mumford* (Chapel Hill: University of North Carolina Press, 1990), 2–4, 47–51, 87, 112.

15. Thomas, *Alternative America*, 48. Demarest Lloyd is quoted by Thomas: "I want power, I must have power, I could not live if I did not think that I was in some way to be lifted above the insensate masses who flood the state of life in their passage to oblivion, but I want power unpoisoned by the presence of obligation." Similarly, Edward Bellamy referred to the Haymarket unionists as uneducated anarchists, well advised to follow rather than to lead. Thomas, *Alternative America*, 233–286, 81.

16. Darrow, *Story of My Life*, 58.

17. Letter from Clarence Darrow to Mary Field, September 9, 1909, box 1 of 1, folder 19 (locator code: Midwest MS Parton), Mary Field Parton—Clarence Darrow Papers, 1909–1925, Newberry Library, Chicago, IL ("Parton-Darrow Papers").

18. See Jane Dailey, *The Age of Jim Crow* (New York: W.W. Norton, 2009); James H. Madison, *A Lynching in the Heartland: Race and Memory in America* (New York: Palgrave, 2001).

19. Quoted in Farrell, *Clarence Darrow*, 195–196. See also David Zucchino, *Washington's Lie: The Murderous Coup of 1898 and the Rise of White Supremacy* (New York: Atlantic Monthly Press, 2020); Nicholas Lemann, *The Promised Land: The Great Migration and How It Changed America* (New York: Random House, 1992); Ira Berlin, *The Making of African America: The Four Great Migrations* (New York: Viking Press, 2010); Isabel Wilkerson, *The Warmth of Other Suns: The Epic Story of America's Great Migration* (New York: Vintage Books, 2010). In July 1919, Chicago experienced race riots triggered by an attack on an African American boy whose small raft floated to an unofficially designated "Whites only" beach on Lake Michigan. Gary Krist, *City of Scoundrels: The Twelve Days of Disaster That Gave Birth to Modern Chicago* (New York: Crown, 2012).

20. McGerr, *A Fierce Discontent*, 182–184, 192, 195–209; quoted in Arthur Weinberg and Lila Weinberg, *Clarence Darrow: A Sentimental Rebel* (New York: G. P. Putnam's Sons, 1980), 84–85; quoted in Farrell, *Clarence Darrow*, 195–196. Mary Field's views regarding race are perhaps best developed and expressed in her short stories. See, for example, "Klem's Perfect 54," folder 6, box 62, Parton Papers, in which gender unites women of all races in confronting social bias. In her fiction, Mary displays great sensitivity to people of minority races and ethnicities. Rejecting the settlement house model under which she once worked, she argues against the promulgation of a single cultural standard, asserting that there should be no need for Blacks, Jews, Asians, or Italians to adopt a mainstream US cultural identity.

21. *Daily Socialist*, September 10, 1909, file 7, Parton Papers. The quote attributed to Mary read as follows: "Does it not seem the height of irony that we maime [sic] and bruise and bring sickness on our foreigners, who do our work for us, and then, when they become public charges and unfit for further exploitation, we send them back to death."

22. Margaret Parton, "Mary Field," typed manuscript, 74, box 38, Parton Papers.

23. Parton, "Mary Field," notes/draft for chap. 4, Parton Papers.

24. Parton, "Mary Field" notes for chap. 5, Parton Papers.

25. Jeremy McCarter, *Young Radicals in the War for American Ideals* (New York: Random House, 2017), xiv.

26. Farrell, *Clarence Darrow*, 203; McGerr, *A Fierce Discontent*, 74, 264 (quotes), 265–274.

27. Parton, "Mary Field," 71, 72, Parton Papers.

28. Writing notebooks, undated, but presumed to be from 1909 and subsequent years in separate file; notes on chap. 5, "Mary Field," Parton Papers.

29. Quoted in Farrell, *Clarence Darrow*, 203. At the time, wage laborers made about $350 per year, and professionals, such as accountants and dentists, earned about $2,500 each year.

30. Letter from Darrow to Mary Field, July 26, 1910, folder 2, Parton-Darrow Papers.

31. Geoffrey Cowan, *The People v. Clarence Darrow: The Bribery Trial of America's Greatest Lawyer* (New York: Random House, 1993), 65.

32. Parton, "Mary Field," 75–77, Parton Papers.

33. Mary Field, "On Strike," *American Magazine* (1911): 736–746, 737, file 6, Parton Papers.

34. Mary Field, "The Drama of Wages," *American Magazine* (n.d.): 71–79, 71, file 6, Parton Papers.

35. This model has more recently been used in multiple formats from the *Oprah Winfrey Show* to political speeches that identity a single person as emblematic of the difficulties, concerns, or sufferings of a large segment of the United States.

36. Mary Field, "India's Challenge to Communism" and "India: A Problem for Communism" (undated and unpaginated), file 2, box 63, Parton Papers.

37. Letter from Darrow to Mary Field, September 27, 1910, folder 19, Parton-Darrow Papers; Farrell, *Clarence Darrow*, 204.

38. Letter from Darrow to Mary Field, March 15, 1910, folder 19, Parton-Darrow Papers.

39. Letter from Darrow to Mary Field, December 22, 1910, folder 19, Parton-Darrow Papers.

40. Letter from Darrow to Mary Field, April 4, 1910, folder 2, Parton-Darrow Papers.

41. Parton, "Mary Field," 87.

42. Quoted in Farrell, *Clarence Darrow*, 268.

43. Letter from Darrow to Mary Field, April 27, 1915, folder 19, Parton-Darrow Papers; quoted in Farrell, *Clarence Darrow*, 11.

44. Parton, "Mary Field," 87, Parton Papers. See also Farrell, *Clarence Darrow*, 213, 204, 269.

45. Parton, "Mary Field," 87, Parton Papers.

46. Quoted in Farrell, *Clarence Darrow*, 268.

47. Untitled and undated notes, box 58, Parton Papers.

48. "Democracy Limited: Chicago Women and the Vote," online exhibit at the Chicago History Museum, 2020, https://democracylimited.com/episode-5/.

49. Darrow, *Story of My Life*, 117, 128, 177–178.

50. Darrow, *Story of My Life*, 172, 174.

51. Parton, "Mary Field," 86, Parton Papers.

52. Quoted in Weinberg and Weinberg, *A Sentimental Rebel*, 162.

53. Parton, "Mary Field," 79, Parton Papers; Darrow, *Story of My Life*, 172–173; Cowan, *People v. Clarence Darrow*, 72.

54. Clearly, hyperbole was not born in the twenty-first century. Farrell, *Clarence Darrow*, 213 (quotes), 220–221nn. The American Federation of Labor raised $170,000 for the defense by collecting quarters from union members across the country. Cowan, *People v. Clarence Darrow*, ixx.

55. Quoted in Weinberg and Weinberg, *A Sentimental Rebel*, 16.

56. Cowan, *People v. Clarence Darrow*, 176–177, 215, 218 (quote).

57. Quoted in Weinberg and Weinberg, *A Sentimental Rebel*, 77.

58. Quoted in Cowan, *People v. Clarence Darrow*, 217.

59. Parton, "Mary Field," 77; Cowan, *People v. Clarence Darrow*, 171–172.

60. Farrell, *Clarence Darrow*, 226 (quote).

61. Farrell, *Clarence Darrow*, 225; Weinberg and Weinberg, *A Sentimental Rebel*, 167; Cowen, *People v. Clarence Darrow*, 172, 178 (quote).

62. Catherine Scholten, "Sara Bard Field," in *Notable American Women: The Modern Period*, ed. Barbara Sicherman and Carol Hurd Green (Cambridge, MA: Belknap Press, 1980), 232–234.

63. Parton, "Mary Field," notes for chap. 6, Parton Papers.

64. Scholten, "Sara Bard Field," 233.

65. Quoted in Cowan, *People v. Clarence Darrow*, 178, 194.

66. Steffens's letter to his sister, November 17, 1911, quoted in Cowan, *People v. Clarence Darrow*, 211.

67. Quoted in Farrell, *Clarence Darrow*, 219.

68. Cowan, *People v. Clarence Darrow*, 192.

69. Letters from Darrow to Mary Field, October 22 and October 4, 1912, file 19, Parton-Darrow Papers; Cowen, *People v. Clarence Darrow*, 173 (quotes).

70. L. Osborne, "A Sketch of Lemuel F. Parton," *Press* (San Francisco, December 1915); "Announcement," Consolidated Press Association, July 2, 1927, in collection 136, box 64, folder 1, Parton Papers; "Mary Field," 93, Parton Papers.

71. Farrell, *Clarence Darrow*, 267, 268; Parton, "Mary Field," 92–93 (quotes), Parton Papers.

72. Quoted in Farrell, *Clarence Darrow*, 275.

73. Farrell, *Clarence Darrow*, 231, 237; Cowan, *People v. Clarence Darrow*, 244, 256, 259, 282.

74. Farrell, *Clarence Darrow*, 270; Cowan, *People v. Clarence Darrow*, 273–274.

75. Quoted in McGerr, *A Fierce Discontent*, 81. Many writers in the early 1900s advocated this environmental deterministic approach. See Simon N. Patten, *The Basis of Civilization* (New York: Macmillan, 1909); Peter d'A. Jones, ed., *Poverty: Social Conscience in the Progressive Era* (New York: Harper & Row, 1965).

76. Darrow, *Story of My Life*, 176; Cowan, *People v. Clarence Darrow*, 179–180, 281; Farrell, *Clarence Darrow*, 230, 227, 233, 239, 241. Letter from F. D. Gardner to Mary Field, March 27, 1913, file 12, Parton-Darrow Papers.

77. Parton, "Mary Field," unnumbered pages in draft for chap. 5, Parton Papers.

78. Mary Field, *Organized Labor*, May 25, 1912. University Club of Chicago Library.

79. Parton, "Mary Field," unnumbered pages in draft of chap. 5, Parton Papers.

80. Quoted in Farrell, *Clarence Darrow*, 265.

81. Quoted in Cowan, *People v. Clarence Darrow*, 277.

82. Quoted in Farrell, *Clarence Darrow*, 259–261.

83. Parton, "Mary Field," unnumbered draft of chap. 5; quoted in Cowan, *People v. Clarence Darrow*, xxvii. Harrison Gray Otis owned the *Los Angeles Times* and had extensive real estate holdings in the San Fernando Valley.

84. Quoted in Farrell, *Clarence Darrow*, 251–252.

85. Farrell, *Clarence Darrow*, 239, 256.

86. Cowan, *People v. Clarence Darrow*, 304 (quote); Parton, "Mary Field," unnumbered pages in draft of chap. 4 (quotes).

87. Darrow letter to Mary Field, November 28, 1912, folder 19, Parton-Darrow Papers.

88. Quoted in Cowan, *People v. Clarence Darrow*, 431.

89. In particular, she reserved a file for papers such as his essay, "Conduct and Profession," which reads both like a confession and a defense of the crimes of which he was accused. Folder 25, p. 39, Parton-Darrow Papers.

5. Liberalism's Decline during and after the Great War, 1914–1924

1. Clarence Darrow, letters to Mary Field Parton, August 13, 1913, and February 9, 1914, folder 19, Parton-Darrow Papers.

2. Margaret Parton, "Mary Field," 87–91, typed manuscript, Parton Papers; John A. Farrell, *Clarence Darrow: Attorney for the Damned* (New York: Vintage Books, 2012), 217–218.

3. Arguably, the same claim could be made for Andrew Jackson in 1828.

4. Robert H. Wiebe, *The Search for Order, 1877–1920*, The Making of America Series, ed., David Herbert Donald (New York: Hill & Wang, 1967), 215; David P. Thelen, *Robert La Follette and the Insurgent Spirit*, The Library of American Biography Series, ed. Oscar Handlin (Boston: Little, Brown & Co., 1976), 96, 109, 99.

5. Geoffrey Cowan, *The People v. Clarence Darrow: The Bribery Trial of America's Greatest Lawyer* (New York: Random House, 1993), 274, 7.

6. Charles Postel, "T.R., Wilson, and the Origins of the Progressive Tradition," in *Progressivism in America: Past, Present, and Future*, ed. David B. Woolner and John M. Thompson (New York: Oxford University Press, 2016), 11.

7. James T. Kloppenberg, *Uncertain Victory: Social Democracy and Progressivism in European and American Thought, 1870–1920* (New York: Oxford University Press, 1986), 411–414.

8. Parton, "Mary Field," unnumbered pages, notes for chap. 6, 86, Parton Papers.

9. Arthur Weinberg and Lila Weinberg, *Clarence Darrow: A Sentimental Rebel* (New York.: G. P. Putnam's Sons, 1980), 265, 267–268.

10. Quoted in Farrell, *Clarence Darrow,* 507–508, note 2 for chap. 14.

11. Parton, "Mary Field," file 10, box 38; notes for chap. 6, 2 (quote). Darrow letter to Mary Field Parton, August 8, 1913, Parton-Darrow Papers.

12. Darrow letters to Mary Field Parton dated June 27 and August 8, 1913, and January 12, 1914, folder 19, Parton-Darrow Papers. In September 2014, Mary Parton edited an entire issue of the *Bulletin* entitled "Wet Special" and devoted to opposition to Prohibition.

13. Letter from Darrow to Mary Field, May 15, 1913, folder 19, Parton-Darrow Papers. At one stop of his tour, in a small town in Minnesota, Darrow wrote to Mary that the people up there "never heard of Nietzsche or anyone else excepting Jesus." Letter from Darrow to Mary Parton, July 4, 1913, folder 19, Parton-Darrow Papers.

14. See Friedrich Nietzsche, *Beyond Good and Evil: Prelude to a Philosophy of the Future,* trans. Walter Kaufmann (New York: Vintage Books, 1966).

15. See Will and Ariel Durant, *Rousseau and Revolution*, vol. X in *The Story of Civilization* (New York: Simon & Schuster, 1967), 136–151.

16. Quoted in Cowan, *People v. Clarence Darrow*, 442. Later on the tour, he wrote to Mary once again professing to having "had a bully time," a phrase he clearly adopted from Roosevelt and enjoyed using. Letter, Clarence Darrow to Mary Field Parton, February 9, 1914, folder 19, Parton-Darrow Papers.

17. Quoted in Farrell, *Clarence Darrow*, 411.

18. Parton, "Mary Field," draft of chap. 4, Parton Papers.

19. Farrell, *Clarence Darrow*, 285.

20. Quoted in Jeffrey S. Adler, *First in Violence, Deepest in Dirt: Homicide in Chicago, 1875–1920* (Cambridge, MA: Harvard University Press, 2006), 15. Mrs. Simpson escaped not only the noose but prison as well. Afterward, Darrow said, "you can't convict a pretty woman of murder in Cook County."

21. Quoted in Weinberg and Weinberg, *A Sentimental Rebel*, 278.

22. Letter from Clarence Darrow to Mary Field Parton, February 9, 1914, folder 19, Parton-Darrow Papers.

23. Letter from Clarence Darrow to Mary Field Parton, August 8, 1913, folder 19, Parton-Darrow Papers.

24. Letter from Clarence Darrow to Mary Field Parton, May 15, 1913, folder 19, Parton-Darrow Papers.

25. Letter from Clarence Darrow to Mary Field Parton, Februery 13, 1913, folder 19, Parton-Darrow Papers.

26. Letter from Clarence Darrow to Mary Field Parton, April 27, 1915, folder 19, Parton-Darrow Papers.

27. Quoted in Farrell, *Clarence Darrow*, 289–291; Weinberg and Weinberg, *A Sentimental Rebel*, 271.

28. William E. Leuchtenburg, *The Perils of Prosperity 1914–1932*, Chicago History of American Civilization series, ed. Daniel J. Boorstin (Chicago: University of Chicago Press, 1958), 13.

29. The traditional account of the start of the war is presented in Barbara Tuchman, *The Guns of August* (New York: Macmillan, 1962). The centennial anniversary of the war produced an abundance of scholarship challenging the traditional perspective. See Margaret MacMillan, *The War That Ended Peace: The Road to 1914* (New York: Random House, 2014); Max Hastings, *Catastrophe 1914: Europe Goes to War* (New York: Alfred A. Knopf, 2013); Christopher Clark, *The Sleepwalkers: How Europe Went to War in 1914* (New York: HarperCollins, 2012); Sean McMeekin, *July 1914: Countdown to War* (New York: Basic Books, 2013).

30. Leuchtenburg, *Perils of Prosperity*. The author writes: "Wilson [had] conducted his foreign policy by rules of war which neither Germany nor Britain respected." He defended interests that had no support "under international law and still less under cold common sense" (p. 31).

31. Catherine Scholten, "Sara Bard Field," in *Notable American Women: The Modern Period*, ed. Barbara Sicherman and Carol Hurd Green (Cambridge, MA: Belknap Press, 1980), 233; Farrell, *Clarence Darrow*, 295; Leuchtenburg, *Perils of Prosperity*, 14; Dean A. Strang, *Worse than the Devil: Anarchists, Clarence Darrow, and Justice in a Time of Terror* (Madison: University of Wisconsin Press, 2016), 155; Clarence Darrow, *The Story of My Life* (New York: Charles Scribner's Sons, 1932; Da Capo Press, 1996), 210–211, 300; Darrow letter to Mary Field Parton, April 27, 1915, folder 19, Parton-Darrow Papers. President Wilson, hoping to capitalize on support of the war by a leading radical, called Darrow to a meeting in Washington, and Darrow went on a speaking tour promoting the war effort. Seeing Germany as the aggressor, Darrow said, "There can be no peace while Prussian militarism lives, and I want to see it destroyed." Cowan, *People v. Clarence Darrow*, 443.

32. Letter from Clarence Darrow to Mary Field Parton, January 29, 1918, folder 19, Parton-Darrow Papers. Weinberg and Weinberg, *A Sentimental Rebel*, 283, 279.

33. Quoted in David M. Kennedy, *Over Here: The First World War and American Society* (New York: Oxford University Press, 2004), 40.

34. Leuchtenburg, *Perils of Prosperity*, 41; Michael McGerr, *A Fierce Discontent: The Rise and Fall of the Progressive Movement in America, 1870–1920* (New York: Free Press, 2003), 282.

35. Thelen, *Robert La Follette*, 101; Strang, *Worse than the Devil*, 32; Leuchtenburg, *Perils of Prosperity*, 44, 46 (quote); McGerr, *A Fierce Discontent*, 287, 289. Debs was eventually released from prison by President Warren Harding, who invited the union leader to the White House and expressed pride in meeting the honorable gentleman who had done so much for the people of the United States. See Weinberg and Weinberg, *A Sentimental Rebel*, 289.

36. Darrow, *Story of My Life*, 210–211, 213 (quote).

37. Darrow, *Story of My Life*, 306. Historians have generally been critical of Wilson's policies during the war. Arthur Ekirch finds that World War I created a powerful militarized state that limited personal freedoms and prompted elite rule and majoritarianism. Arthur A. Ekirch Jr., *The Decline of American Liberalism* (New York: Atheneum, 1980). John Higham asserts that Wilson, by limiting civil liberties, created a powerful central government and a repressive majority intolerant of dissent. John Higham, *Strangers in the Land: Patterns of American Nativism, 1860–1925* (New York: Atheneum, 1977). See also John Braeman, "World War I and the Crises of American Liberty," *American Quarterly* 16 (Spring 1964): 104–112; Paul L. Murphy, *World War I and the Origins of Civil Liberties in the United States* (New York: W.W. Norton, 1979).

38. Letter from Clarence Darrow to Mary Field Parton, January 29, 1918, folder 19, Parton-Darrow Papers. Mary lashed out at Wood in her diary: "I could sue him for alienation of affections, for surely he has done that to me." Mary Field Parton, diary entry for Wednesday, March 23, 1921, box 58, Parton Papers.

39. Quoted in Weinberg and Weinberg, *A Sentimental Rebel*, 288.

40. Quoted in Farrell, *Clarence Darrow*, 325, and Strang, *Worse Than The Devil*, 155; Leuchtenburg, *Perils of Prosperity*, 125.

41. Quoted in Thelen, *Robert La Follette*, 219.

42. Mary Field Parton diary entries, January 24, 1926, December 5, 1933, box 59, Parton Papers.

43. Wiebe, *Search for Order*, 289–290; Farrell, *Clarence Darrow*, 308 (quote).

44. Gary Krist, *City of Scoundrels: The 12 Days of Disaster that Gave Birth to Modern Chicago* (New York: Random House, 2012), 97.

45. Strang, *Worse than the Devil*, 6; Wiebe, *Search for Order*, 207.

46. Jill Lepore, "The Fireman: Eugene V. Debs and the Endurance of American Socialism," *New Yorker*, February 18 and 25, 2019, 92.

47. The Clayton Act is at 38 Stat.737 (1913). Christopher Tomlins argues that collective labor action gained legitimacy only with the creation of the corporate state that integrated the dominant position of capitalism with the vital supportive roles of labor. Christopher Tomlins, *The State and the Unions: Labor Relations, Law, and the Organized Labor Movement in America, 1880–1960* (New York: Cambridge University Press, 1988).

48. Calvin Coolidge, "Speech to the Amherst College Alumni Association," February 4, 1919, in Calvin Coolidge, *Have Faith in Massachusetts* (Boston: Houghton Mifflin, 1919), 14; Heather Cox Richardson, *To Make Men Free: A History of the Republican Party* (New York: Basic Books, 2014), 189–191.

49. Railway Labor Act, 44 Stat. 577 (1926); Norris-LaGuardia Act, 47 Stat. 70 (1932).

50. Thelen, *Robert La Follette*, 173.

51. Parton, "Mary Field," unnumbered page, notes for chap. 7, Parton Papers.

52. Diary entries from March 20 and 21, 1921, box 58, Parton Papers. On the meaning of justice, Mary writes, "I said [that there is] no such thing. Justice is the accepted

rule of the strong." She then expressed great disappointment in the others with whom she was seated, as they lacked the "moral point of view" to further the discussion.

53. Quoted in Farrell, *Clarence Darrow*, 305. See also Scholten, "Sara Bard Field," 233. Albert retained custody of the children.

54. Undated journal entries, 1918, box 58, Parton Papers.

55. Parton, "Mary Field," 4, Parton Papers.

56. Wiebe, *Search for Order*.

57. Mary Field Parton, diary entries October 3 and 4, 1924, box 58, Parton Papers.

58. Mary Field Parton, diary entry September 23, 1924, box 58, Parton Papers.

6. A Rights Revival in the Roaring Twenties, 1924–1929

1. Quotes from Geoffrey Cowan, *The People v. Clarence Darrow: The Bribery Trial of America's Greatest Lawyer* (New York: Random House, 1993), 64; Parton, "Mary Field," unnumbered pages in draft of chap. 4, Parton Papers.

2. "Mary Parton," notes for last chapter (7), Parton Papers.

3. Edward M. Steel, ed., *The Correspondence of Mother Jones* (Pittsburgh: University of Pittsburgh Press, 1985). Later in the letter, after reciting some news of personal and labor concerns, Mother Jones noted that she recently saw Darrow in Washington, DC, and that he always spoke so fondly of Mary.

4. Letter, Darrow to Mary Field Parton, September 8, 1922, folder 19, Parton-Darrow Papers.

5. Mary Field Parton, diary entry March 9, 1925, box 58, Parton Papers.

6. Clarence Darrow, "Introduction," in *Autobiography of Mother Jones*, ed. Mary Field Parton (Mineola, NY: Dover, 2004) (originally published in 1925 by Charles H. Kerr & Co., Chicago), v.

7. Parton, *Mother Jones*, 2.

8. Parton, *Mother Jones*, ii.

9. Parton, *Mother Jones*, 16–17, 23, 48–53, 76, 87–88 (quote), 138.

10. Mary Field Parton, diary entry January 25, 1923, box 58, Parton Papers.

11. Mary Field Parton, diary entries March 2 and 5, 1926, box 59, Parton Papers.

12. Mary Field Parton, diary entry March 10, 1927, box 59, Parton Papers.

13. Mary Field Parton, diary entry February 2, 1927, box 59, Parton Papers.

14. Mary Field Parton, diary entries August 9, January 19, and September 14, 1926, January 6, 1923, and June 3, 1927, boxes 58 and 59, Parton Papers. She acknowledged a certain competition or status in shopping in writing: "Shopped. Shops full of useless, expensive luxuries—women amid the stalls looking at the whirlpool of meaningless things. I don't feel superior to those who buy—inferior!" Diary entry December 3, 1925, box 58, Parton Papers.

15. Mary Field Parton, diary entry September 12, 1924, box 58, Parton Papers. Lux was a commercial brand of soap. Andy Hardy was a fictional young man who was the focus of a series of books addressed to children and young adults. In later movies, he was depicted by the actor Mickey Rooney.

16. Mary Field Parton, diary entries March 19, 1924, box 58, Parton Papers, and June 10, 1926, and June 7 and August 11, 1927, box 59, Parton Papers. See also, regarding flappers, entries for July 29, 1923, box 58, and September 6, 1926, box 59, Parton Papers. Emphasis in original.

17. Charles J. Shindo, *1927 and the Rise of Modern America* (Lawrence: University Press of Kansas, 2010), 53 (quote), 54 (quote), 55 (quote), 55 (quote). See also Joshua Zeitz, *Flapper: A Madcap Story of Sex, Style, Celebrity, and the Women Who Made Modern America* (New York: Crown, 2006).

18. Mary Field Parton, diary entry January 16, 1926, box 59, Parton Papers.

19. John A. Farrell, *Clarence Darrow: Attorney for the Damned* (New York: Vintage Books, 2012), 437.

20. Farrell, *Clarence Darrow*, 417, 419, 411–412.

21. Mary Field Parton, journal entry December 20, 1928, folder 31, Parton-Darrow Papers.

22. Mary Field Parton, journal entry January 24, 1928, folder 31, Parton-Darrow Papers. The feelings between Mary and Ruby were mutual. Ruby once said: "I shudder at the indecency of Mary Field Parton." Cowan, *People v. Clarence Darrow*, 6.

23. Mary Field Parton, diary entry February 2, 1926, box 59, Parton Papers.

24. Clarence Darrow, "The Crime of Compulsion," in *Attorney for the Damned*, ed. Arthur Weinberg (New York: Simon & Schuster, 1957), 16–19, 32.

25. Quoted in Farrell, *Clarence Darrow*, 334.

26. Mary Field Parton, diary entries June 20, 24, and 19, 1924, box 58, Parton Papers.

27. Quoted in "Crime of Compulsion," 19; quoted in Farrell, *Clarence Darrow*, 357.

28. Mary Field Parton, diary entries, August 9, 15, and 27, 1924, and September 10, 1924, box 58, Parton Papers.

29. Mary Field Parton, diary entry October 14, 1924, box 58, Parton Papers.

30. Mark Douglas McGarvie, *Law and Religion in American History: Public Values and Private Conscience* (New York: Cambridge University Press, 2016), 111–115; Sydney E. Ahlstrom, *A Religious History of the American People* (New Haven, CT: Yale University Press, 1972), 808–819, 909–910.

31. Edward J. Larson, *Summer for the Gods: The Scopes Trial and America's Continuing Debate over Science and Religion* (New York: Basic Books, 1997), 50 (quote); Noah Feldman, *Divided by God: America's Church-State Problem and What We Should Do About It* (New York: Farrar, Straus and Giroux, 2006), 135–149. See also Jeffrey P. Moran, *The Scopes Trial: A Brief History with Documents* (Boston: Bedford / St. Martins, 2002).

32. Clarence Darrow, *The Story of My Life* (New York: Charles Scribner's Sons, 1932; Da Capo Press, 1996), 249. Edgar Lee Masters commented on Darrow's enthusiasm: "He is a grey-eyed infidel, and all his life he has been talking this stuff; now he can empty his mind of it on a good occasion." Quoted in Farrell, *Clarence Darrow*, 380.

33. Mary Field Parton, diary entry July 14, 1925, box 58, Parton Papers.

34. Darrow, opening statement in Scopes trial, in *Attorney for the Damned*, ed. Arthur Weinberg (New York: Simon & Schuster, 1957), 183–184.

35. Darrow, opening statement in Scopes trial, 175–176 (quote).

36. Mary Parton on Darrow's views of labor, quoted in Farrell, *Clarence Darrow*, 369.

37. Americans' utter shock at the tenets of fundamentalist theology prompted ridicule and fear. See Norman Furniss, *The Fundamentalist Controversy, 1918–1931* (New Haven, CT: Yale University Press, 1954), 1–13; Karen Armstrong, *The Battle for God: A History of Fundamentalism* (New York: Random House, 2000), 176–178; McGarvie, *Law and Religion in American History*, 111–118.

38. Mary responded in her diary: "Bryan died today of gluttony. God should have struck the agnostic Darrow instead of his saint. No accounting for the Almighty." Mary Field Parton, diary entry July 26, 1925, box 58, Parton Papers.

39. Mary Field Parton, diary entries December 12 and February 10, 1925, box 58, Parton Papers.

40. Mary Field Parton journal, 1925–1938, entries from March 30 and 31, 1925, folder 31, Parton-Darrow Papers.

41. Quoted in Farrell, *Clarence Darrow*, 427.

42. Letter from Darrow to Mary Field Parton, August 8, 1922, folder 19, Parton-Darrow Papers.

43. Mary Parton, diary entries July 30 and February 11, 1923, box 58, Parton Papers.

44. Mary Parton, diary entry January 9, 1924, box 58, Parton Papers.

45. Mary Parton, diary entries January 9, 12, and 22, 1924, box 58, Parton Papers.

46. Mary Field Parton, diary entry January 12, 1924, box 58, Parton Papers.

47. Mary Field Parton, diary entry April 18, 1924, box 58, Parton Papers.

48. Mary Field Parton, diary entries August 23 and June 17, 1925, box 58; November 17 and January 25, 1927, box 59, Parton Papers. On political and economic liberty, see Joyce Appleby, *Capitalism and a New Social Order: The Republican Vision of the 1790s* (New York: NYU Press, 1992).

49. Mary Field Parton, diary entries January 26 and February 14, 1926, box 59, Parton Papers.

50. Mary Field Parton, diary entry February 27, 1926, box 59, Parton Papers. The reference to Babbitt emanates from Sinclair Lewis's novel of the same name, published in 1922, lampooning the vacuous nature of middle-class US life, its emphasis on conformity, and its imposition of social pressures. George Babbitt, the main character, unquestioningly accepts society's moral and social impositions and attempts to pursue popularly accepted goals.

51. Obituary of Lemuel Parton entitled "Lemuel Parton Dies," *New York Herald Tribune*, January 31, 1943, Parton Papers, collection 136, folder 1, box 64. Introductory materials on Parton family, Parton Papers.

52. Mary Field Parton, Diary entry July 7, 1927, box 59, Parton Papers.

53. Quoted in Arthur Weinberg and Lila Weinberg, *Clarence Darrow: A Sentimental Rebel* (New York: G. P. Putnam's Sons, 1980), 291.

54. Mary Field Parton, diary entry June 23, 1927, box 59, Parton Papers. Nicola Sacco and Bartolomeo Vanzetti were two Italian immigrants who most liberals believed were innocent of murder and executed for political anarchism.

55. Mary Field Parton, diary entries December 12 and March 31, 1925, box 59, Parton Papers.

56. Mary Field Parton, diary entries March 22 and April 21, 1927, and February 23, 1926, box 58, Parton Papers.

57. Mary Field Parton, diary entries February 22 and June 11, 1925, box 58, Parton Papers.

58. Mary Field Parton, diary entry April 10, 1925, box 58, Parton Papers.

59. Mary Field Parton, diary entry February 10, 1925, box 58, Parton Papers. French philosopher Jean-Jacques Rousseau was a leading exponent of the natural rights theory

that dominated Enlightenment thought. His book *Emile*, published in 1762, encouraged an undisciplined education of the young rooted in an appreciation of nature and freedom. Such an education would allow one's true nature, understood as benevolent, inquisitive, rational, and reasonable, to come to fruition, untainted by the perverting influences of society.

60. Mary Field Parton, diary entries February 10, 1923, and February 26, 1925, box 58, Parton Papers.

61. Mary Field Parton, diary entries March 29, 1926, box 59, and September 16, 1924, box 58, Parton Papers.

62. Mary Field Parton, diary entry January 20, 1926, box 59, Parton Papers.

63. Mary Field Parton, diary entries June 12, July 4, and August 8, 1926, box 59, Parton Papers.

64. Mary Field Parton, diary entry March 23, 1926, box 59, Parton Papers; Farrell, *Clarence Darrow*, 419.

65. Mary Field Parton, diary entries October 12 and November 7, 1926, box 59, Parton Papers.

66. Farrell, *Clarence Darrow*, 435, 438. Mary Field Parton, journal entry, August 13, 1928, folder 31, Parton-Darrow Papers.

67. Weinstein, *A Sentimental Rebel*, 358.

68. Mary Field Parton, diary entries December 9 and 10, 1926, box 59, Parton Papers.

69. Quoted in Farrell, *Clarence Darrow*, 434. Mary Field Parton, journal entry November 12, 1927, folder 31, Parton-Darrow Papers.

70. Letter, Darrow to Mary Parton, August 25, 1928, Parton-Darrow Papers, folder 19; Darrow, *Story of My Life*, 333.

7. A New Deal for Liberalism and the United States, 1929–1969

1. William E. Leuchtenburg, *The Perils of Prosperity 1914–1932*, Chicago History of American Civilization series, ed. Daniel J. Boorstin (Chicago: University of Chicago Press, 1958), 9.

2. Mary Parton, diary entries of October 26 and 29 and November 3 and 5, 1929, box 59, Parton Papers.

3. Mary Parton, diary entries of November 25 and December 13, 1929, box 59, Parton Papers.

4. Mary Parton, undated notes in file on apartment in Greenwich Village, box 62, Parton Papers.

5. Mary Parton, diary entries October 24 and September 30, 1933, box 59, Parton Papers; emphasis in the original.

6. Mary Parton, diary entries January 27, 1935, November 18, 1933, January 22, 1935, and May 12, 1932, boxes 60 and 59, Parton Papers.

7. Mary Parton, diary entries July 25, June 9, and September 26 and 22, 1933, boxes 59 and 60, Parton Papers.

8. Mary Parton, diary entries for May 31 and May 9, 1929, box 59, Parton Papers.

9. Mary Parton, diary entry December 5, 1933, box 59, Parton Papers.

10. Mary Parton, diary entries January 22, 1935, box 60, Parton Papers.

11. Leuchtenburg, *Perils of Prosperity*, 2–7, quotes at 3.

12. David M. Kennedy, *Freedom from Fear: The American People in Depression and War* (New York: Oxford University Press, 1999), 177–189. Mary Parton, diary entry August 23, 1933 (quotes), box 59, Parton Papers.

13. John C. Livingston, *The Mind of a Sentimental Rebel*, in *Modern American History, A Garland Series*, ed. Robert E. Burke and Frank Freidel (New York: Garland, 1988), 87–88 (quote).

14. Quoted in Arthur Weinberg and Lila Weinberg, *Clarence Darrow: A Sentimental Rebel* (New York: G. P. Putnam's Sons, 1980), 379.

15. Good resources on the Wagner Act include Charles J. Morris, ed., *The Developing Labor Law*, 2 vols. (Washington, DC: Bureau of National Affairs, 1983), 25–37; Leon H. Keyserling, "The Wagner Act: Its Origins and Current Significance," *George Washington Law Review* 29 (1960): 199.

16. Barry D. Karl, *The Uneasy State: The United States from 1915–1945* (Chicago: University of Chicago Press, 1983), 118–119, 227 (quote); see generally Paul Conklin, *The New Deal*, Crowell American History series, ed. John Hope Franklin and Abraham Eisenstadt (New York: Thomas Y. Crowell Co., 1967).

17. *Lochner v. New York*, 198 U.S. 4 (1905)

18. *National Labor Relations Board v. Jones and Laughlin Steel Corp.*, 301 U.S. 1 (1937). In May, the Court upheld the Social Security Act, *Helvering v. Davis*, 301 U.S. 619 (1938).

19. *United States v. Carolene Products*, 304 U.S. 144, 152–53 (1938).

20. Mary Parton, diary entry February 26, 1935, box 60, Parton Papers.

21. Mary Parton, diary entries January 14, 1933, November 27, 1933, box 59, Parton Papers. Diary entry February 28, 1935, box 60, Parton Papers.

22. Weinberg, *A Sentimental Rebel*, 379–380.

23. Mary Parton letter to Sara, February 27, 1938, quoted in John A. Farrell, *Clarence Darrow: Attorney for the Damned* (New York: Vintage Books, 2012), 531n25.

24. Mary Parton, journal entry March 31, 1938, 12:30 p.m., folder 31, Parton-Darrow Papers.

25. Mary Parton, "The Golden Child," folder 4, box 62; "Just Being With James," folder 6, box 62, Parton Papers.

26. Mary Parton, "The Durable Angel"; "The Miracle in Apartment Five—Rear," folder 3, box 62, Parton Papers.

27. Mary Parton, "The Sails of Destiny"; "As Old as the Hills," folder 8, box 62, Parton Papers.

28. Language from *Your Washington* in file 7, box 63; unidentified review also in file 7, box 63; *Los Angeles Times* review of April 17, 1938, in file 9, box 63, Parton Papers.

29. Unidentified reviews of *Metropolis*, file 7, box 63, Parton Papers.

30. Mary Parton, diary entry June 18, 1935, box 60, Parton Papers.

31. Mary Parton, diary entries November 23, April 15, May 2, and April 29, 1935, box 60, Parton Papers.

32. Mary Parton, diary entries April 25 and November 11, 1935, box 60, Parton Papers.

33. Mary Parton, diary entries January 16, 1936, and March 4 and July 28, 1935; emphasis in original. On March 3, 1935, Mary noted that "the great Fremont Older" had died, box 60, Parton Papers.

34. Mary Parton diary entries March 1 and July 4, 1935, box 60, Parton Papers.

35. Mary Parton, diary entries October 27, 1936, February 12, 1940, November 3, 1936, folder 3, box 60, Parton Papers.

36. Mary Parton, diary entries May 11 and January 20, 1940, folder 3, box 60, Parton Papers.

37. Mary Parton, diary entries June 24, January 17 and 29, and February 2, 1940, folder 3, box 60, Parton Papers. Father Charles Coughlin was a Catholic priest who advocated populist conservatism rooted in Christianity and collective responsibility. He reached millions of Americans with his radio show, *The Golden Hour of the Shrine of the Little Flower.*

38. Mary Parton Diary entries May 11 and June 22, 1940, folder 3, box 60. The entries build on Mary's anger over British prime minister Neville Chamberlain's behavior and the need to address Hitler's evil. No diary or journal exists from the time of the attack on Pearl Harbor in 1941.

39. National Labor Relations Act, 29 U.S.C. 7.

40. Mary Parton, diary entry June 25, 1947, box 60, Parton Papers.

41. Typed manuscript of Mary Field Parton interview, file 9, box 38, Parton Papers.

42. Mary Parton, diary entries February 12 and March 8, 1952, December 4, 1956, box 61, Parton Papers.

43. Mary Parton, diary entries August 15, 1950, box 60, Parton Papers, and November 11, 1952, box 61, Parton Papers. William O. Douglas asserted the same conclusion. Transcript of radio broadcast, "People's Platform" featuring Dwight Cooke, William O. Douglas, and Ferdinand Kuhne, October 28, 1951, William O. Douglas Papers, Library of Congress, Washington, DC ("Douglas Papers"); William O. Douglas, *Democracy's Manifesto: A Counter Plan for the Free Society* (Garden City, NY: Doubleday, 1962).

44. Mary Parton, diary entries August 1, 1956, box 61; January 16, 1953, box 59, Parton Papers.

45. Mary Parton, diary entries April 11, 1955, April 3, 1952, and August 19, 1956, box 61, Parton Papers. Sara married Erskine in 1938 after his longtime first wife died. Catherine Scholten, "Sara Bard Field," in *Notable American Women: The Modern Period*, ed. Barbara Sicherman and Carol Hurd Green (Cambridge, MA: Belknap Press, 1980), 233.

46. Mary Parton, diary entry of August 13, 1950, box 60, Parton Papers; emphasis in original. See also David Halberstam, *The Fifties* (New York: Villard Books, 1983), 131–143, for more on Levittown.

47. Mary Parton, diary entries May 1, 1953, and July 11, 1956, box 61, Parton Papers.

48. Mary Parton, diary entries May 1, 1954, and July 11, 1956, box 61, Parton Papers; emphasis in original.

49. Parton, diary entries March 11 and October 16, 1952, box 61, Parton Papers.

50. Mary Parton, diary entries November 5, 1952, January 19, 1953, August 17, 1956, November 7, 1956, and January 19, 1953, box 61, Parton Papers. A recent account by a noted historian considers Eisenhower the more liberal of the candidates, at least on civil rights, in 1952 and 1956. Jill Lepore, "All the King's Data," *New Yorker*, August 3 and 10, 2020, 18–24. See also Heather Cox Richardson, *To Make Men Free: A History of the Republican Party* (New York: Basic Books, 2014), 221–271.

51. Mary Parton, diary entries July 26, 1960, January 30 and June 7 and 30, 1963, box 61, Parton Papers.

52. Legal positivism is a legal doctrine rooted in pragmatism that asserts that law can act positively to address social needs. Legal positivism accepts law as a fungible social creation that must be unrestrained by the Constitution and precedent.

53. William O. Douglas, *The Court Years, 1939–1975* (New York: Random House, 1980), 8. Douglas stated this idea in similar words innumerable times in Supreme Court opinions and writings from the 1940s until his death. Barry Goldwater, *The Conscience of a Conservative* (Shepherdsville, KY: Victor, 1960), 21 (quote), 24 (quote), 59 (quote); Barry Goldwater, "Acceptance Speech," Republican National Convention, July 16, 1965, Daly City, CA.

54. W. O. Douglas, "Discussion on American Character," at the Center for the Study of Democratic Institutions, November 1, 1961, folder 6, box 522, Douglas Papers.

55. Samantha Barbas, "When Privacy Almost Won: Time, Inc. v. Hill," *Journal of Constitutional Law* 18, no. 2 (December 2015): 505–591, quote at 534. See also David Farber, *The Age of Great Dreams: America in the 1960s* (New York: Hill & Wang, 1994), 8, 65–66; Todd Gitlin, *The Sixties: Years of Hope, Days of Rage* (New York: Bantam Books, 1987).

56. See David Maraniss, *They Marched Into Sunlight: War and Peace, Vietnam and America October 1967* (New York: Simon & Schuster, 2004) 78–90; Beth Bailey, "Sexual Revolution(s)," in *The Sixties: From Memory to History*, ed. David Farber (Chapel Hill: University of North Carolina Press, 1994), 235–262. But see also Todd Gitlin, *The Sixties*, 81–221.

57. Mary Field Parton, diary entry January 30, 1963, box 61, Parton Papers.

Afterword

1. Hermann Hesse, *Demian: The Story of Emile Sinclair's Youth* (New York: Bantam Books, 1965), frontispiece.

2. Robert L. Payton, *Philanthropy: Voluntary Action for the Public Good* (New York: Macmillan, 1988); Robert H. Bremner, *American Philanthropy*, 2nd ed., The Chicago History of American Civilization Series, ed. Daniel J. Boorstin (Chicago: University of Chicago Press, 1988).

3. Lawrence J. Friedman and Mark Douglas McGarvie, eds., *Charity, Philanthropy, and Civility in American History* (New York: Cambridge University Press, 2003).

4. David A. Hollinger, "The Problem of Pragmatism in American History: A Look Back and A Look Ahead," in *Pragmatism: From Progressivism to Postmodernism*, ed. Robert Hollinger and David DePew (Westport, CT: Praeger Press, 1995), xvi, xvii.

5. See, for example, Richard Rorty, *Achieving Our Country: Leftist Thought in Twentieth-Century America* (Cambridge, MA: Harvard University Press, 1998), and, by the same author, *Philosophy's Cultural Politics* (New York: Cambridge University Press, 2007) and Richard Rorty, *Objectivity, Relativism, and Truth* (New York: Cambridge University Press, 1991).

6. Robert Hollinger and David DePew, eds., *Pragmatism: From Progressivism to Postmodernism* (Westport, CT: Praeger Press, 1995), 6, 7.

INDEX

CPSIA information can be obtained
at www.ICGtesting.com
Printed in the USA
BVHW042234171022
649668BV00002B/117